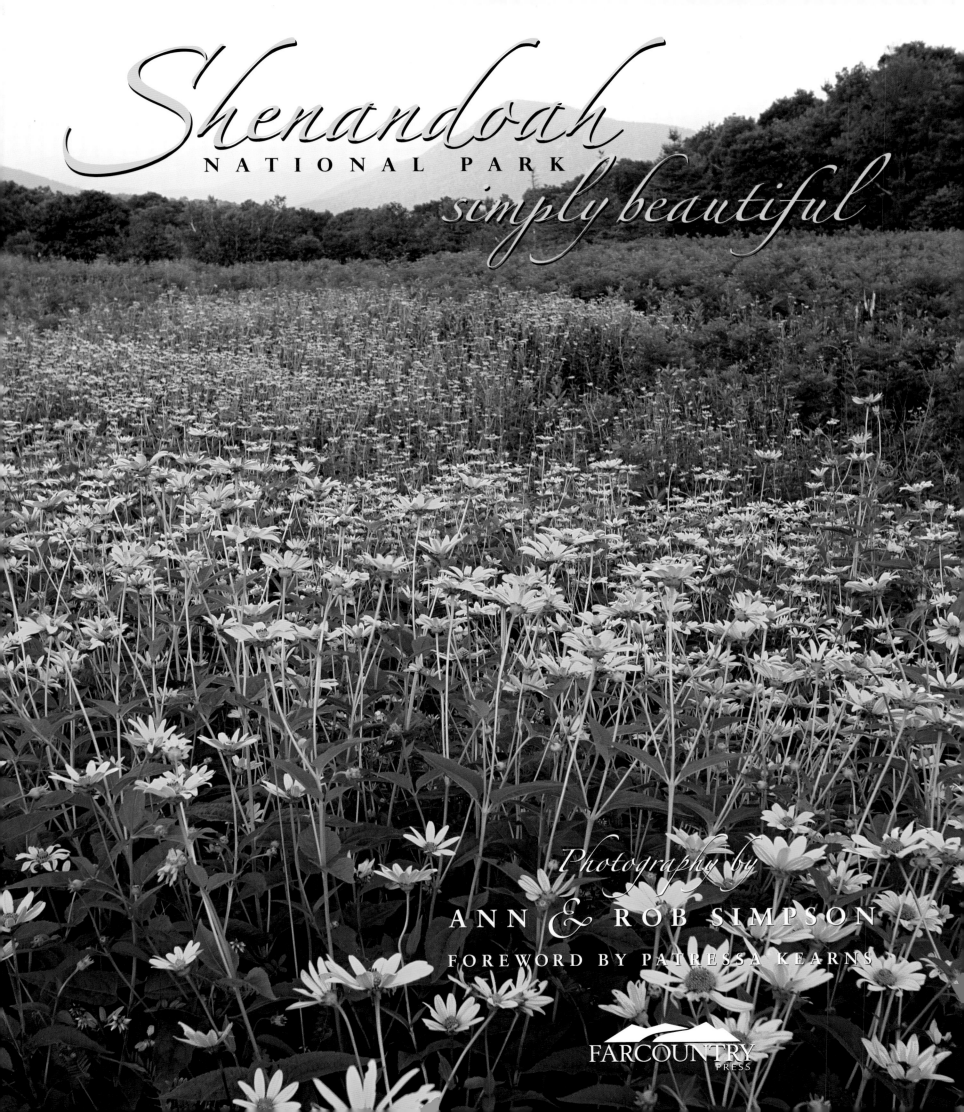

Shenandoah
NATIONAL PARK
simply beautiful

Photography by
ANN & ROB SIMPSON
FOREWORD BY PATRESSA KEARNS

FARCOUNTRY
PRESS

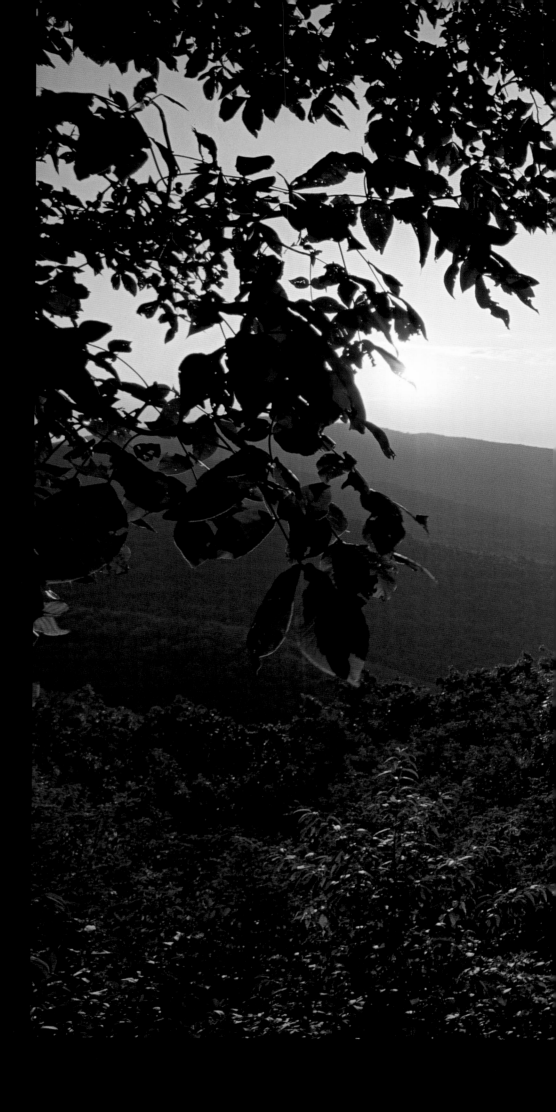

TITLE PAGE: Midsummer meadows are carpeted with
summer wildflowers, including ox-eye sunflowers. The
peak in the distance, Old Rag Mountain, is composed
of Old Rag Granite, which is more resistant to erosion
than the rocks surrounding it.

RIGHT: Break of day in Shenandoah National Park,
from Ivy Creek Overlook.

FRONT COVER: From the Spitler Knoll Overlook,
one can see the cerulean-colored outlines of the
Blue Ridge Mountains.

BACK COVER (LEFT): Mountain laurel blooms in June
along the rocky Franklin Cliffs.

BACK COVER (RIGHT): A park ranger holds up a barred
owl, one of 200 bird species that inhabit the park.

FRONT FLAP: A close-up of the pink blossoms of
mountain laurel.

ISBN 13: 978-1-56037-416-9
ISBN 10: 1-56037-416-0

© 2007 by Farcountry Press
Photography © 2007 by Ann & Rob Simpson

For more information about our books, write Farcountry Press,
P.O. Box 5630, Helena, MT 59604; call (800) 821-3874; or visit
www.farcountrypress.com.

Created, produced, and designed in the United States.
Printed in China.

12 11 10 09 08 07 1 2 3 4 5 6

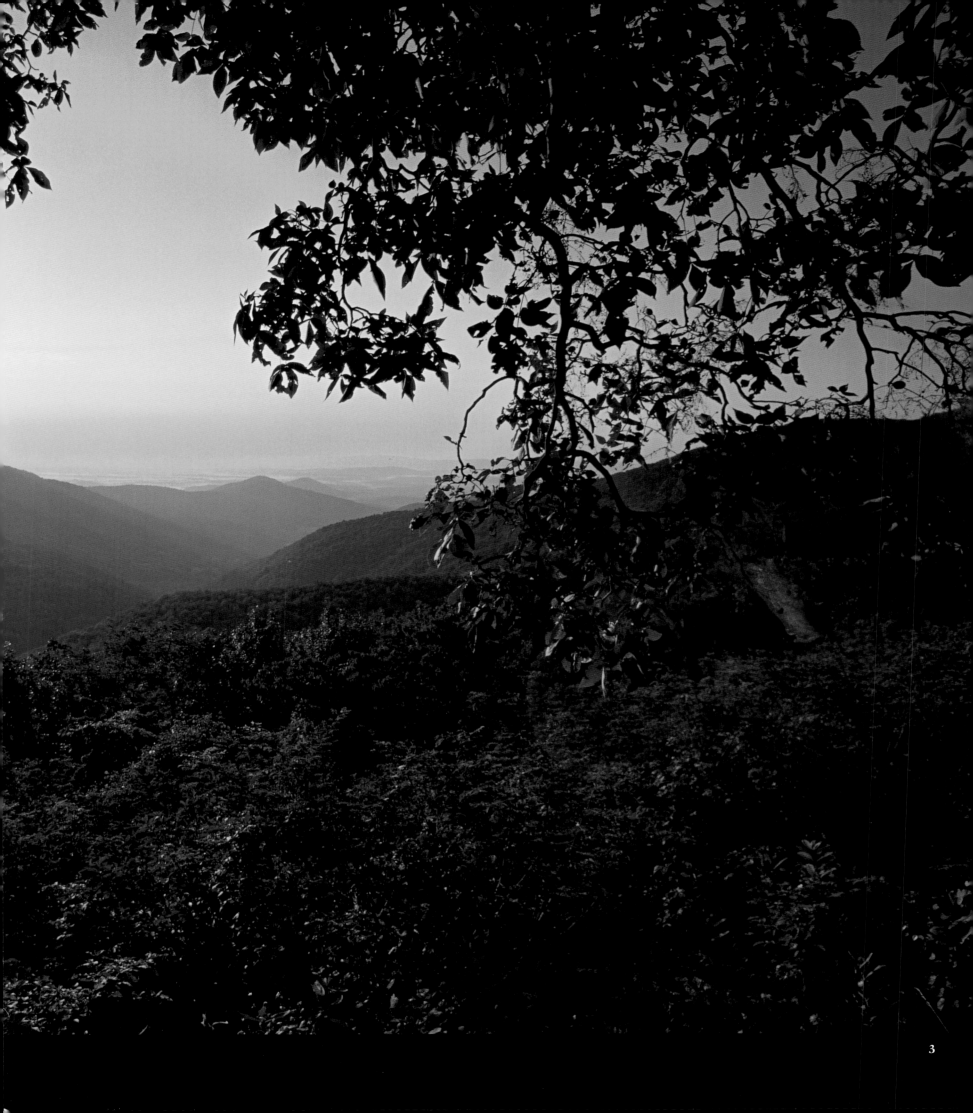

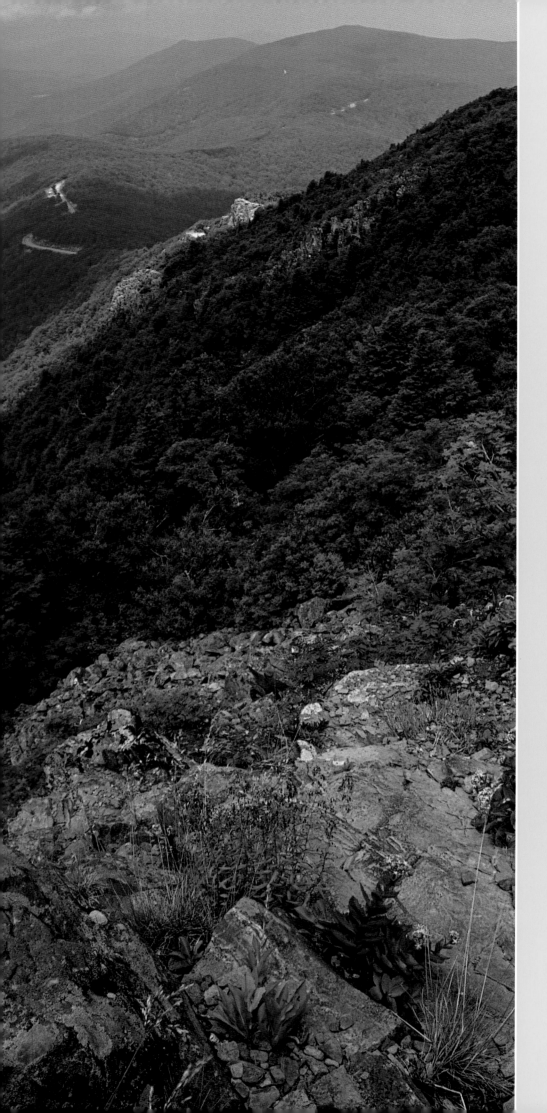

Foreword
BY PATRESSA G. KEARNS

The name of this place is Shenandoah National Park. And within this park there are other names—Bootens Gap, Naked Creek Overlook, Bacon Hollow Overlook, Rapidan Camp, Rattlesnake Point—names that suggest a history of who lived in a spot or of what happened there or of how a piece of land was used. A name tells us what kinds of apples—Milams—were once grown at Milam Gap. A name tells us of the former inhabitants of Nicholson Hollow. A name reflects an area's geology as in Franklin Cliffs or Sawmill Ridge. And a name echoes the stories of long-dead dwellers, as in Stony Man or Old Rag mountains. A name even haunts us, as in Slaughter Trail or Little Devils Stairs.

But, as evocative as they are, these words cannot give you the sharp intake of breath you experience when you turn a page and are struck by the blood reds, resplendent golds, and neon oranges of a photograph taken in autumn in this place called Shenandoah. A name cannot give you the bite of ice in your chest the way a snapshot of a frozen Robinson River can. The name Big Meadows Lodge does not give you the sensation of all-over toastiness you feel at the sight of the crackling fire glowing in the lodge's fireplace. You want to be there, warming your hands at the fire. You want to enter the scene and experience it yourself.

No one has captured Shenandoah National Park with any more finesse or adoration, more respect or *je ne sais quoi*, than have Ann and Rob Simpson. In *Shenandoah National Park Simply Beautiful*, you will find evidence of a love affair between two photographers and a place. It is an intimacy at once touching and alarming, for how can two people, armed only with cameras and a collection of lenses, get at the very soul of a place like these two get at

the soul of Shenandoah? And how can a 105-mile-long strip of land—albeit a ravishing one—wreak such lovely havoc on the emotions of a woman and a man and then elicit from them and a small piece of technology such stunning imagery? Ann and Rob Simpson are well educated in and have a deep appreciation of the splendors and eccentricities of biology, and it shows in their images of this national park, a place they have photographed for more than 30 years.

It's the nature and history of Shenandoah National Park to work magic on people. Although its history is more than a million years old—when magma was thrust up from inside the earth and then cooled, cracked, settled, and eroded to create the park's bedrock, hollows and granite peaks—the 300-square-mile, mostly woodland park was established in 1935.

In the 1930s, after the successes of Yellowstone and Yosemite national parks, citizens and Congress began longing for a national park in the east. In 1929, President Herbert Hoover and First Lady Lou Hoover established their Summer White House at the headwaters of the Rapidan River, bringing the area to national attention. In 1936, President Franklin Delano Roosevelt attended the dedication ceremony for Shenandoah National Park, held in Big Meadows. Skyline Drive, the 105-mile road that runs the length of the park, was built from 1931 to 1939. The Civilian Conservation Corps from 1933 to 1942 built visitor facilities, graded the slopes, and built the 75 overlooks along Skyline Drive. The CCC also built rock walls, improved the landscape, and planted much of the mountain laurel that blooms along the roadway today.

Fast forward to the twenty-first century. Today, Shenandoah National Park is wooded with hundreds of trees, including red oaks, chestnuts, and hickories. It is lavish with wildflowers, ferns, and grasses and dotted with mushrooms, lichens, and mosses. Black bears, white-tailed deer, bobcats, songbirds of almost infinite variety, eastern brook trout and other fishes, snakes, salamanders, turtles, and small creatures ranging from monarch butterflies to millipedes call the park home. While much of the park is forested, there are also rocky outcrops, streams and rivers, meadows (Big Meadows, smack dab in the middle of the park, is the largest), wetlands, and watersheds. Even more than its geologic and human history, it is its natural features and ecosystems, its biology and its names, that make this park shine. This park is a stunner, a caster of spells. And we are bewitched.

In *Shenandoah National Park Simply Beautiful*, Ann and Rob Simpson capture the essence of Shenandoah but do not steal its soul, as some ancient cultures believed a snapshot could do. Rather, these photographers have offered this national park to us, so that, armed with the inspiration and charm this book bestows on us, we will be able to give back to Shenandoah.

What's in a name? A little, but not a lot. What's in a picture? A thousand words, and more. What's in these pictures and in this book and in this national park? Magic.

Enter this book and fall in love with this place called Shenandoah.

Patressa Kearns worked in Shenandoah National Park for seven years and co-wrote The Birds of Shenandoah National Park: A Naturalist's View *with Terry Lindsay. She currently works as an editor for the National Park Service at Harpers Ferry Interpretive Design Center in Harpers Ferry, West Virginia.*

RIGHT: This stile on the Appalachian Trail provides hikers with an assist over a fence in McCormick Gap.

FACING PAGE: Pink blossoms of Allegheny stonecrop and blue Appalachian bellflowers color this view of Skyline Drive from Stony Man Mountain. The word "Shenandoah" is commonly thought to mean "daughter of the stars."

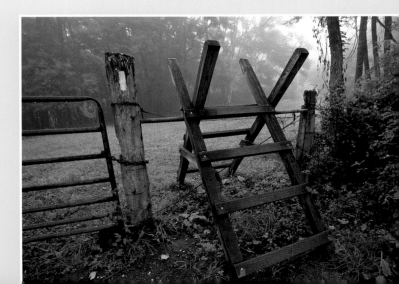

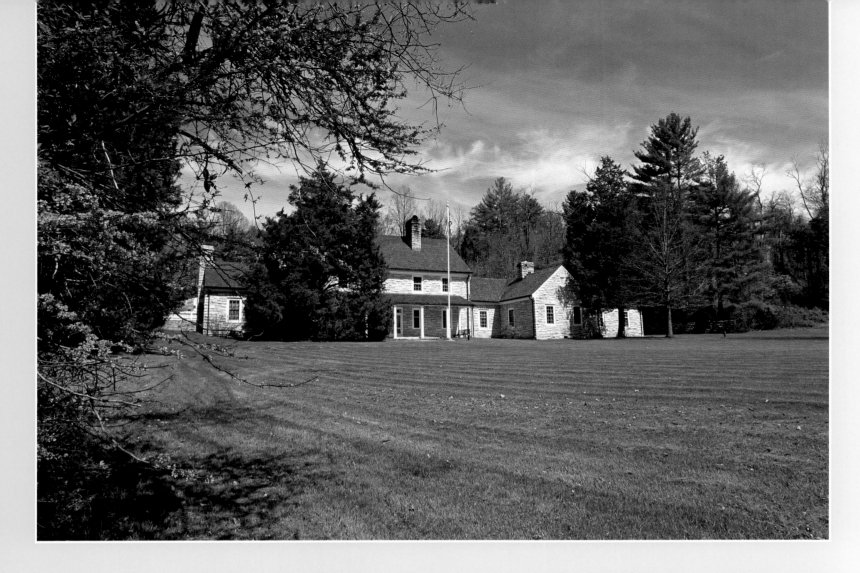

ABOVE: Flowering redbud trees, such as these framing the historic park headquarters on Route 211 in East Luray, Virginia, line the roadsides in the park's lower elevations.

RIGHT: Delicate pink ladyslippers are some of the many wildflowers, including bluets, trilliums, and geraniums, that arrive in spring.

FACING PAGE: Mountain laurel thrives in this protected nook in the Franklin Cliffs.

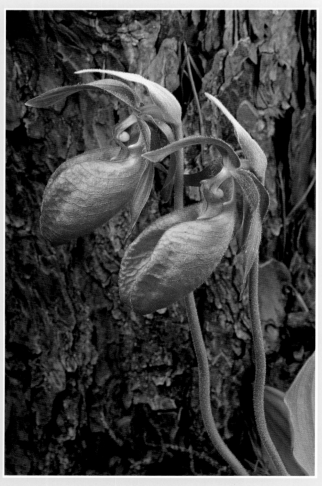

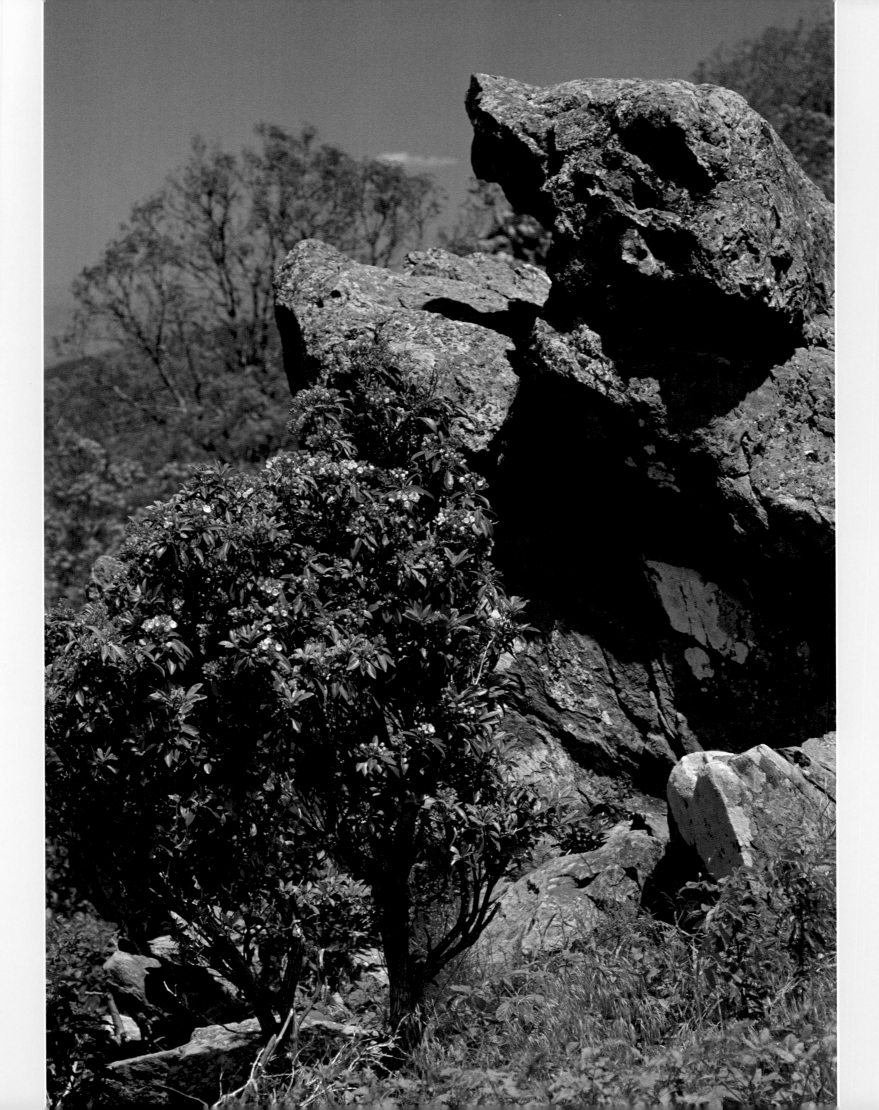

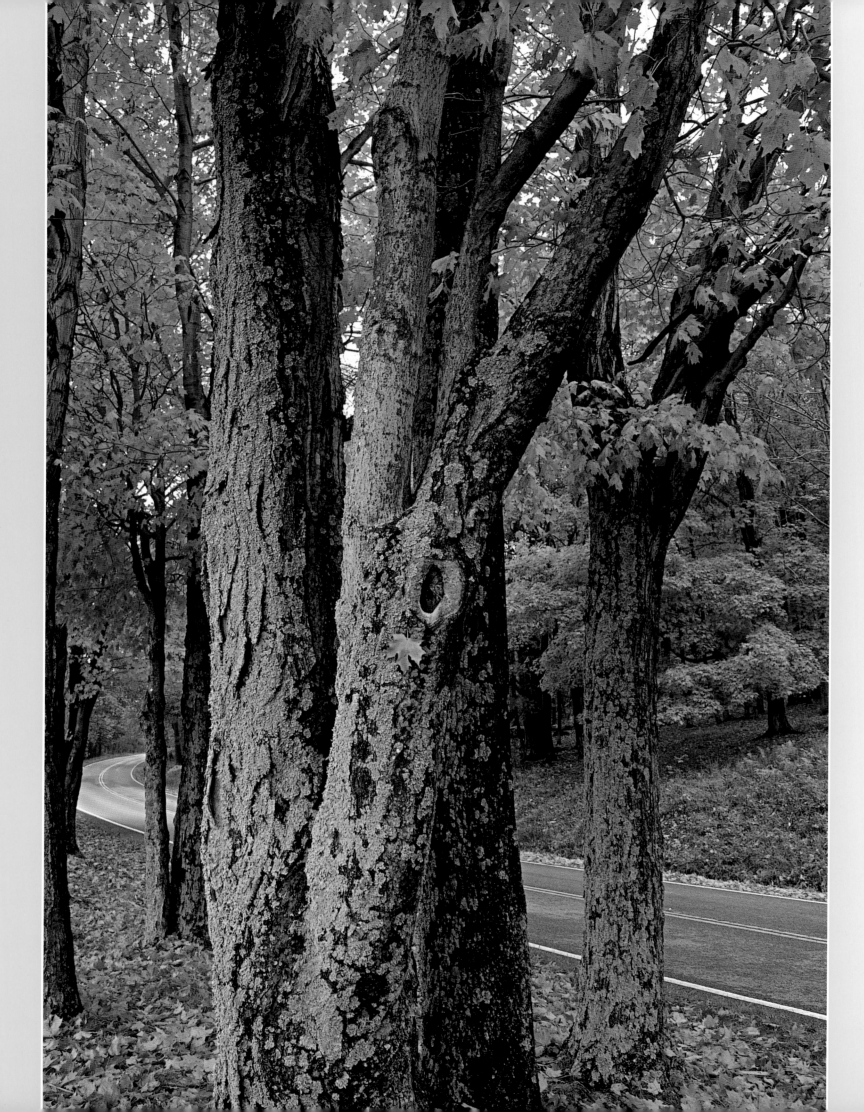

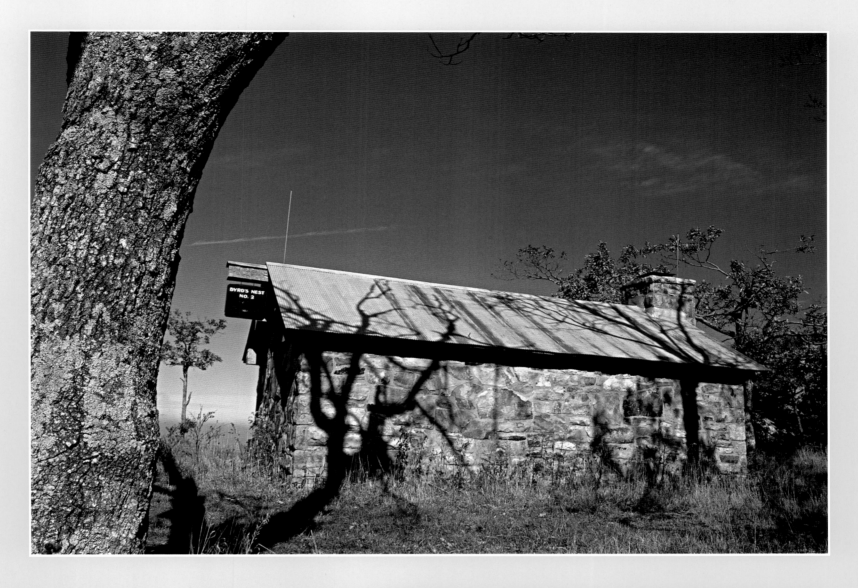

ABOVE: A sturdy, stone-walled structure provides shelter for hikers going to Hawksbill Mountain Summit, the park's highest point at 4,051 feet.

RIGHT: This mated pair of eastern bluebirds belongs to the approximately 125 bird species that depend on Shenandoah National Park's habitat for breeding and nesting. Park biologists have documented up to 205 species of birds that use the park during the year; about 30 species are year-round residents.

FACING PAGE: Pale-green lichens contrast with the brilliantly colored sugar maples on Skyline Drive. This route, along with 349 park buildings, structures, and features, was added to the National Register of Historic Places in 1997.

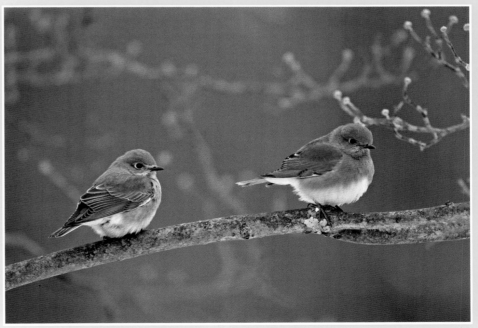

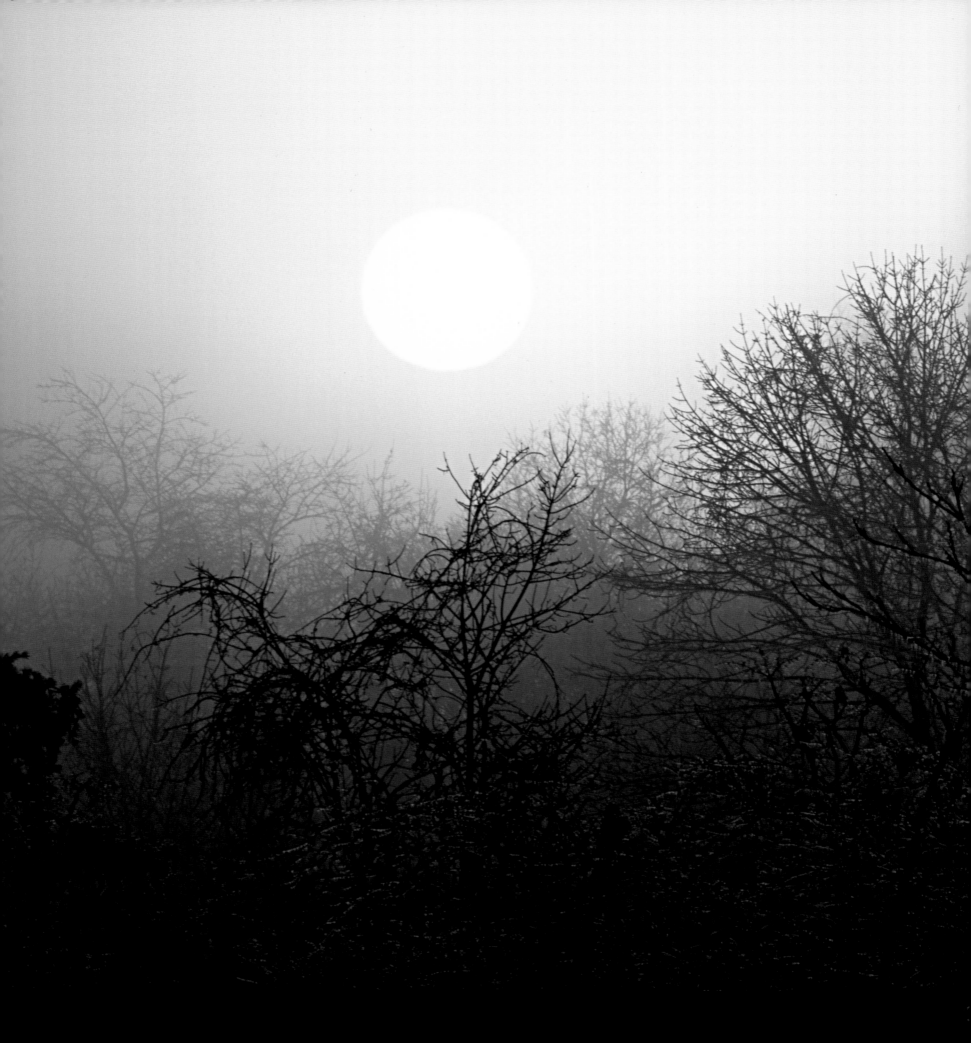

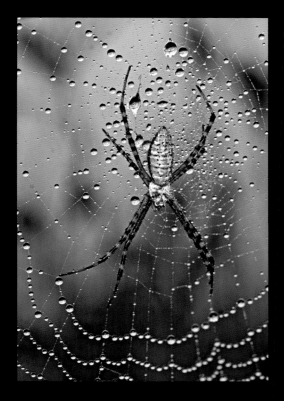

ABOVE: A banded argiope spider checks its dewy web for prey.

LEFT: Winter moisture encases trees in ice near the north entrance. December temperatures in the park range from 23 degrees F to 46 degrees F.

RIGHT: Is anything more beautiful than sunrise in Shenandoah National Park? This view eastward into the Piedmont is from Beagle Gap Overlook, one of 75 overlooks on Skyline Drive, where wind, water, and frost continue to carve these distinctive deep valleys between the long ridges.

BELOW: Umbrella magnolias and American beech trees blaze in their autumn glory in Swift Run Gap.

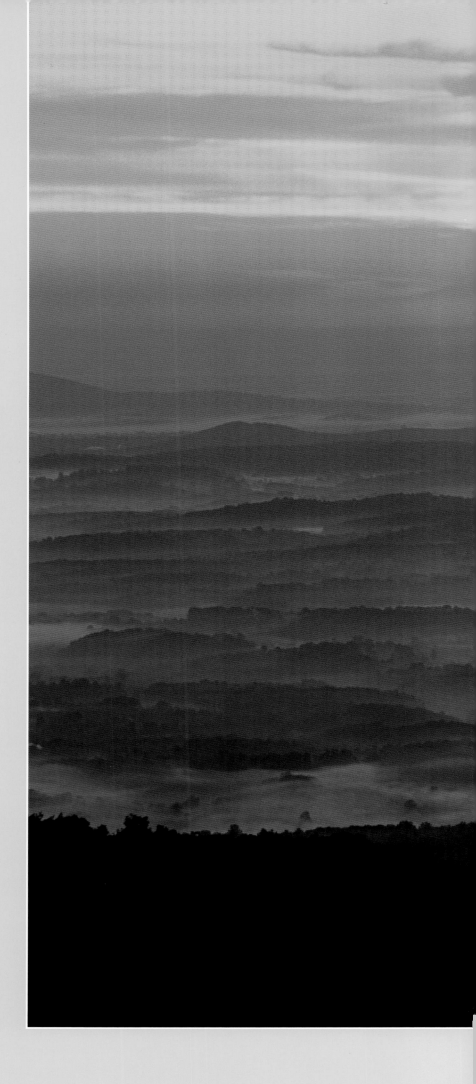

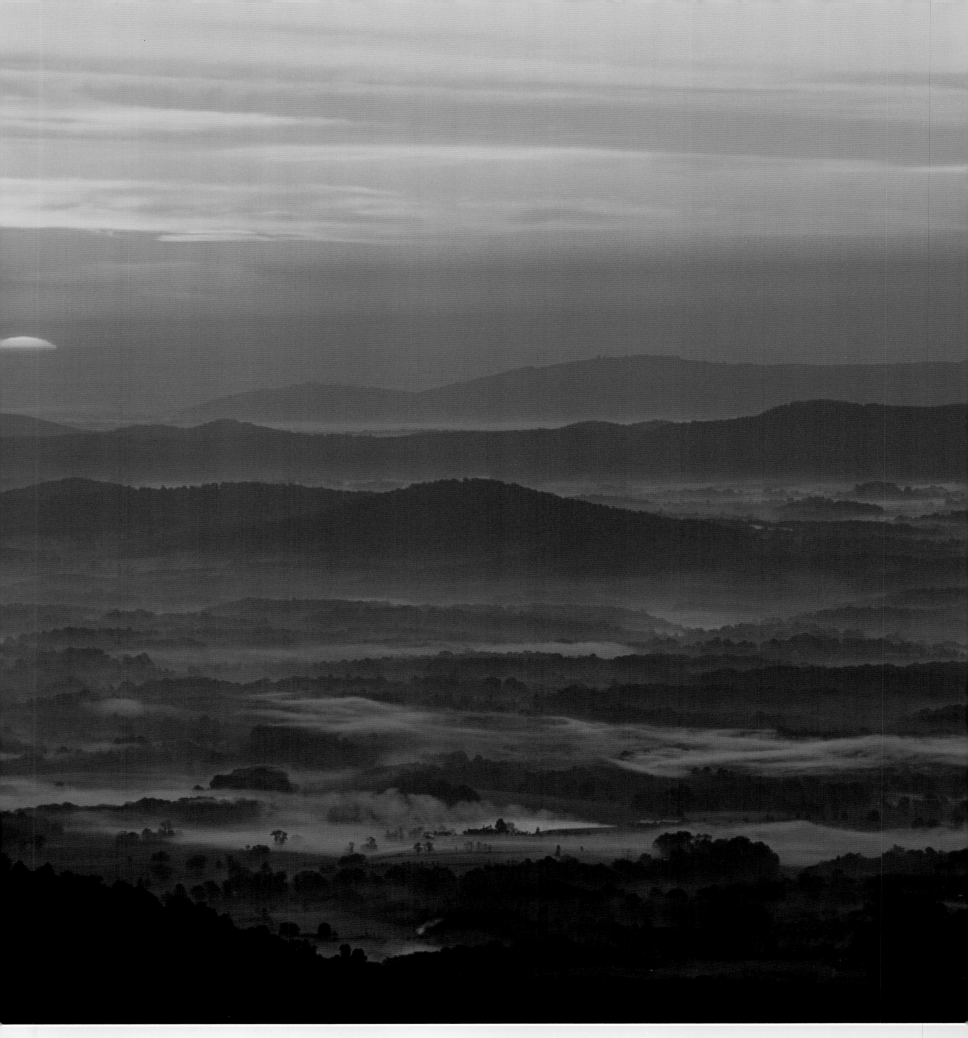

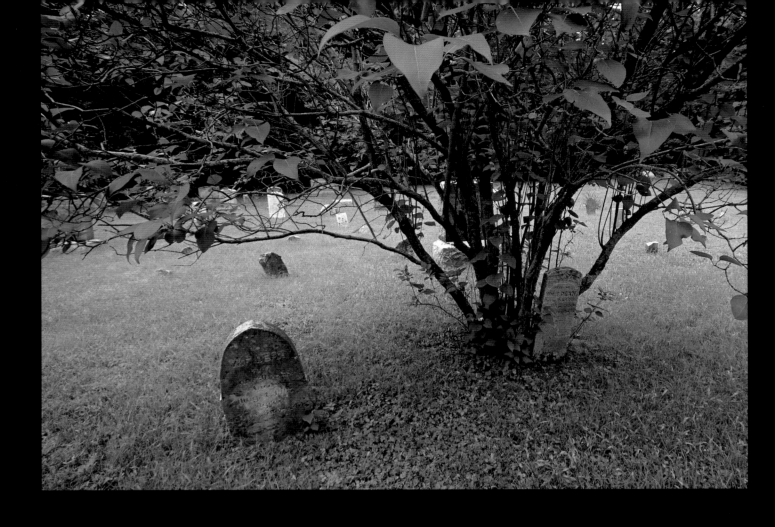

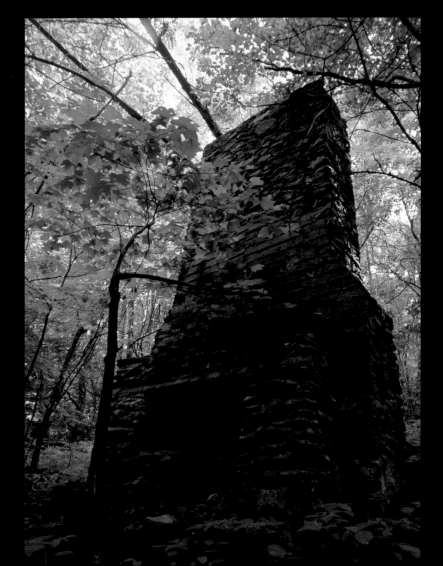

ABOVE: Tombstones mark graves in Dean Cemetery. There are more than 100 family cemeteries within the park's boundaries.

LEFT: This chimney is all that remains of the earliest platform tent cabins at "Five Tents" in Rapidan Camp. The tents were soon replaced by cabins because guests complained that the noise of the tents flapping kept them awake at night.

FACING PAGE: Mountain lettuce thrives in the moist riparian habitat along the South River.

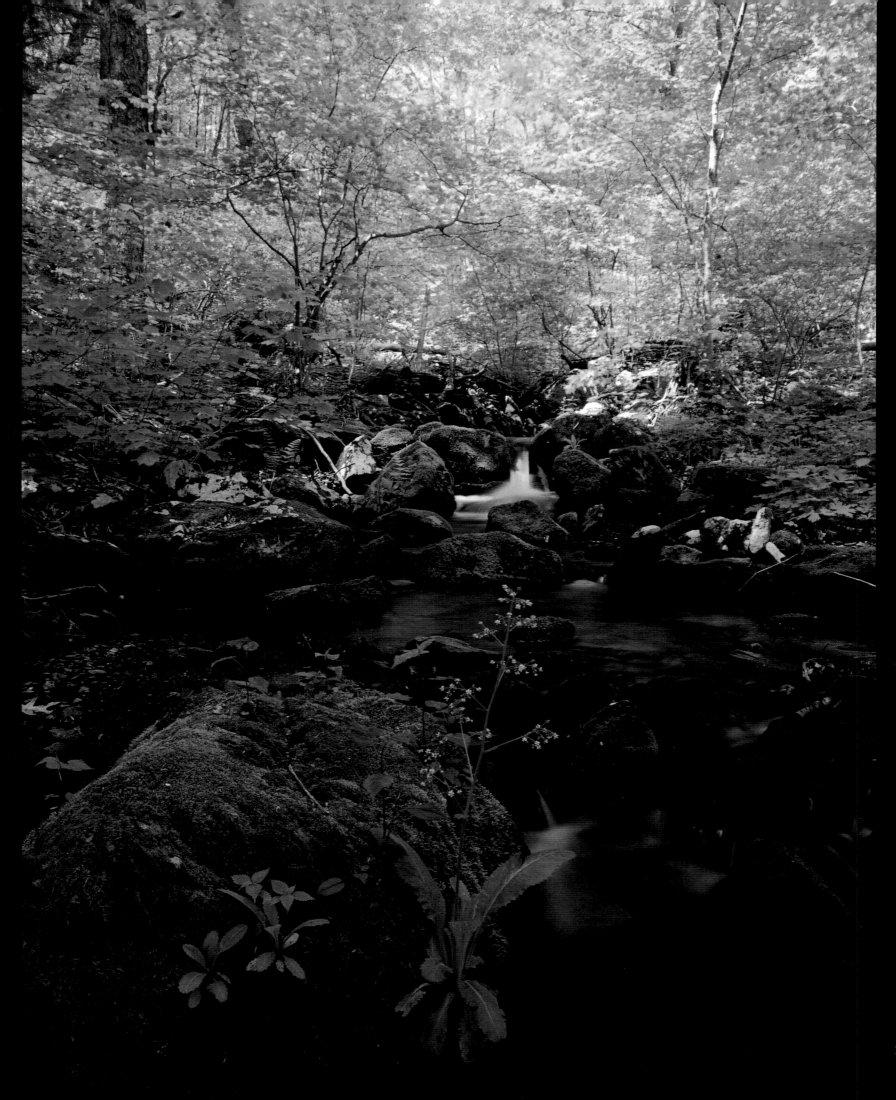

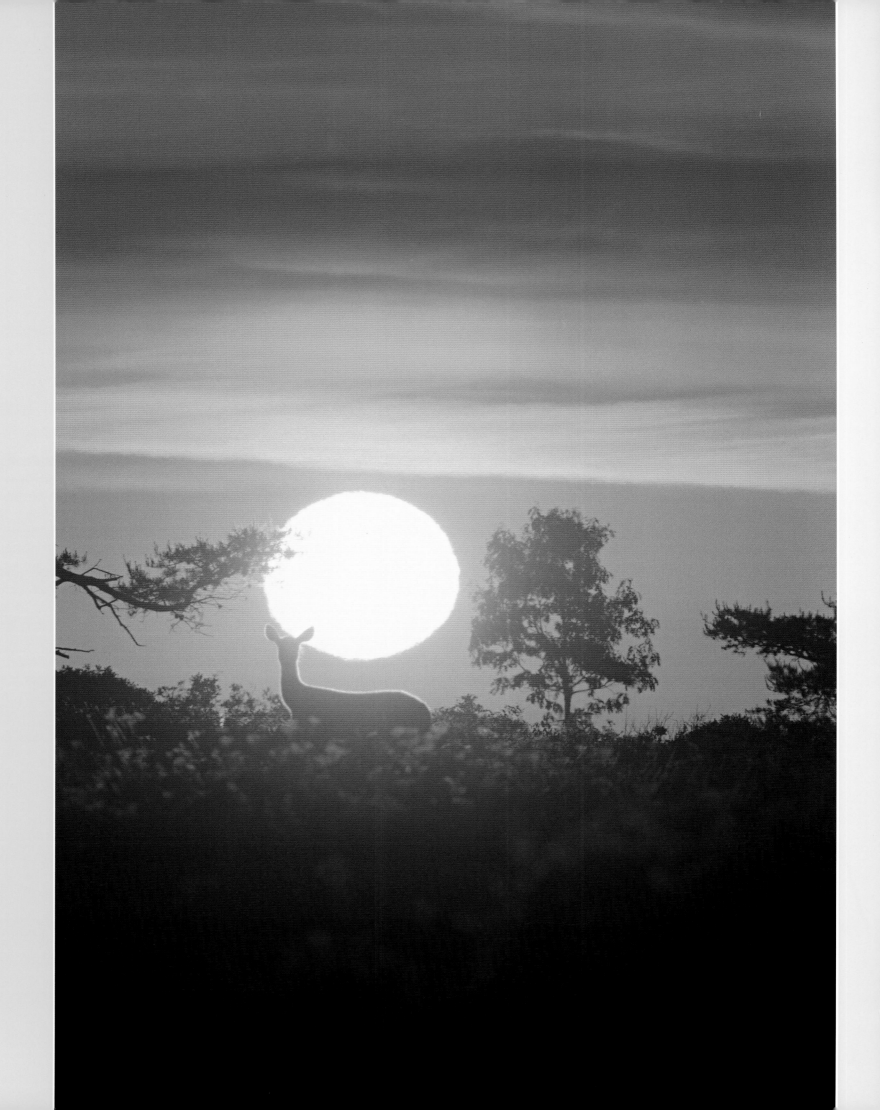

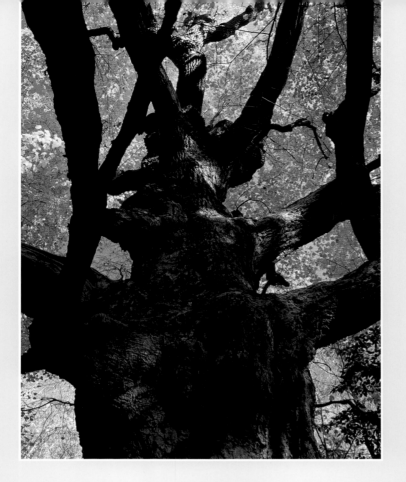

LEFT: This tulip tree near Rapidan Camp is one of the largest in North America.

FACING PAGE: A white-tailed doe at sunrise in Big Meadows, an area underlain by 1,800 feet of bedrock.

BELOW: Sunset peeks through the windows of Dickey Ridge Visitor Center, built in 1938.

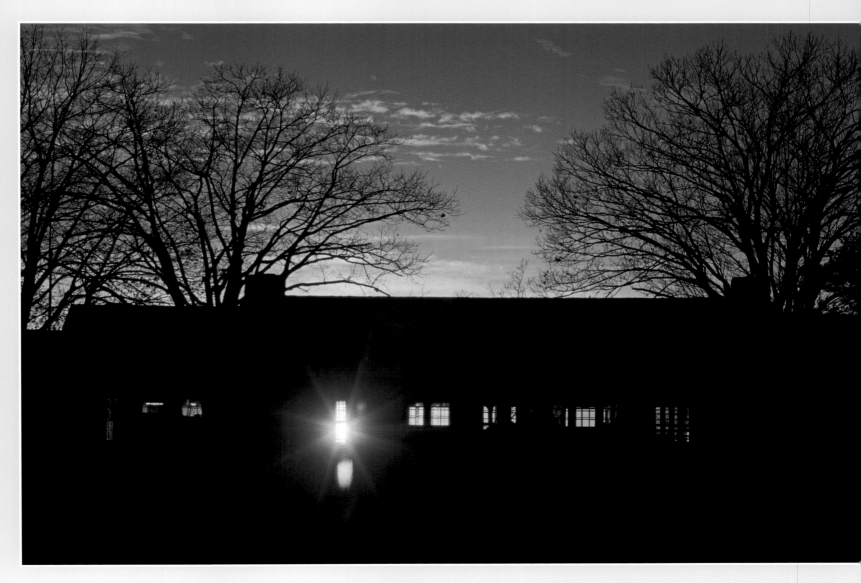

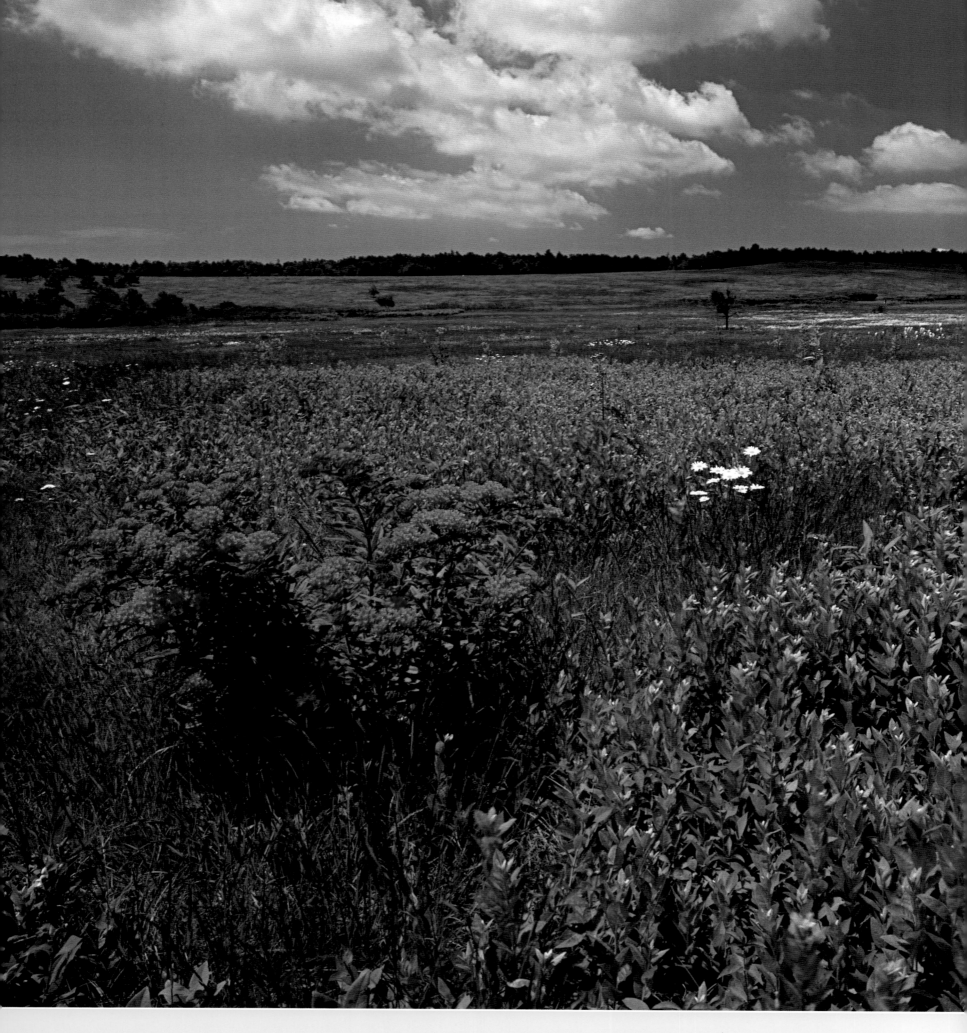

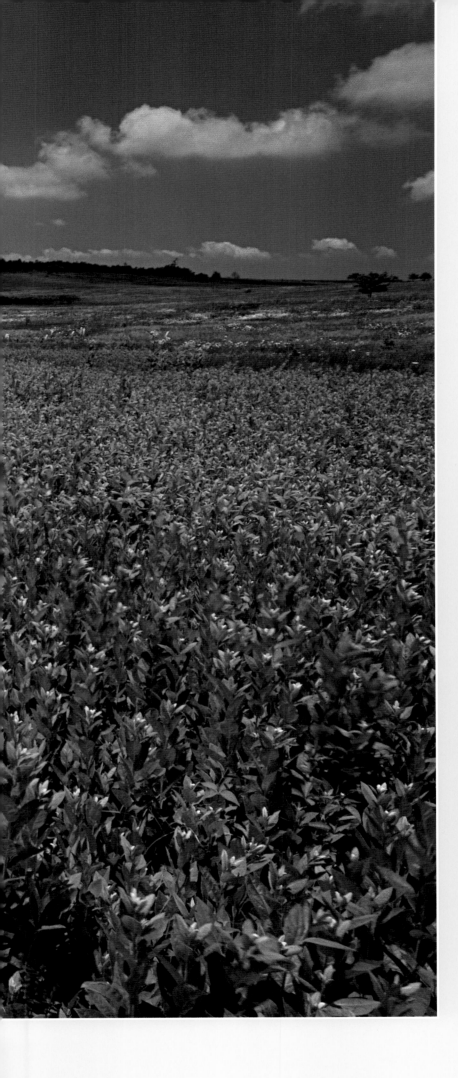

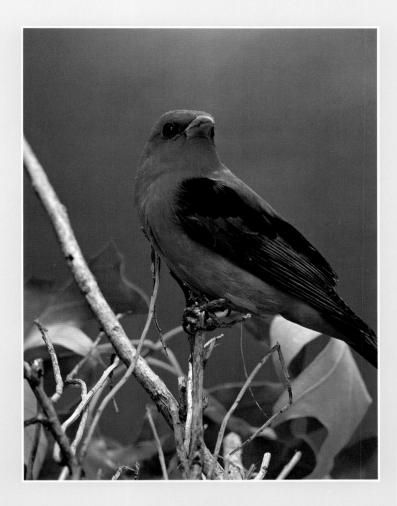

ABOVE: A male scarlet tanager in full breeding plumage. Tanagers migrate from the tropics to breed in the park. A tanager's beak has a specialized, enlarged piece that helps the bird subdue and capture large caterpillars.

LEFT: In summertime, brilliant orange butterfly weeds and other wildflowers adorn Big Meadows, a year-round home to more than 270 species of plants.

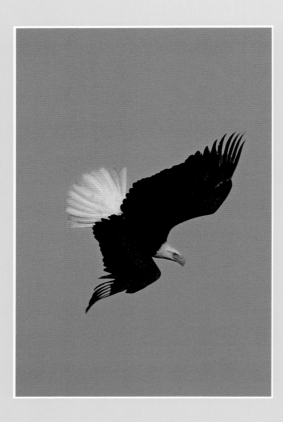

ABOVE: A bald eagle soars in flight, wings black against a pink-hued sky.

RIGHT: Rainbows, such as this one that is visible from Mount Marshall Overlook, are frequent light shows on Skyline Drive. Mount Marshall was named for John Marshall, who served as chief justice of the Supreme Court from 1801 to 1835.

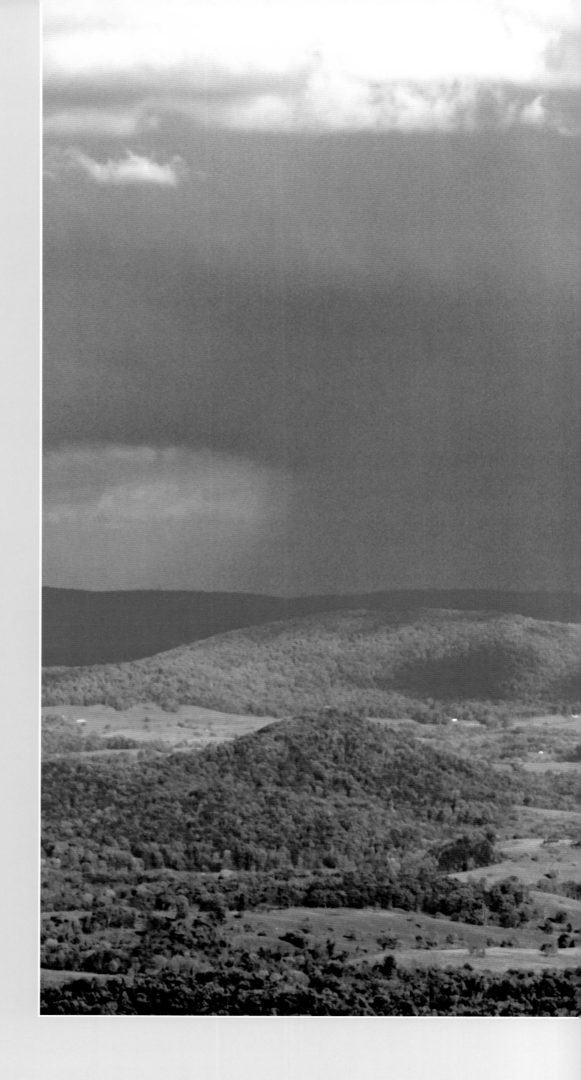

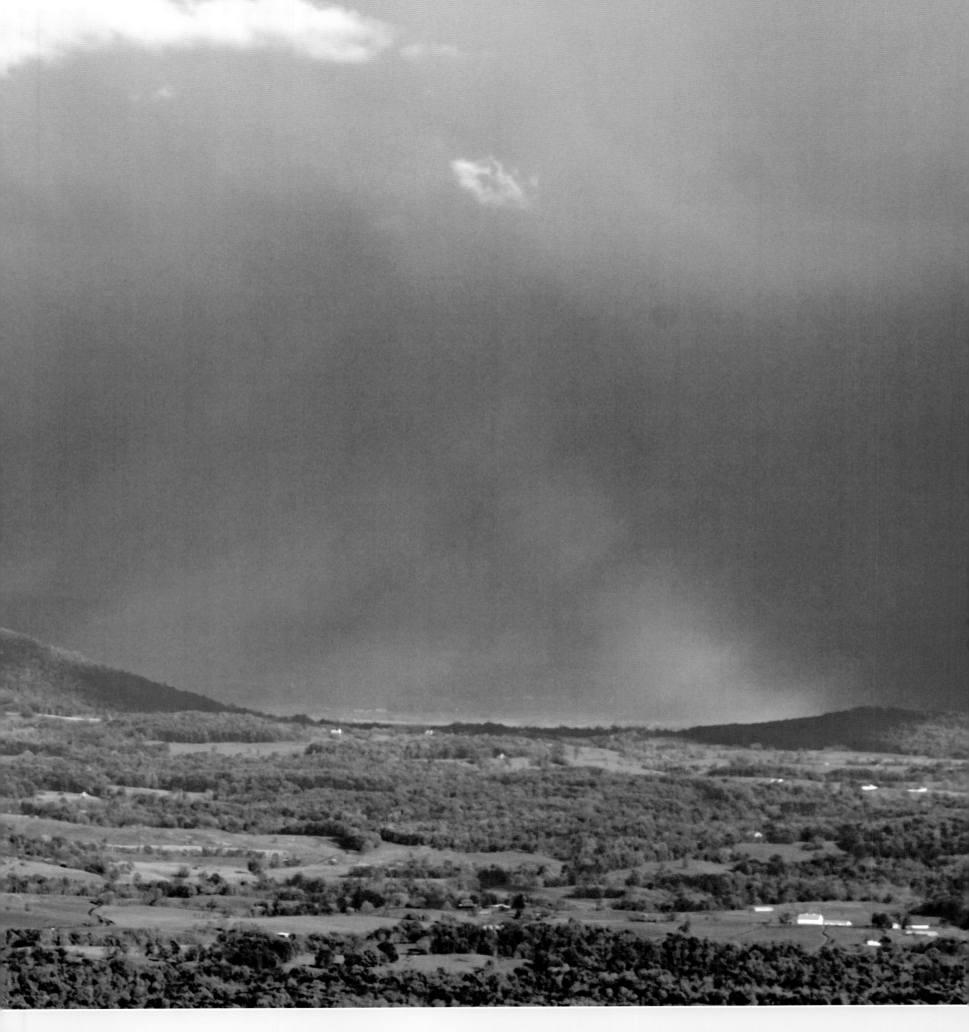

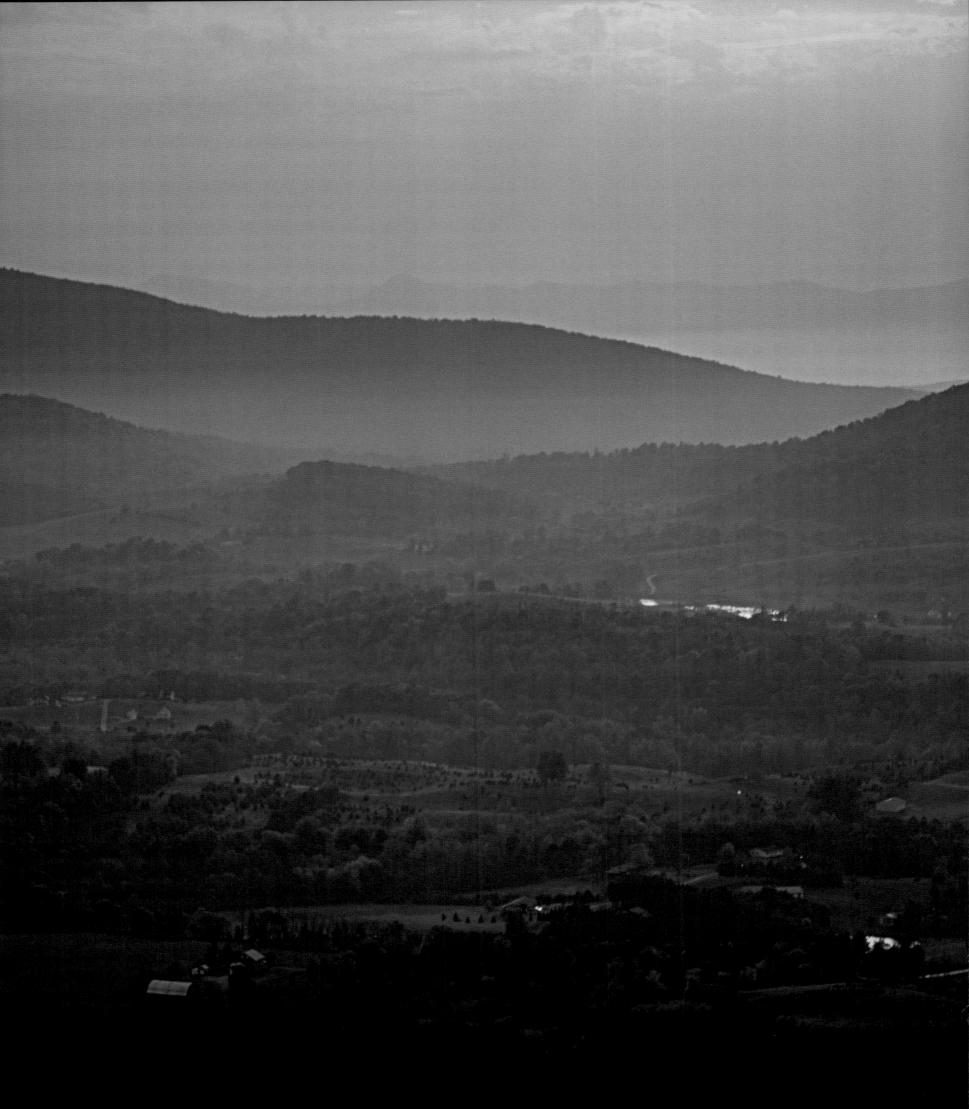

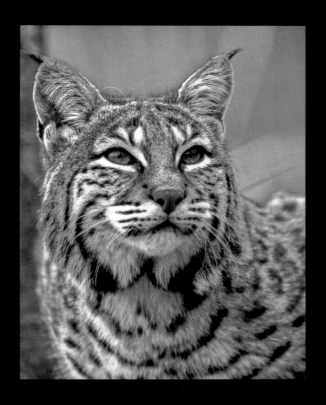

LEFT: A bobcat pauses to watch and listen, one of more than 50 species of mammals that live in the park, ranging from black bears to tiny shrews.

FACING PAGE: Mist settles into the Shenandoah Valley near Browntown, seen from Gooney Manor Overlook.

BELOW: From Naked Creek Overlook, a lone pear hawthorne tree rises above the yellow blossoms of common winter cress to provide a focal point.

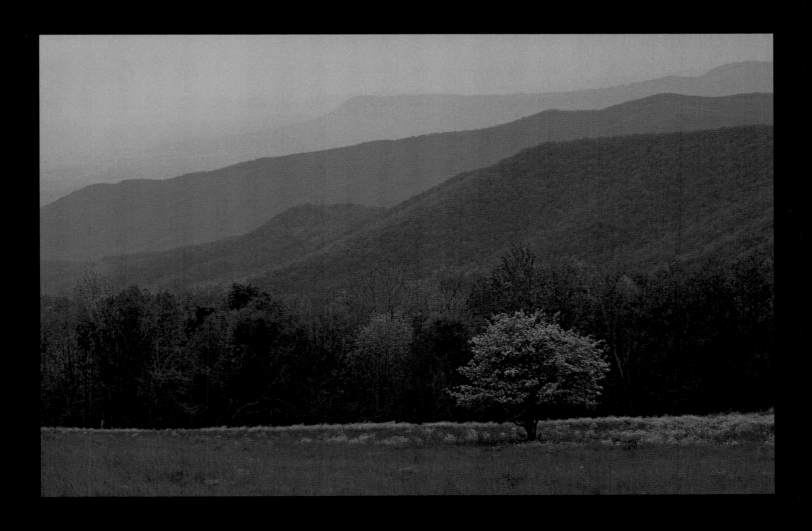

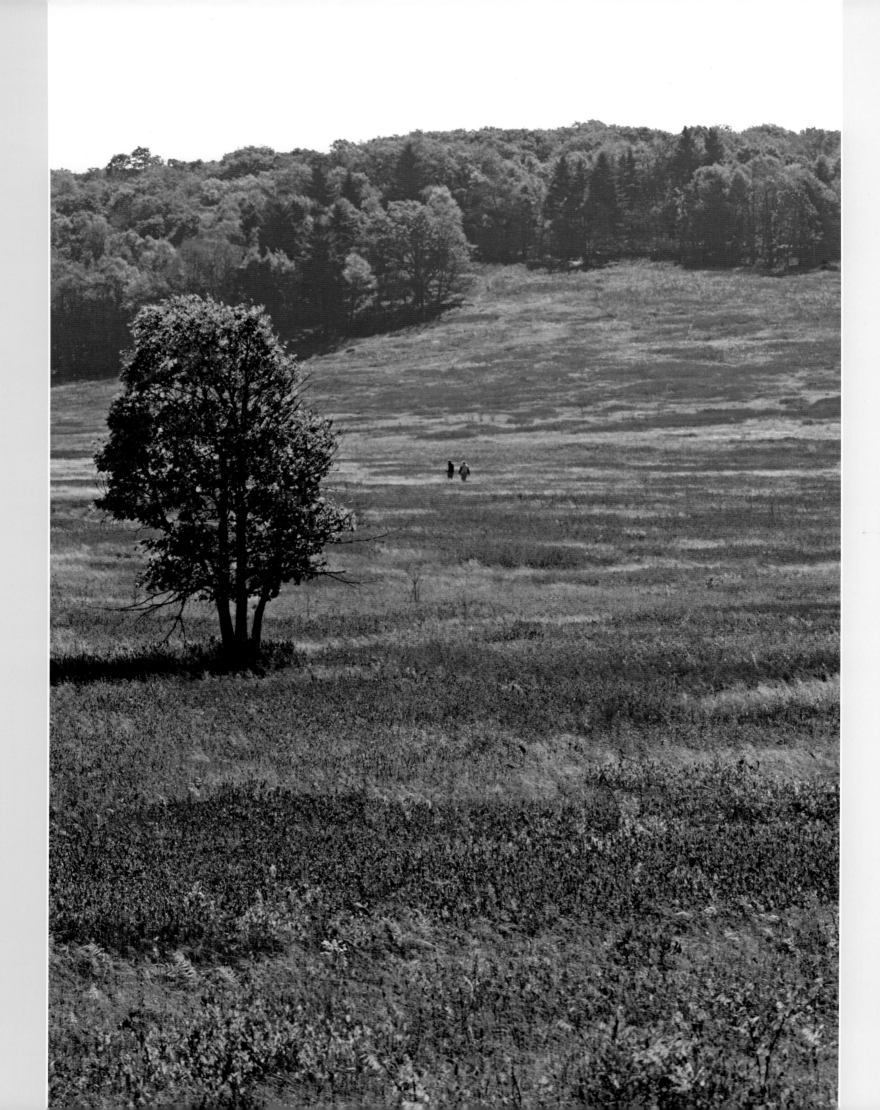

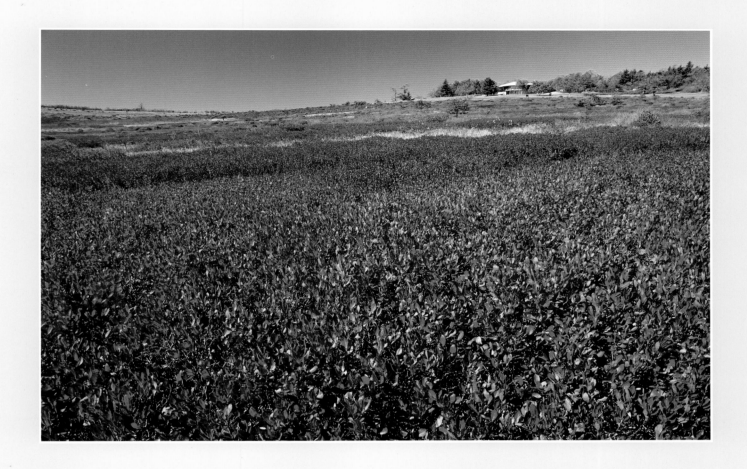

ABOVE: Every autumn, a rich mix of blueberry, maleberry, huckleberry, and deerberry shrubs creates a carpet of red in Big Meadows.

FACING PAGE: Hikers wander along game trails in Big Meadows. The wetland area is one of Virginia's very few high-elevation swamps, home to plants and animals rarely found elsewhere in the state, such as ladies-tress orchids that bloom in fall.

RIGHT: This rich autumn palette atop Dickey Ridge is created by the mixed hardwood forest that includes flowering dogwoods, black gums (also called sour-gums), red maples, and white oaks.

FOLLOWING PAGES: Springtime blooms of mountain laurel match the pink hues of the sunset-stained sky. Mountain laurels were planted in the park by the CCC in the 1930s.

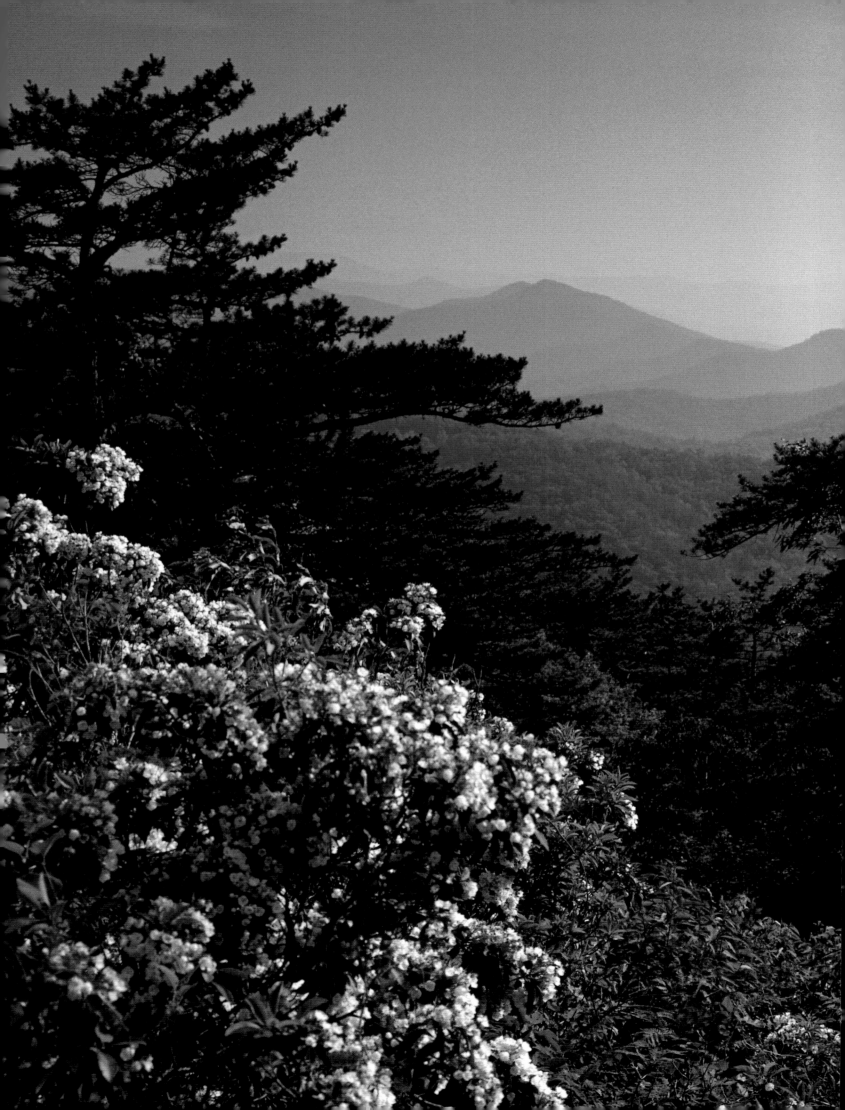

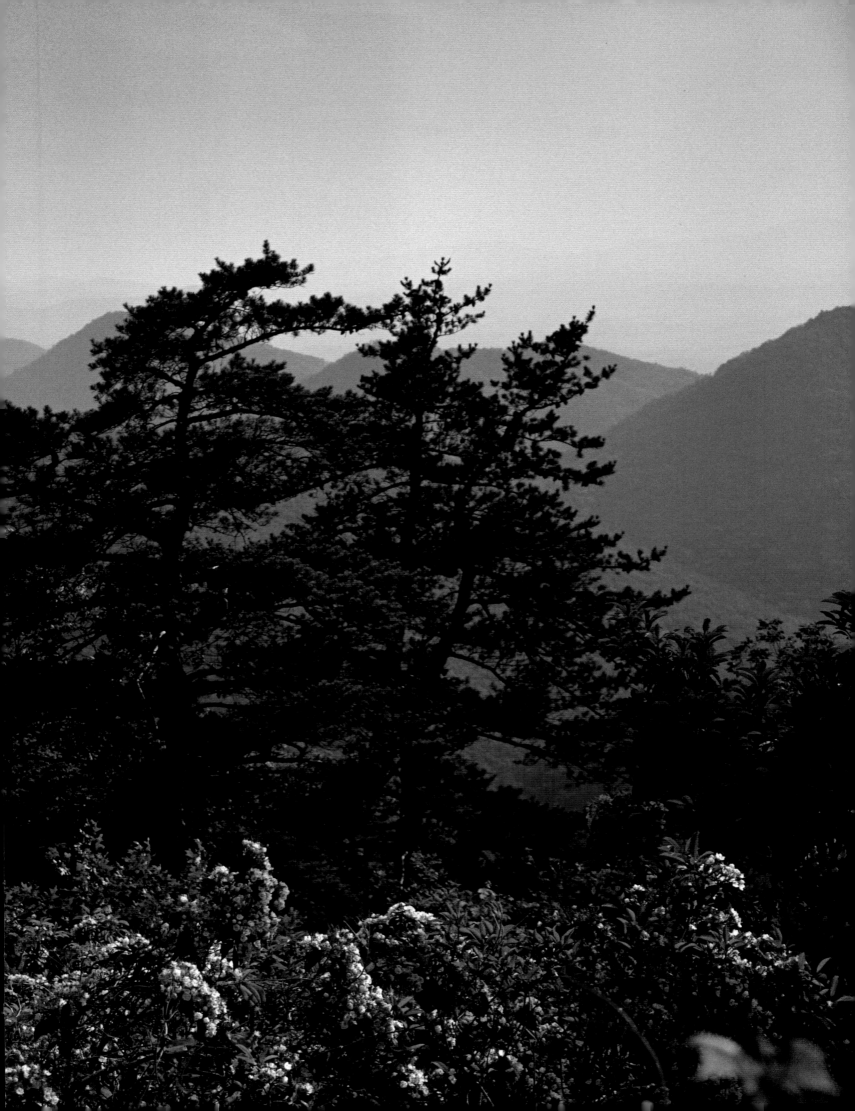

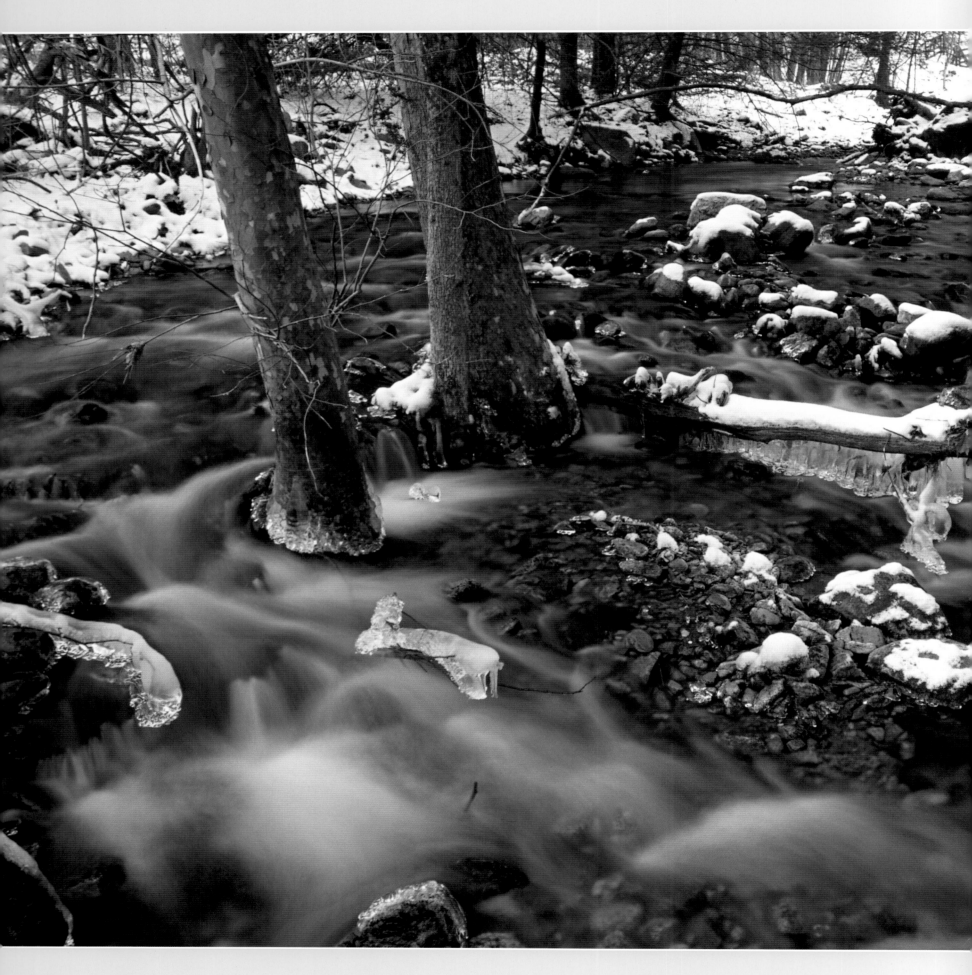

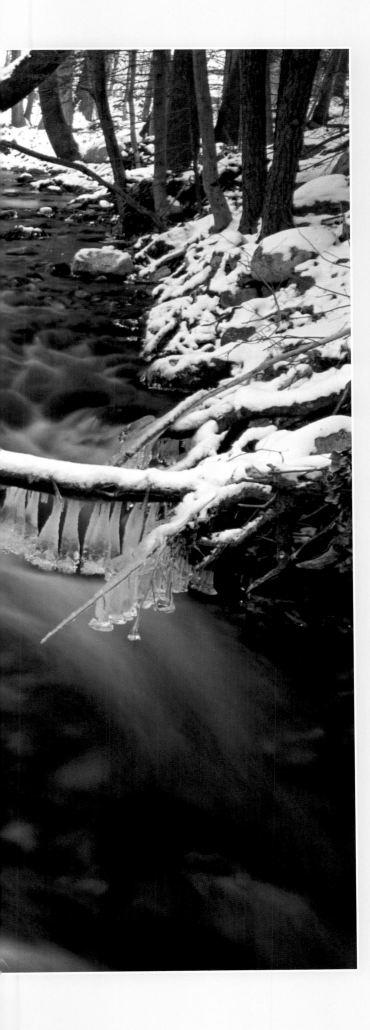

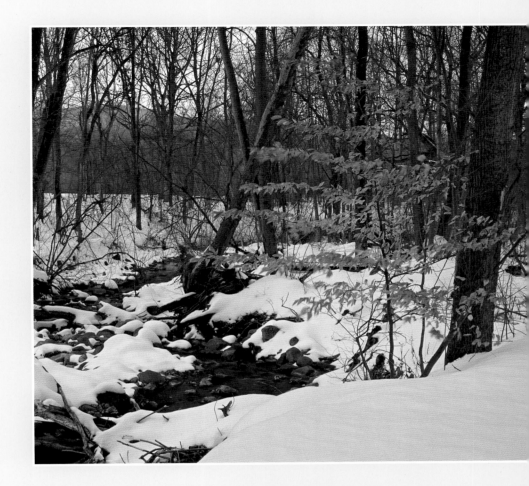

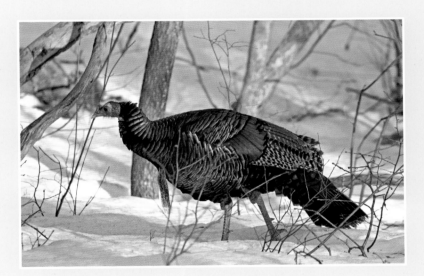

ABOVE (TOP): An American beech tree holds its leaves into February along Smith Creek. It is common for beeches and oaks to retain some of their dead leaves until spring.

ABOVE (BOTTOM): Wild turkeys thrive in Shenandoah National Park's environment. These year-round residents range from lower to higher elevations in search of food and shelter.

LEFT: Robinson River in its wintry glory is one of the park's streams that eventually empties into Chesapeake Bay.

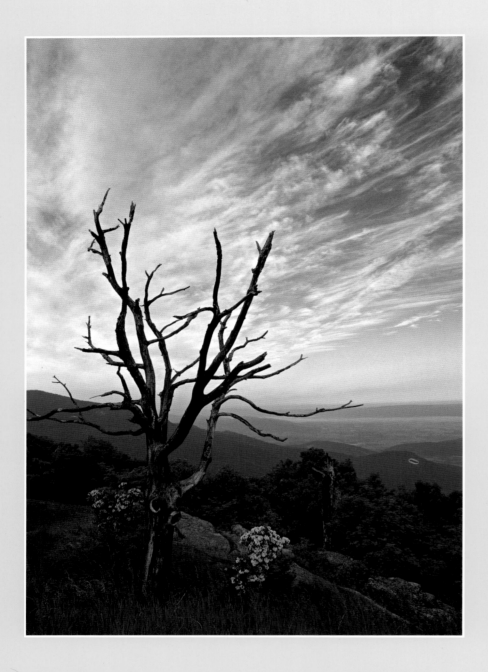

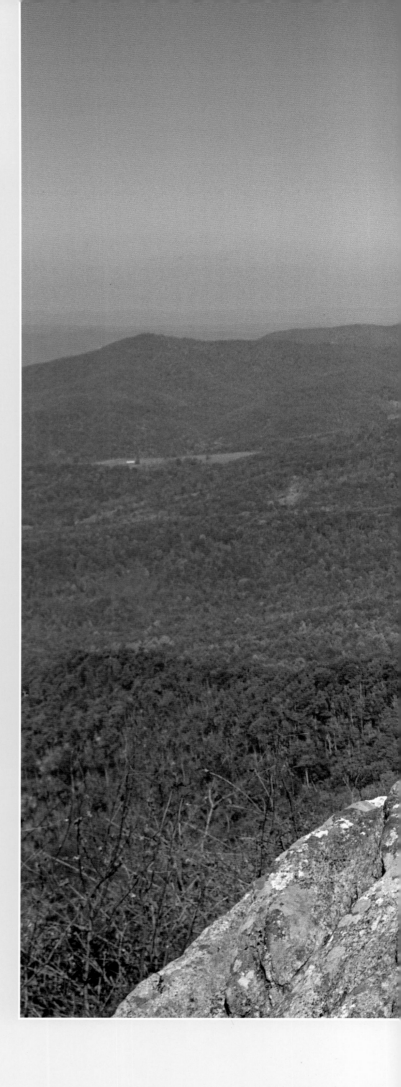

ABOVE: Mountain laurel and the intricate branches of a snag highlight the foreground in this view from Timber Hollow Overlook.

RIGHT: A lone hiker stands atop Jewel Hollow Overlook to see the mesmerizing view of red, yellow, and orange foliage in autumn. More than 95 percent of the park is forested.

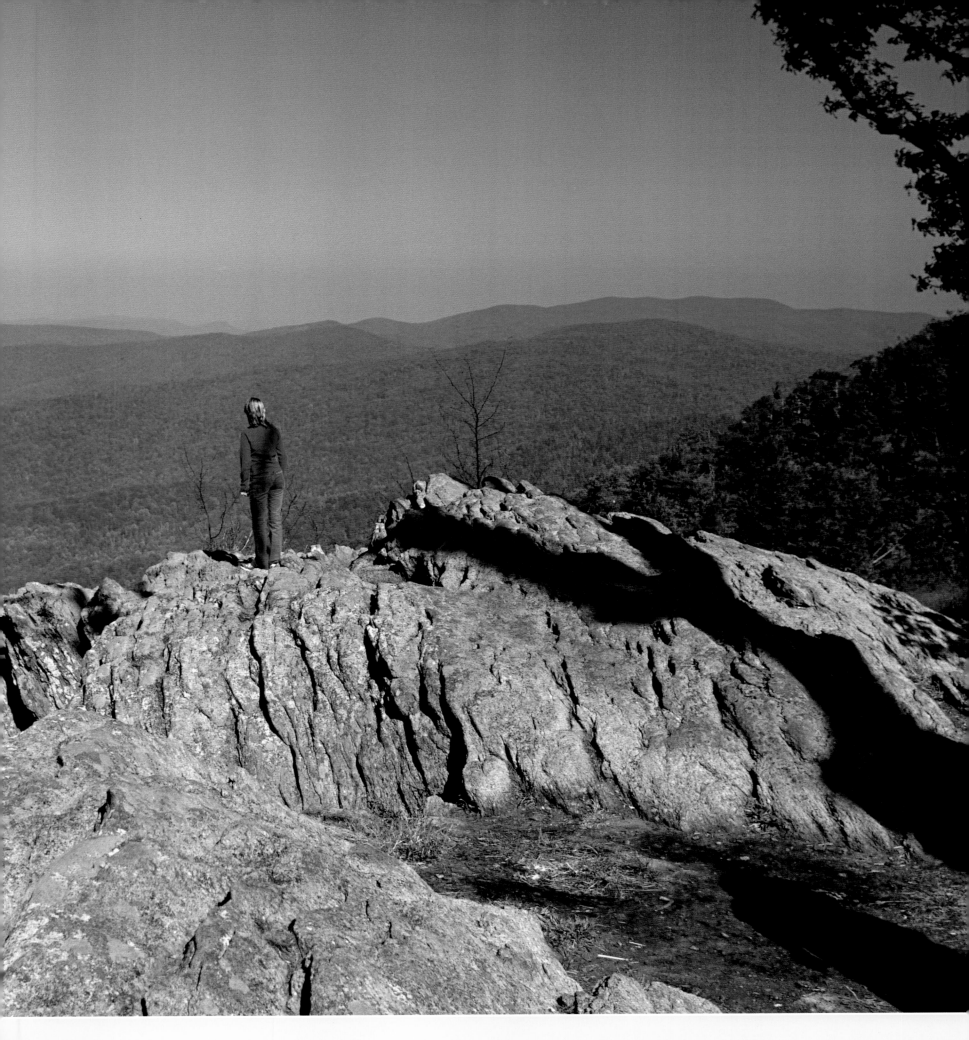

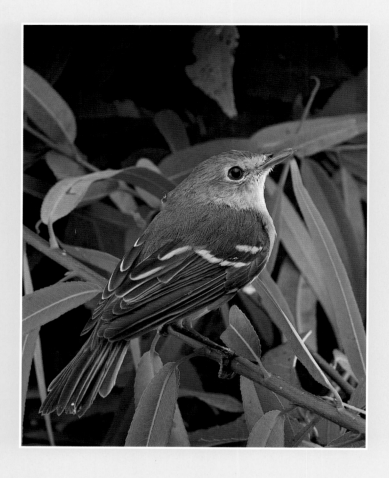

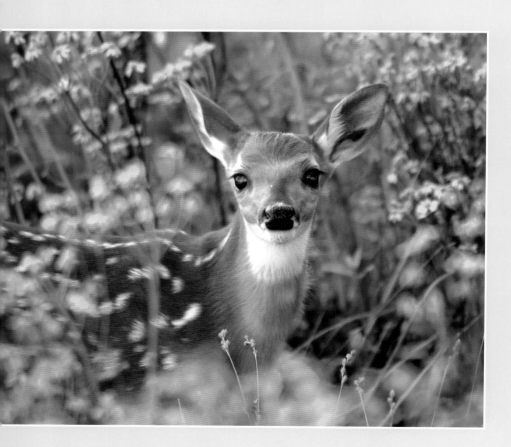

ABOVE: This white-eyed vireo perches precariously on a branch.

LEFT: The arrival of June in the park brings with it the beginnings of new life. Most white-tailed deer fawns are born during this time and can be seen exploring Big Meadows with their mothers. Fawns are born with spots to help camouflage them from predators.

RIGHT: A white-tailed deer is bedded down in Big Meadows in a pool of golden ragwort.

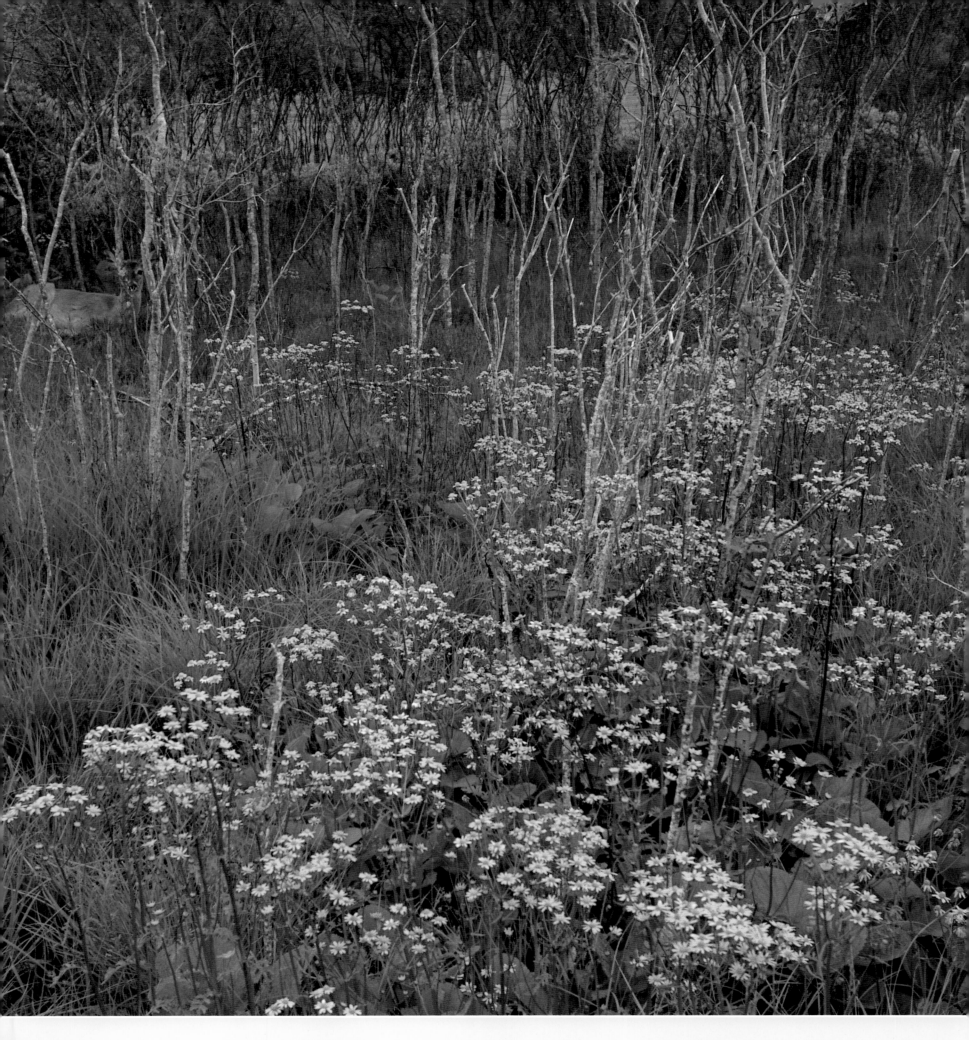

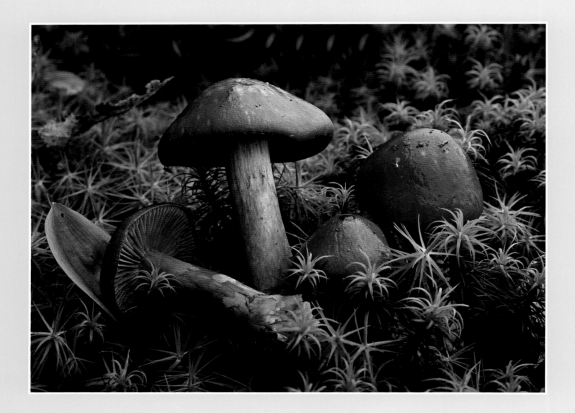

ABOVE: Colorful fungi abound in
Shenandoah National Park, including
these fuschia-colored heliotrope
webcap mushrooms growing in
the Limberlost area. The once-grand
hemlock forest was decimated by
an infestation of insects called the
hemlock woolly adelgids.

RIGHT: A greater purple-fringed orchid
is a show-stopper—in full bloom it is
nearly three feet tall.

FACING PAGE: Sunbeams illuminate
the Shenandoah Valley, as seen from
Massanutten Overlook. Previous
names for the Shenandoah region were
"Silver Water," "Great Meadows,"
and "River of High Mountains."

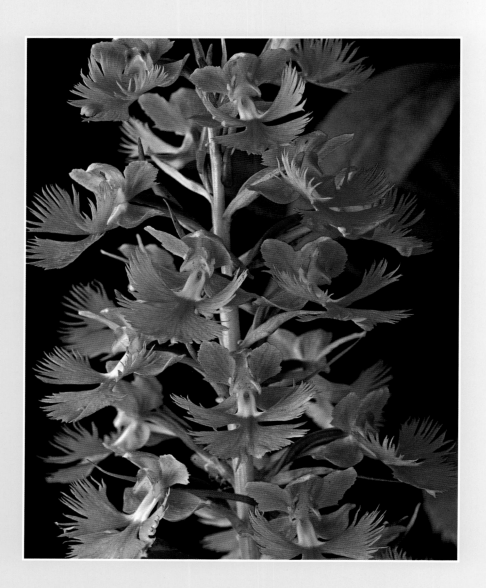

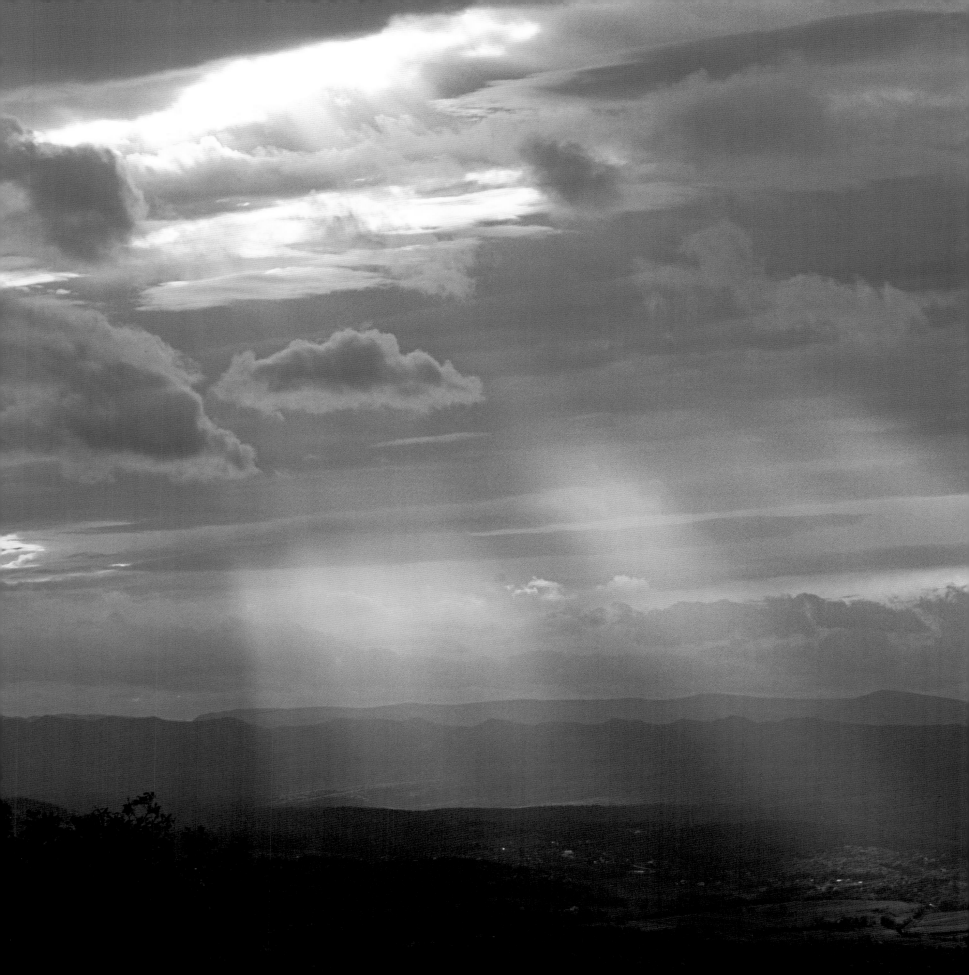

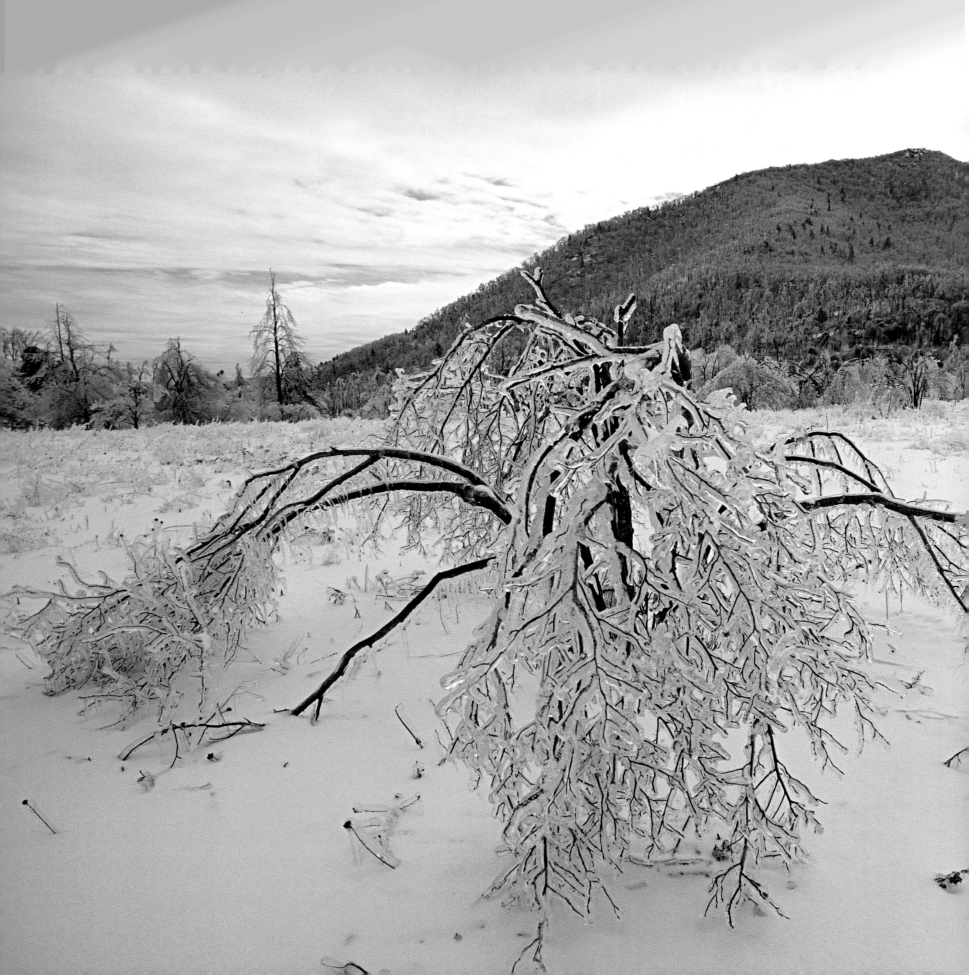

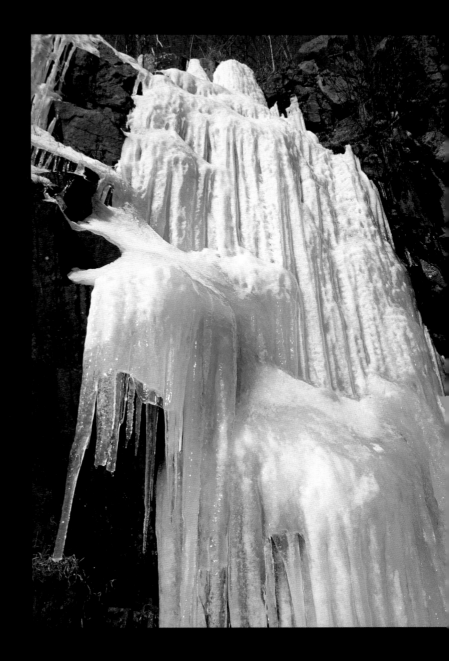

ABOVE: Endless dripping and wintry temperatures created this icefall near Marys Rock Tunnel. Marys Rock has a distinctive hump composed of the park's oldest exposed granite basement rock.

LEFT: Panorama's Thornton Gap is subject to frequent winter storms. People visit in winter to enjoy the wide open views, the wildlife, and the ice sculptures.

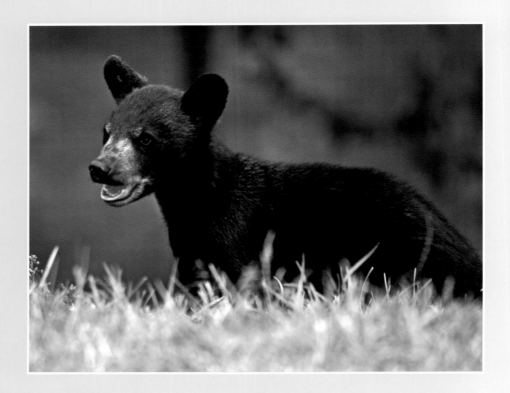

RIGHT: A wild black bear cub, about five months old. Shenandoah National Park has one of the densest populations of black bears in North America; visitors frequently see the animals along park roads.

FACING PAGE: South River Falls, cascading 83 feet, is the reward for a moderately strenuous 1.2-mile hike from the South River picnic grounds. In springtime, hikers can hear warblers all along the trail—up to 18 species of warblers breed in the park.

BELOW: White markers keep hikers on the Appalachian Trail, pictured here at Sawmill Run Overlook. The public footpath extends 2,144 miles between Maine and Georgia; 101 miles of it trek through Shenandoah National Park.

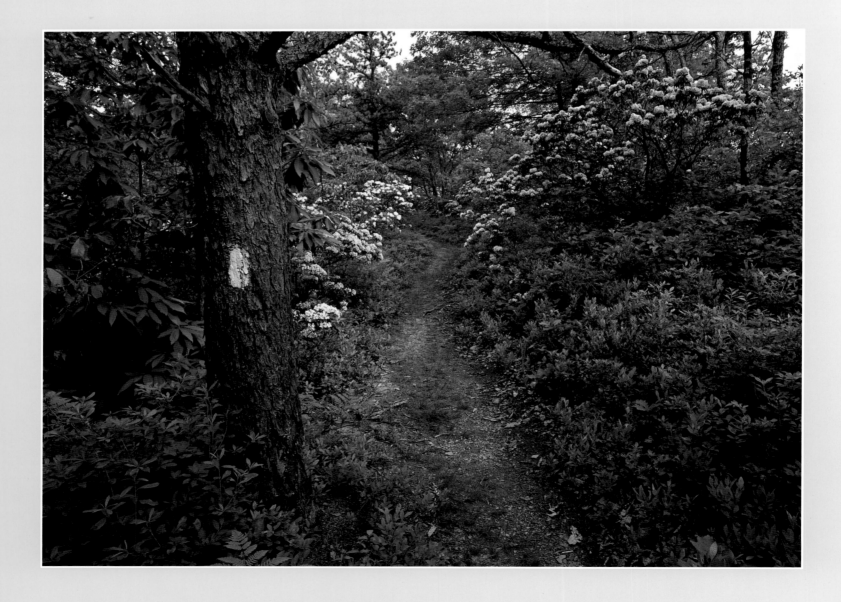

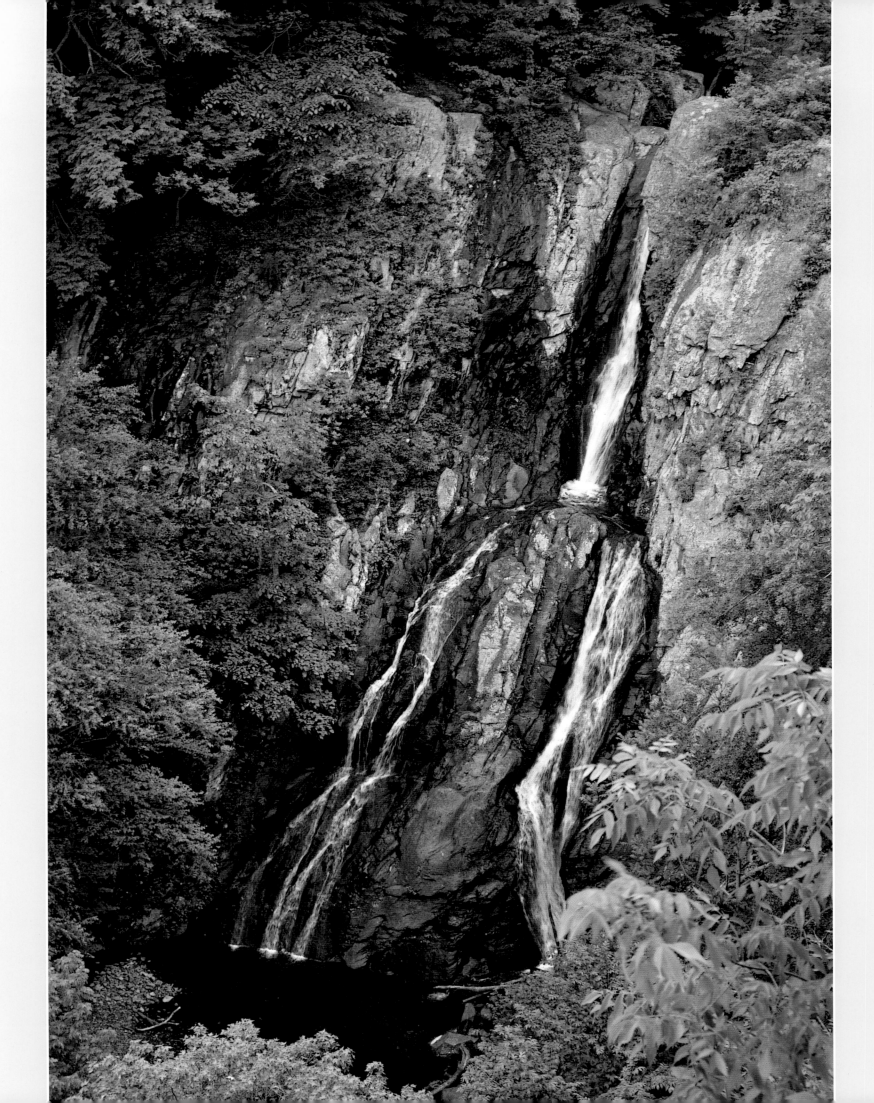

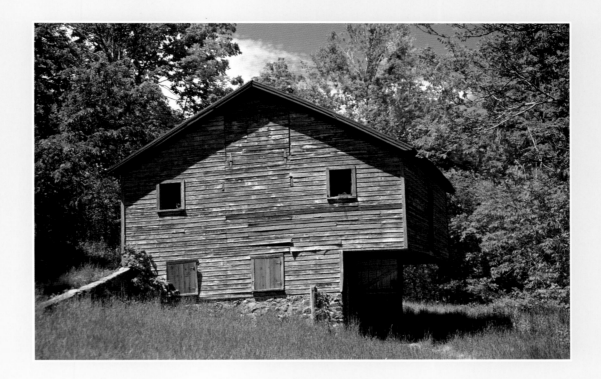

ABOVE: One of 5,000 structures within the park, this historic barn was once part of Sneads Farm.

LEFT: This cemetery on Fox Hollow Trail at Dickey Ridge is on land farmed for several centuries by early mountain settlers who cleared the trees, hunted, and raised sheep and cattle.

RIGHT: This columnar jointing at Limberlost shows the "columns" of 570-million-year-old metabasalt that were formed by magma as it cooled, which created the Appalachian Mountains.

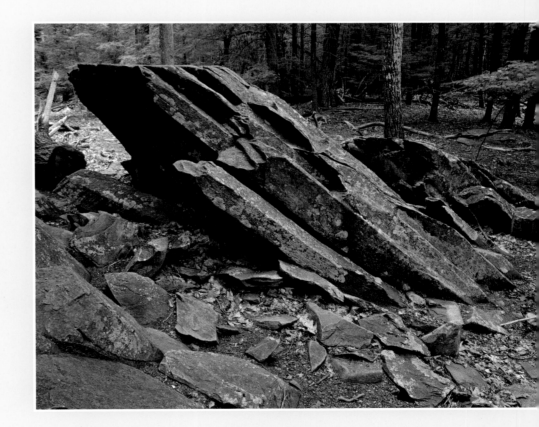

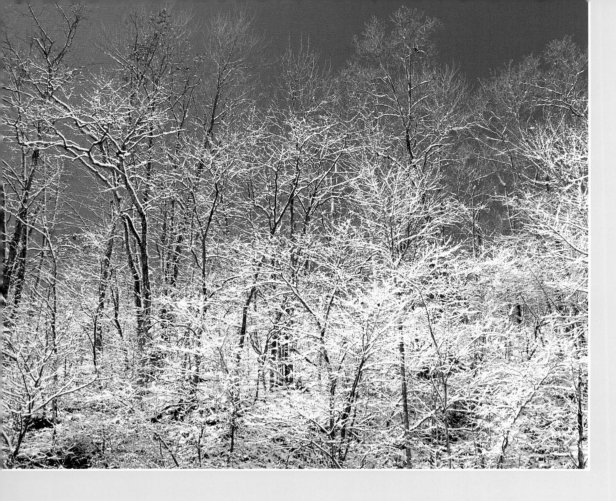

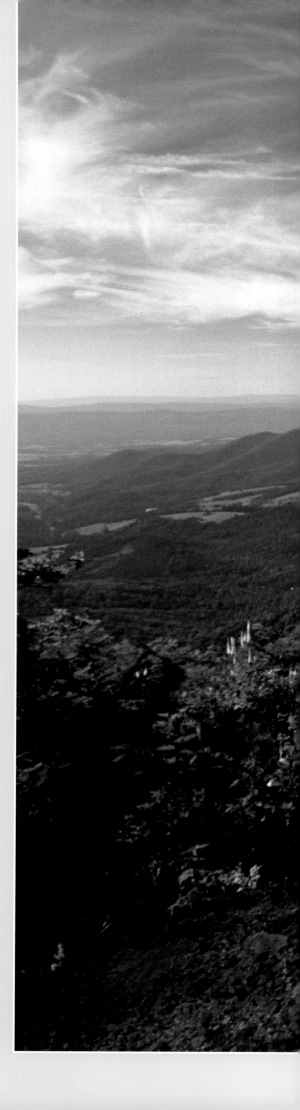

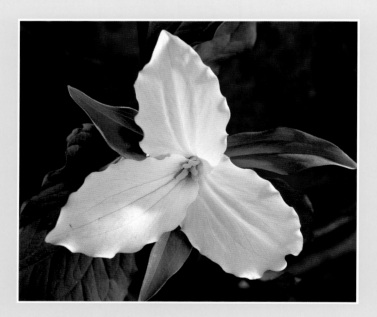

ABOVE (TOP): Hoarfrost encases trees on Dickey Ridge, the northernmost entrance to park. Even when the roads are closed due to winter conditions, warmly clad park visitors find solitude and beauty on the wintry trails.

ABOVE (BOTTOM): Large-flowered white trillium blooms in late spring. The Shenandoah National Park Association uses an image of this blossom on their logo.

RIGHT: The sweeping views from Jewel Hollow Overlook include 79,579 acres of wilderness—or about 40 percent of the park.

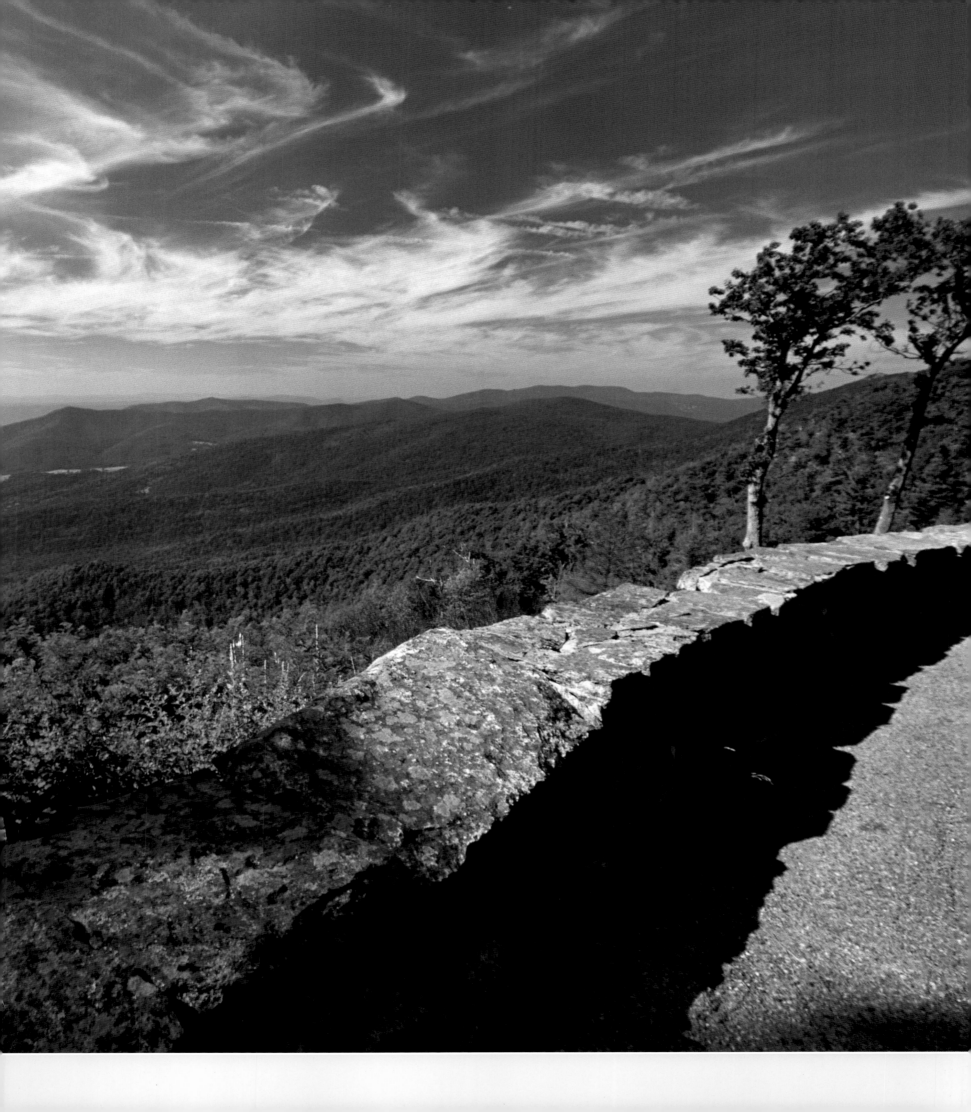

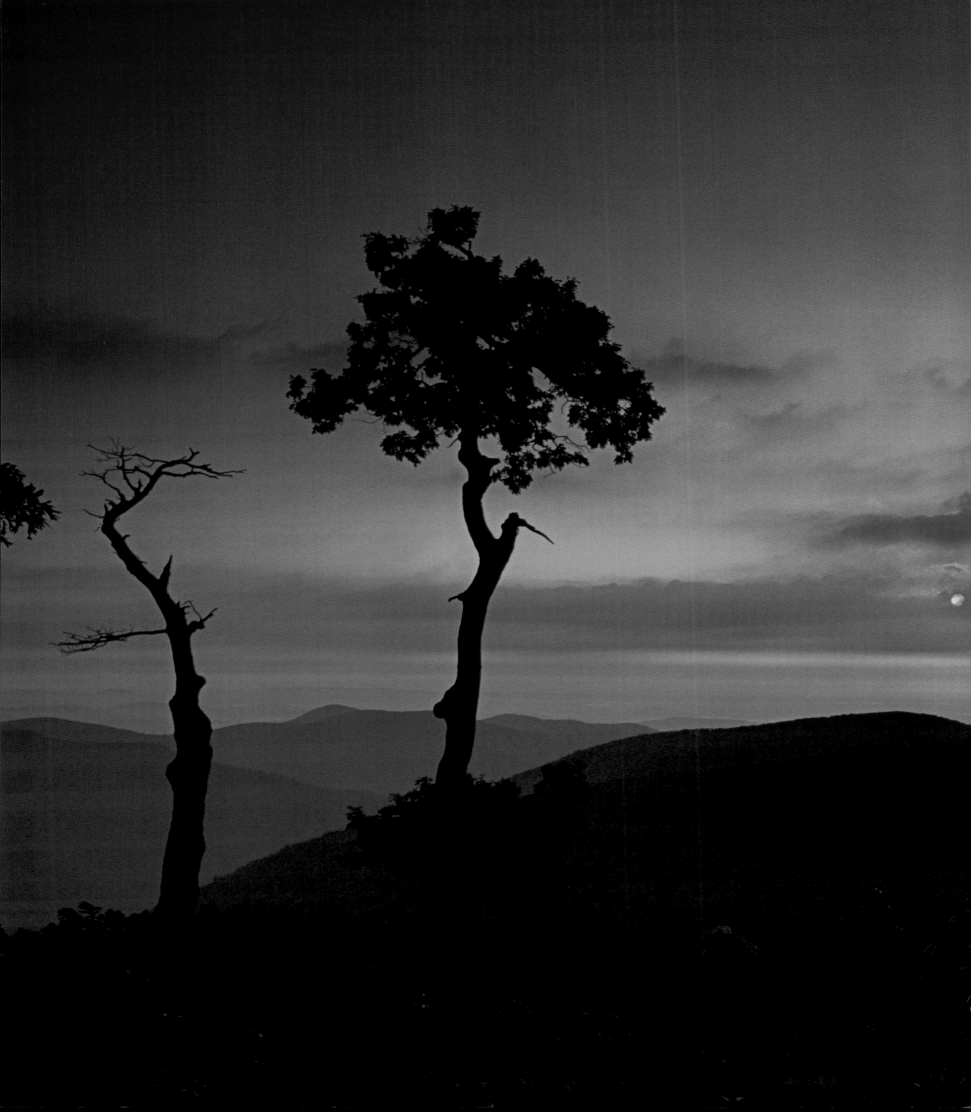

LEFT: It's worthwhile to rise early to see sunrise from Thorofare Mountain Overlook.

BELOW: From Stony Man Overlook, a red spruce tree anchors this view of the Shenandoah Valley. Stony Man Camp, now Skyland Resort, was a destination resort for upper-middle-class urban families at the turn of the twentieth century.

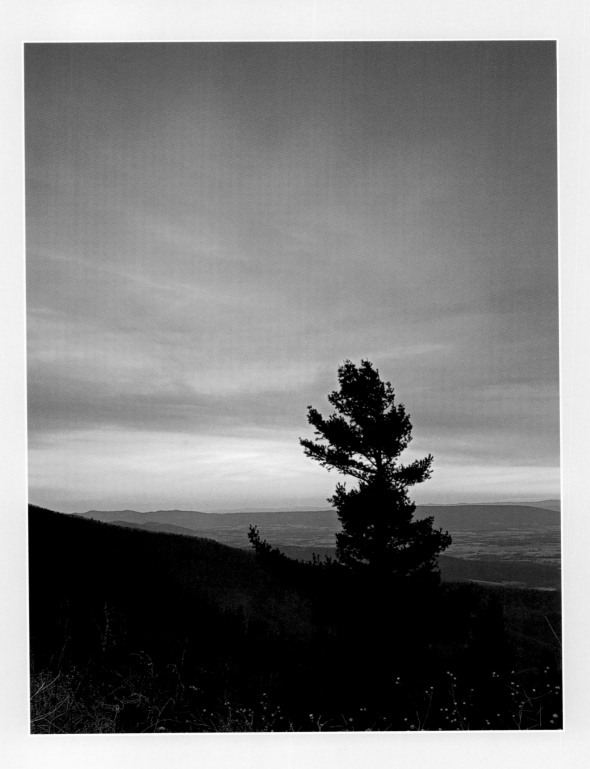

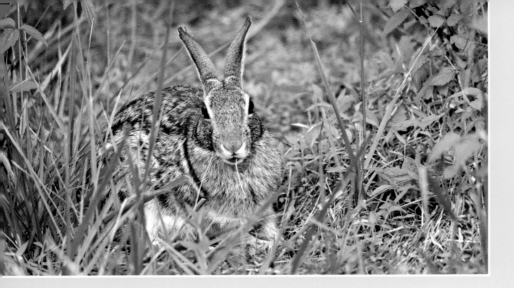

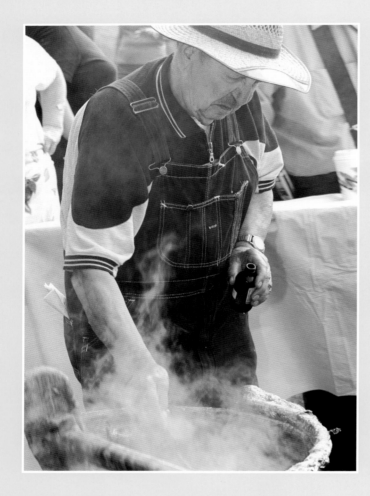

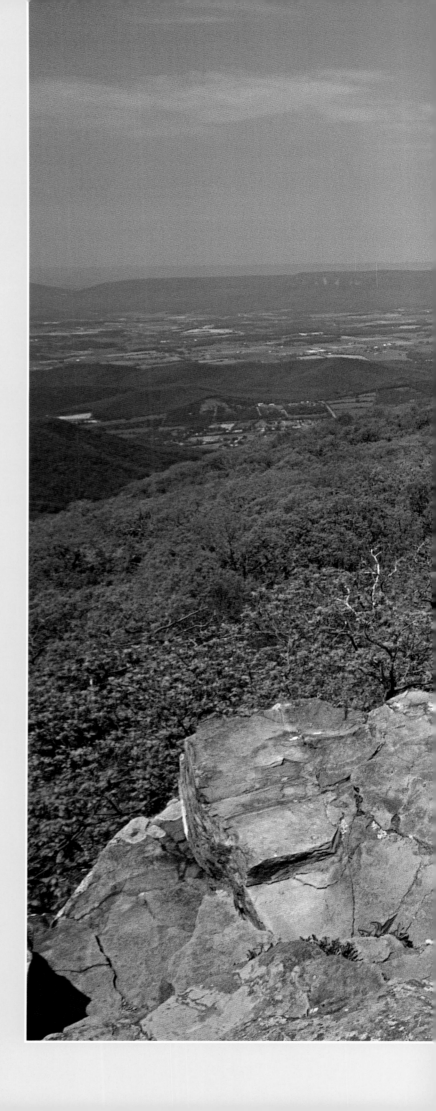

ABOVE (TOP): An eastern cottontail, a common sight in Shenandoah National Park. Appalachian cottontails, on the other hand, would be more unusual sights because they live in densely forested areas.

ABOVE (BOTTOM): Keeping traditions alive at the Apple Butter Festival in Skyland. Visitors can help with peeling, snitting, and boiling the delicious concoction, which simmers for about fifteen hours. "Snitting" means to quarter a peeled apple, scoop out the core and seeds, then halve the quarters.

RIGHT: Three-toothed cinquefoil, tucked in the crevices of Bettys Rock, grows only in a few high-elevation places in Virginia.

46

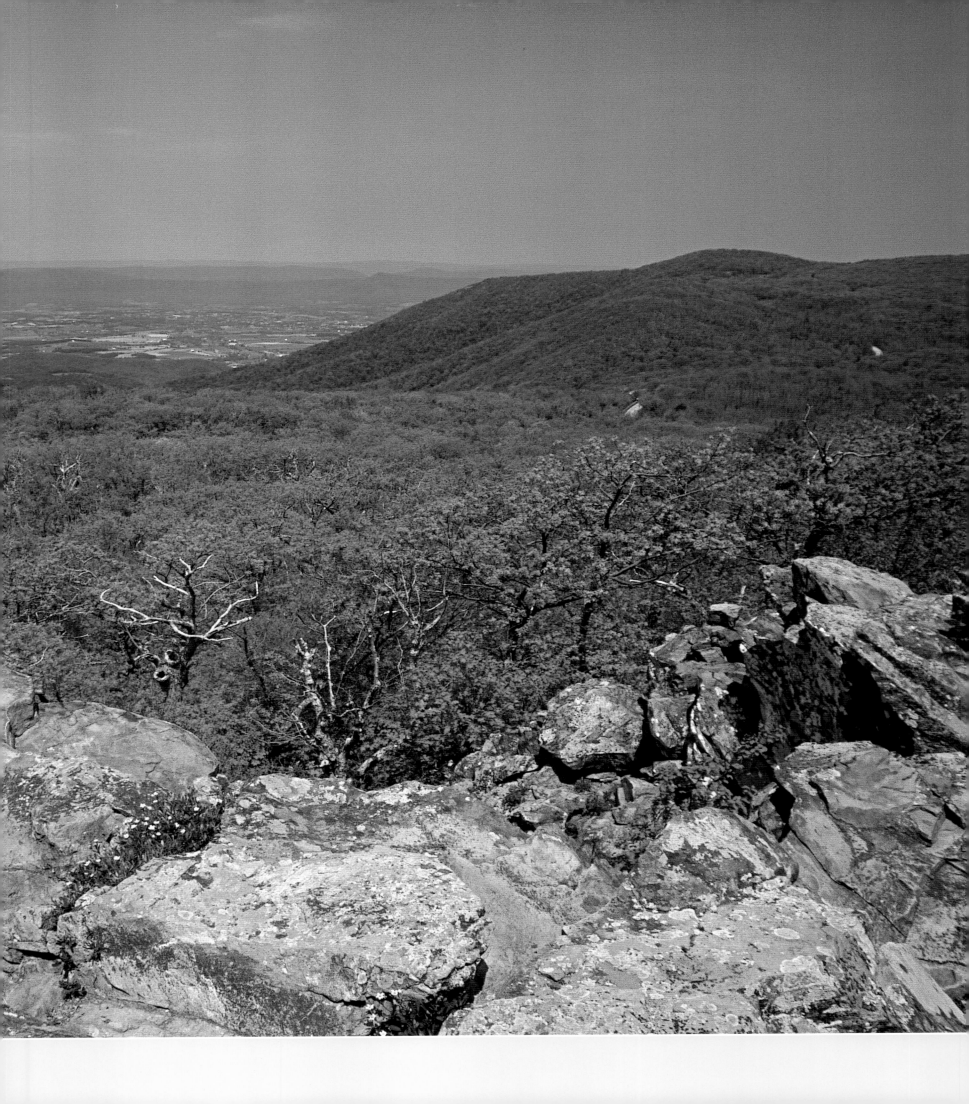

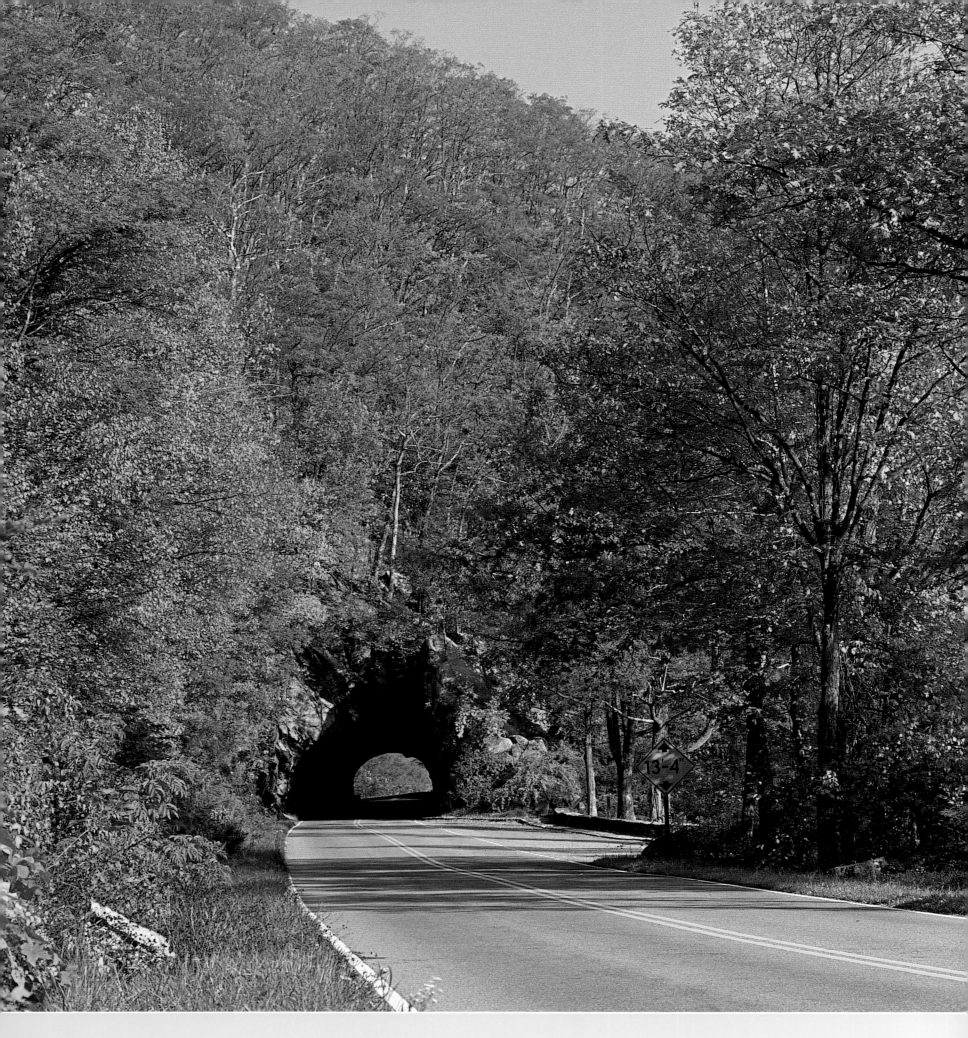

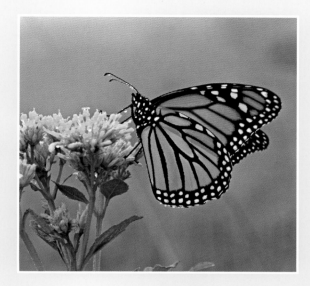

LEFT: A monarch butterfly sips nectar from a crown-beard blossom. Because monarchs cannot survive the cold winters in the park, they must migrate to the mountain forests of Mexico.

FAR LEFT: Marys Rock tunnel in the park's central district was blasted through billion-year-old metamorphic rock.

BELOW: Nearly everyone pulls off to absorb the exquisite autumn colors in the many tulip tree groves in the park's lower elevations. Tulip trees, also called yellow poplars, grow quickly and may live as long as 300 years.

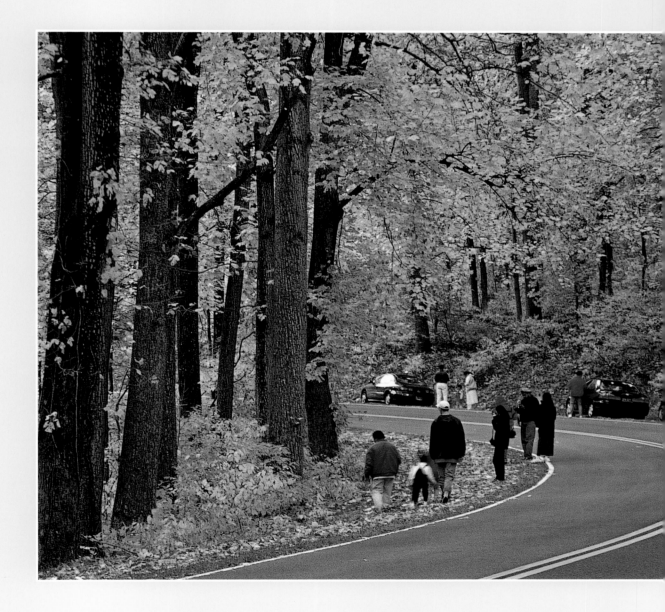

RIGHT: The Shenandoah salamander, which does not have lungs and breathes through its skin, is found only on high mountain talus slopes in Shenandoah National Park.

FACING PAGE: A red-tinged view of the Blue Ridge Mountains from Hazel Mountain Overlook. Here the gneiss, or metamorphic rock, contains small garnet crystals.

BELOW: Mist-shrouded deer forage in Big Meadows. Once kept open by frequent fires, Big Meadows today provides diverse forage for wildlife and is the park's largest treeless area.

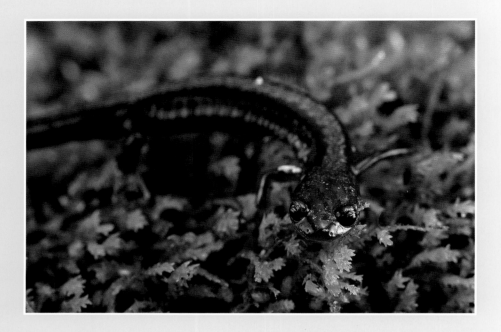

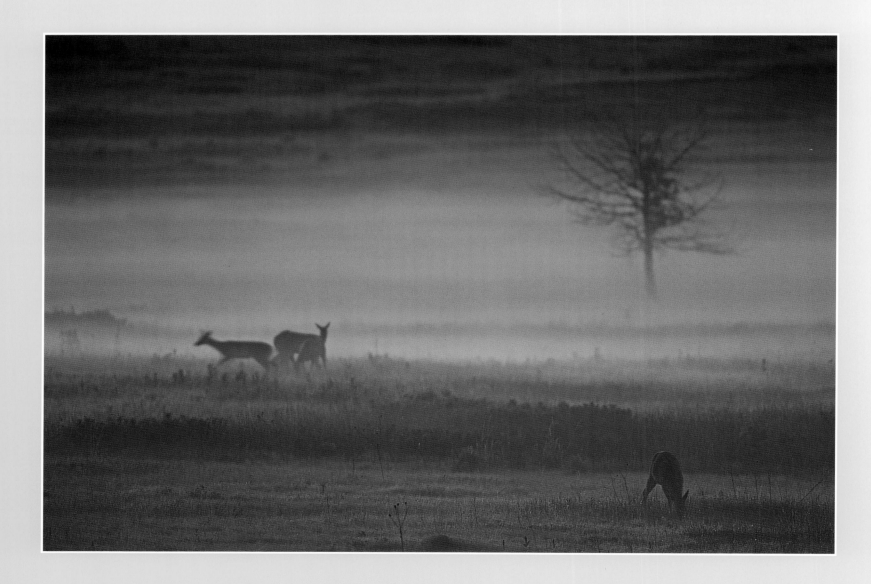

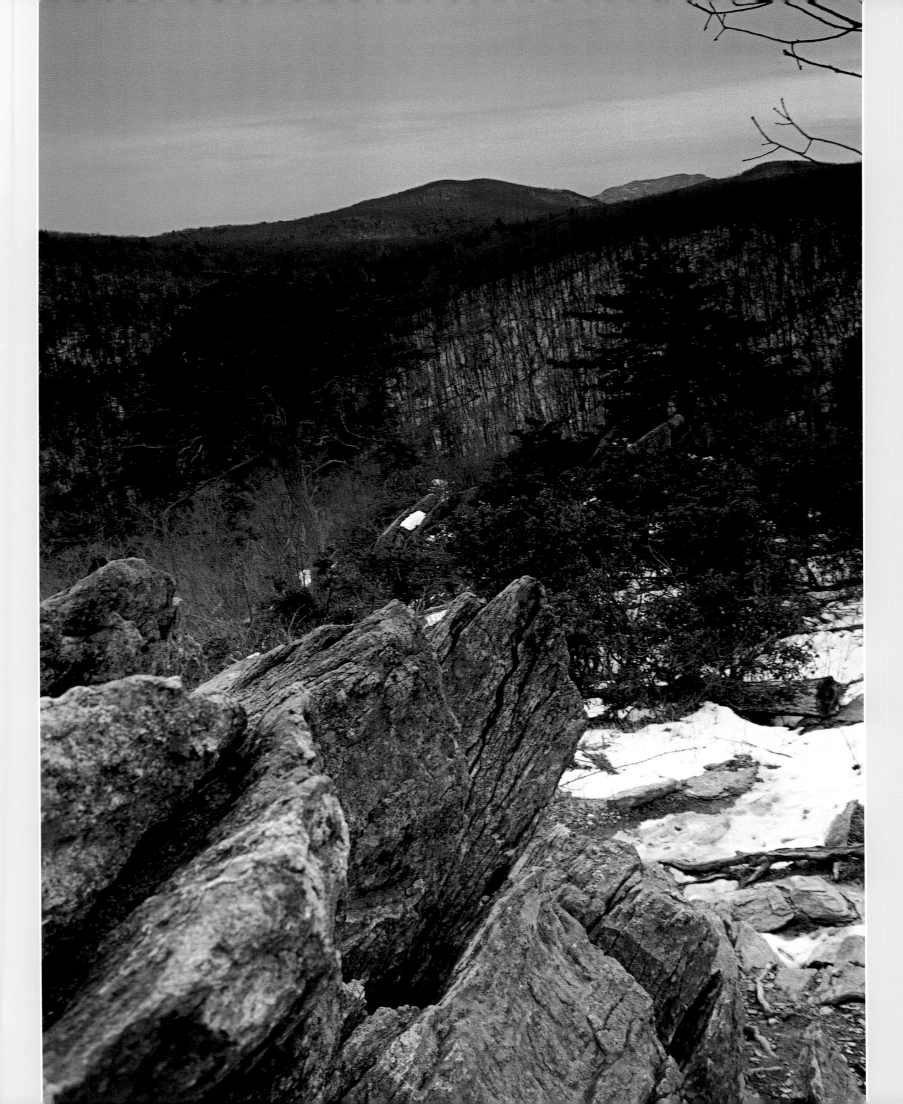

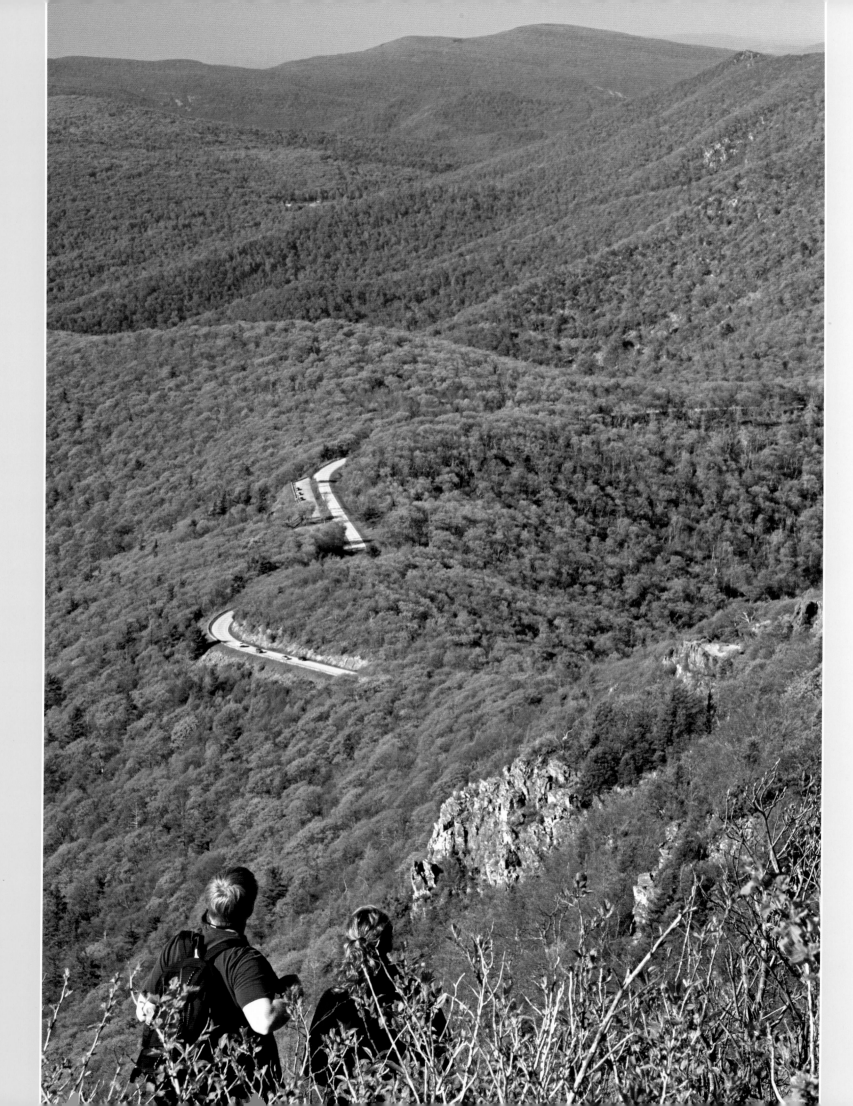

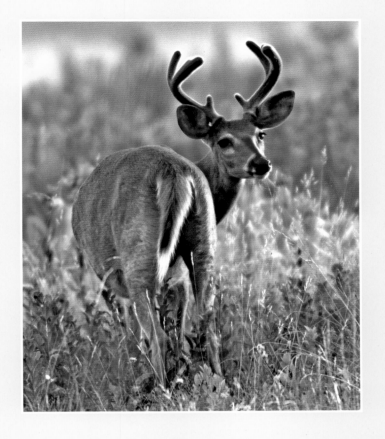

LEFT: This buck has "velvet" on its antlers—the velvet nourishes the buck's antlers while they grow. In fall, the buck will rub off the velvet to expose the hard, white bone.

FACING PAGE: Hikers at Little Stony Man Overlook can see Skyline Drive winding through the Blue Ridge Mountains. The entire park straddles the Blue Ridge, the easternmost flank of the Appalachian Mountains between Pennsylvania and Georgia.

BELOW: Visitors enjoy horseback riding through the park.

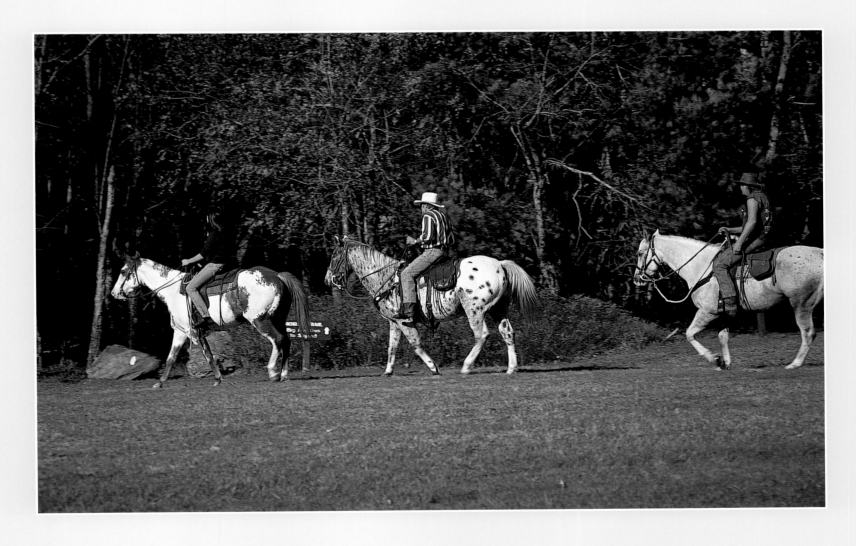

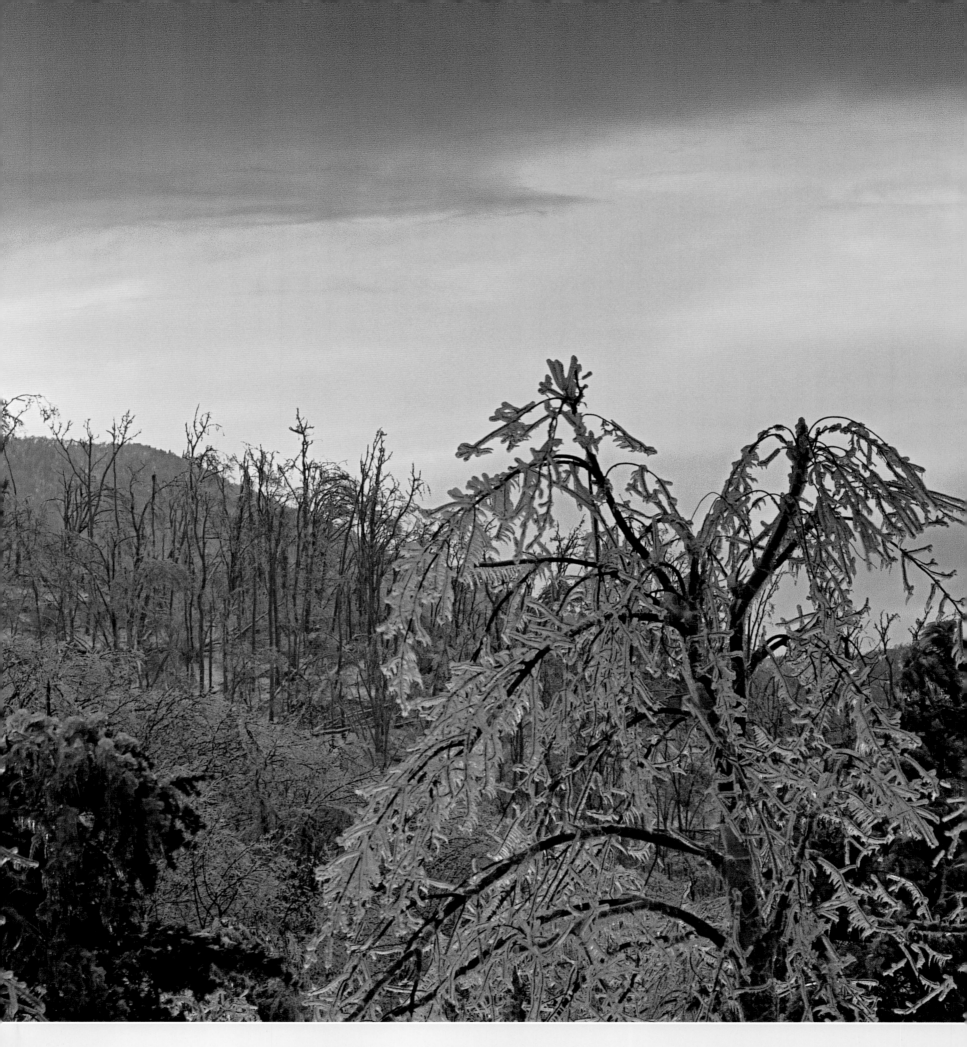

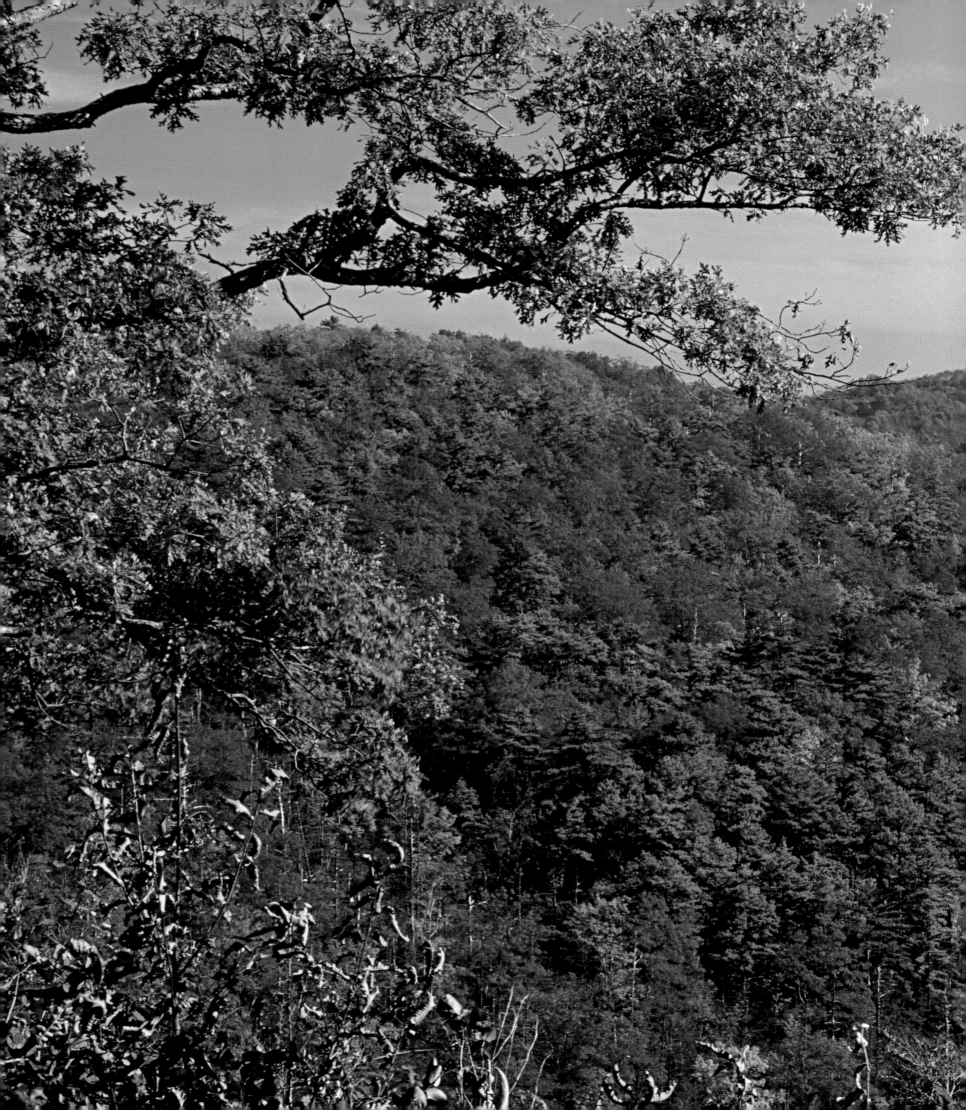

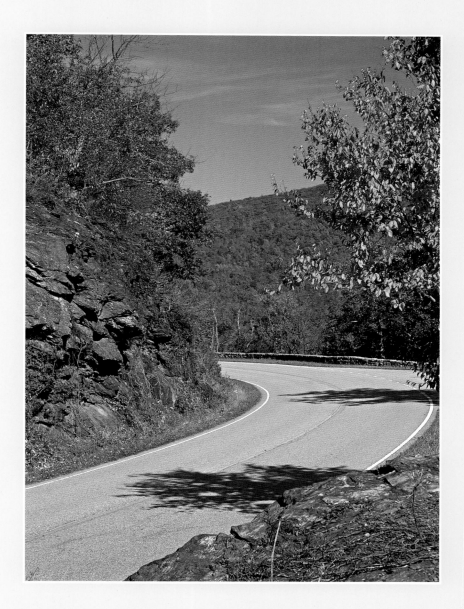

ABOVE: Loft Mountain Overlook provides an enticing view of Skyline Drive lined with trees blazing with fall color. The road, constructed between 1931 and 1939, cost approximately $5 million to build.

LEFT: The multi-hued forest that spreads below Thornton Hollow Overlook includes chestnut oak trees (yellowish-brown leaves), white oak trees (red leaves), hickory trees (yellow leaves), and evergreen Virginia and Table Mountain pines.

FOLLOWING PAGES: Pignut hickory leaves frame this view from the Appalachian Trail across to the summits of Flattop and Hightop mountains. Shenandoah National Park has more than 500 miles of trails, many of which are located in designated wilderness areas.

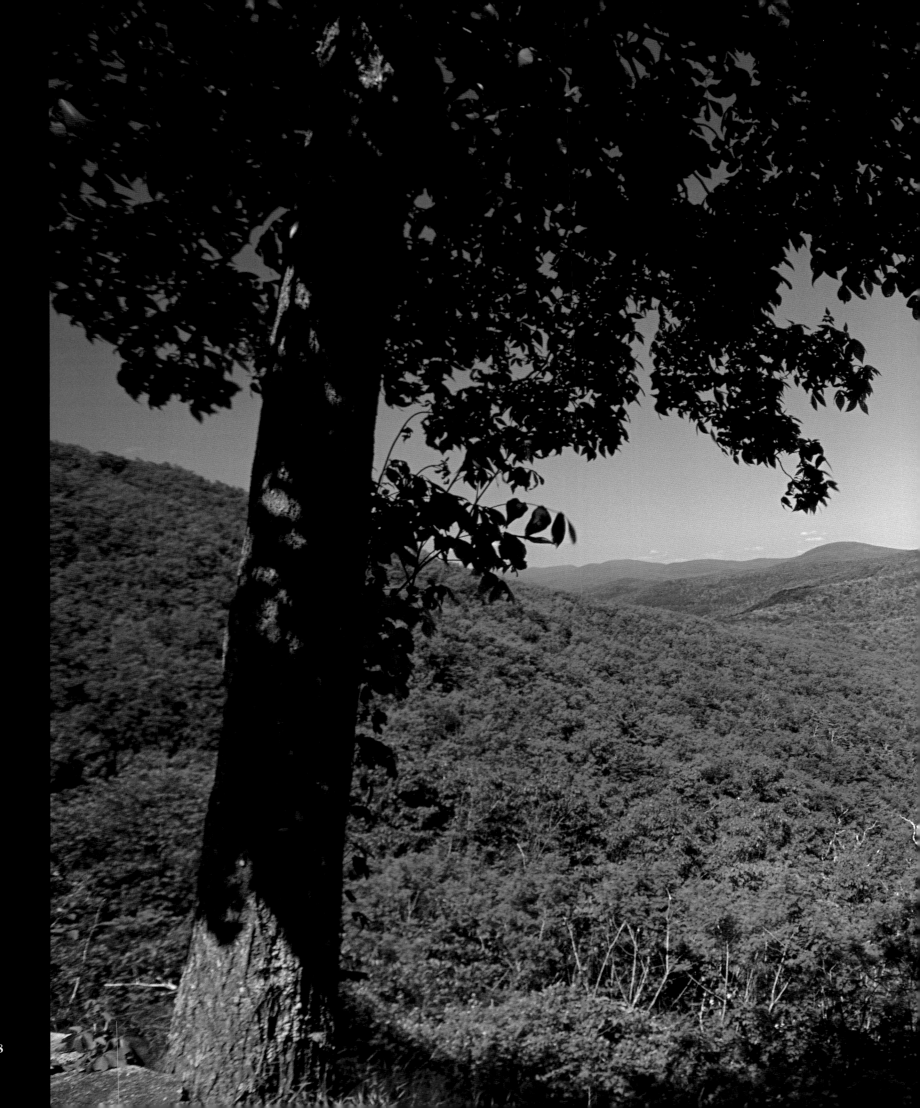

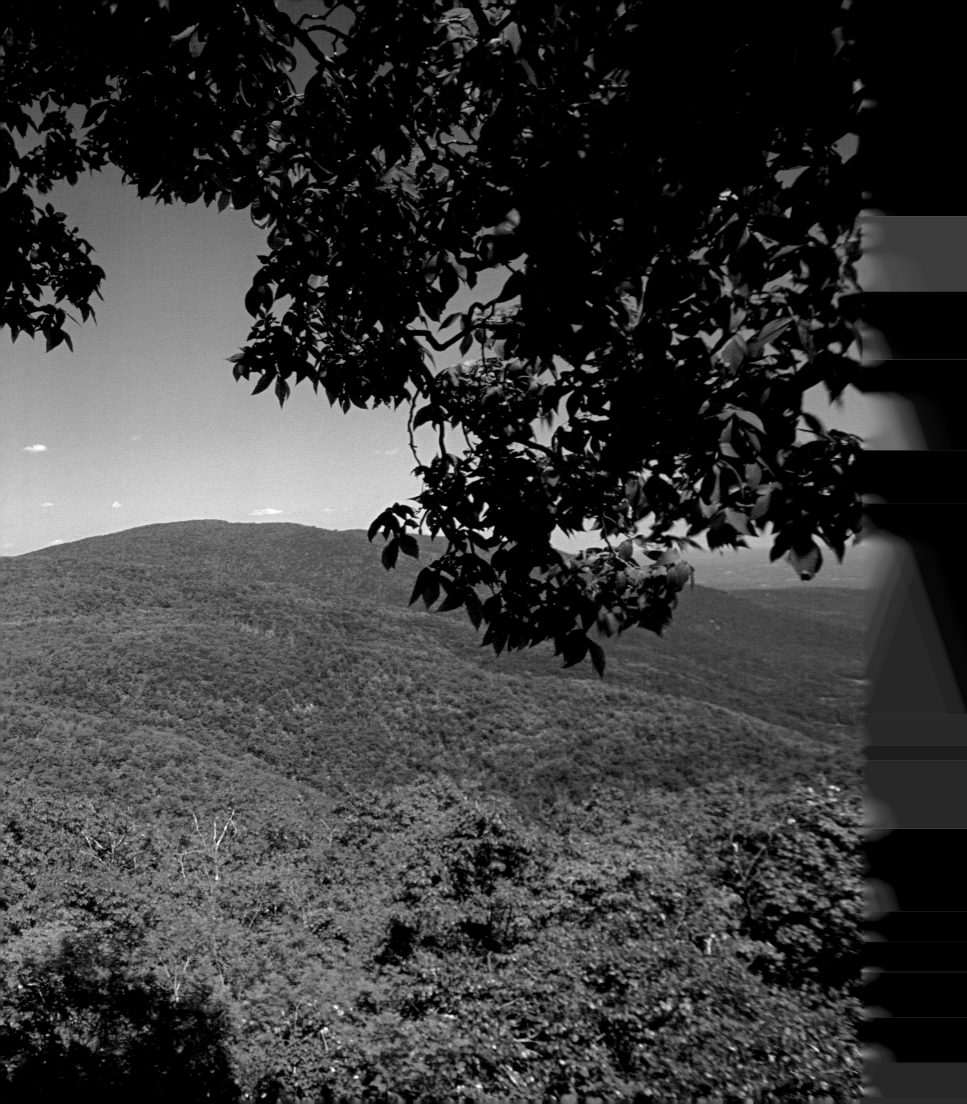

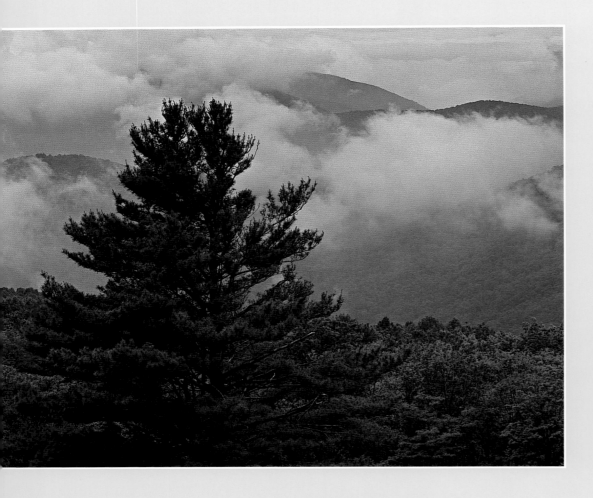

ABOVE: Hazeltop Ridge Overlook provides a glimpse of clouds hovering above the Blue Ridge Mountains and the Shenandoah Valley.

RIGHT: On an early September morning, fog rises from the valley floor at Indian Run Overlook. Common to the region, fog is formed when a pool of cool air is trapped in the valleys.

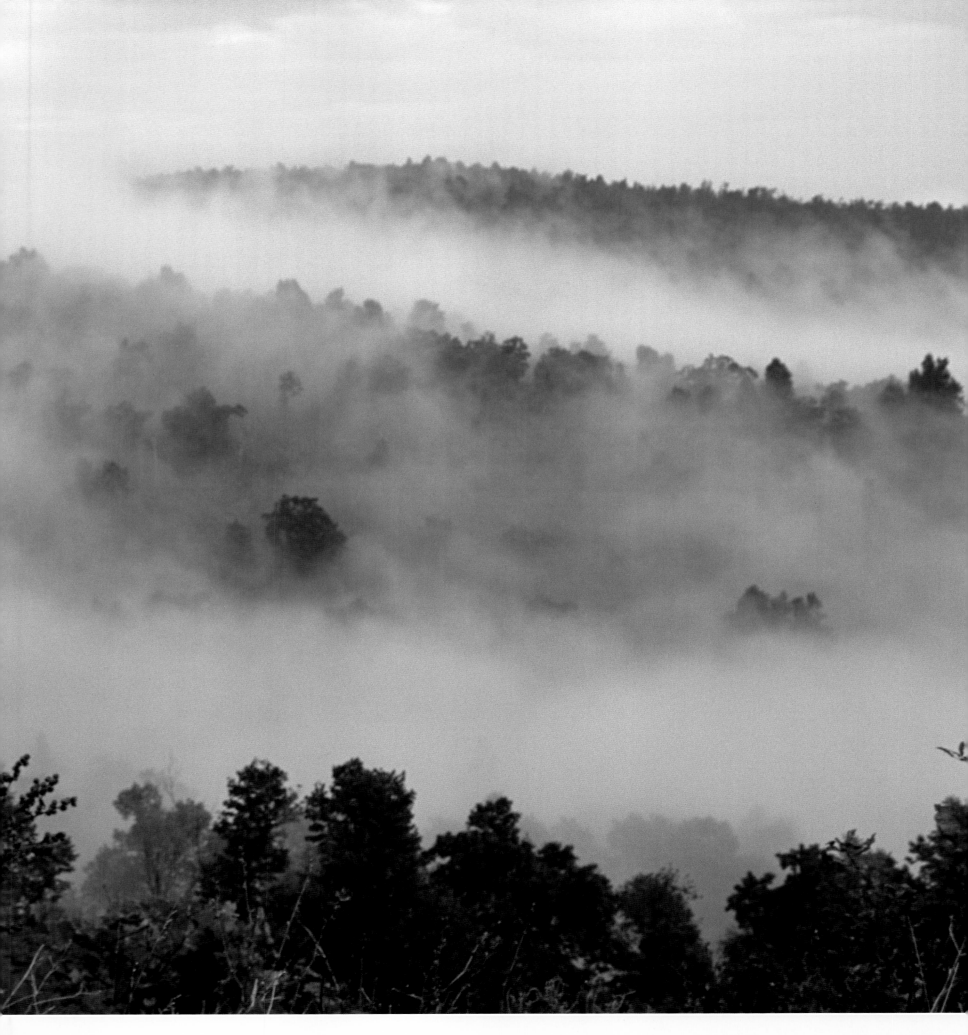

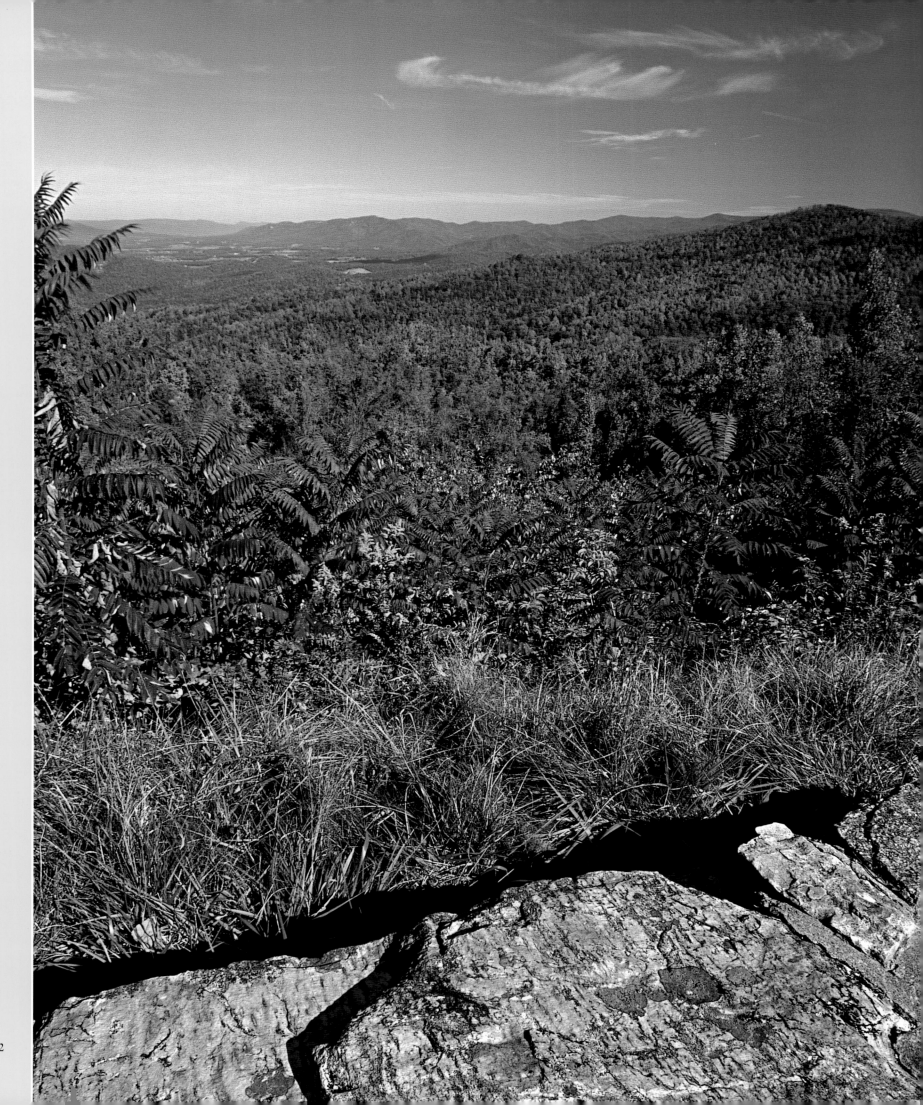

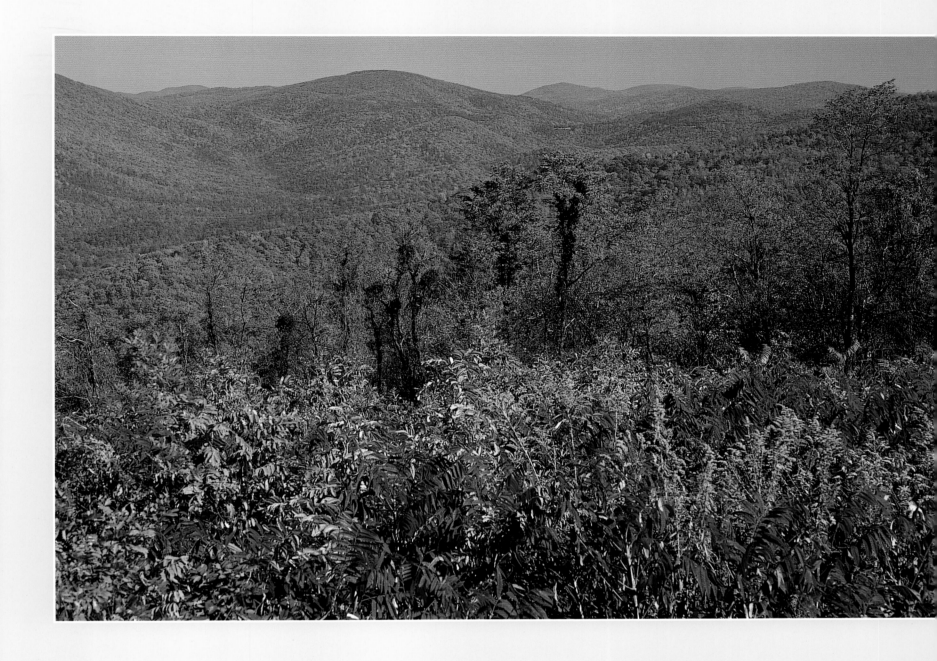

ABOVE: From the McCormick Gap Overlook, the brilliant red of smooth sumac prepares your eyes for the rich autumn colors of the Shenandoah Valley beyond.

RIGHT: Normally found farther north, red trillium is common in Swift Run Gap and along the trail to the summit of Hightop Mountain.

FACING PAGE: Staghorn sumac's red leaves highlight the view from Eaton Hollow Overlook.

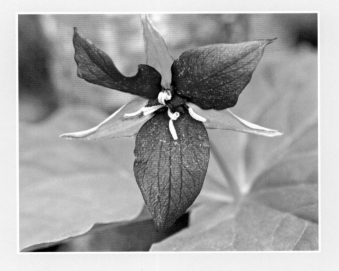

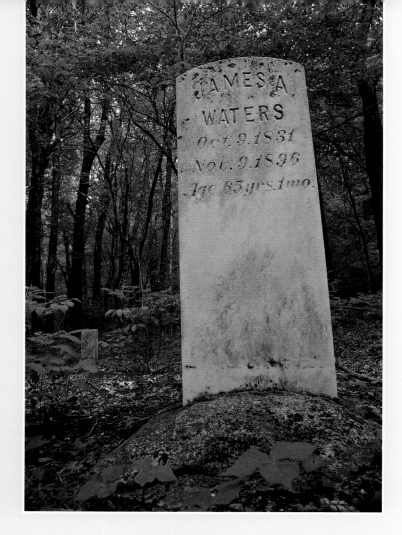

RIGHT: Another family cemetery, this one in Beahms Gap.

FACING PAGE: From 1929 to 1933, President Herbert and First Lady Lou Henry Hoover built their rustic summer retreat, Rapidan Camp, in what later became Shenandoah National Park. Their fishing retreat, "the Brown House," at the headwaters of the Rapidan River, later became Hoover's retreat from the press, where he held numerous strategy meetings in an effort to head off the troubles of the Great Depression.

BELOW: An abandoned millstone along Fox Hollow Trail provides a clue that the Fox family's home site was at one time nearby.

FOLLOWING PAGES: From Signal Knob Overlook, sunset colors the Massanutten Mountain landscape in January.

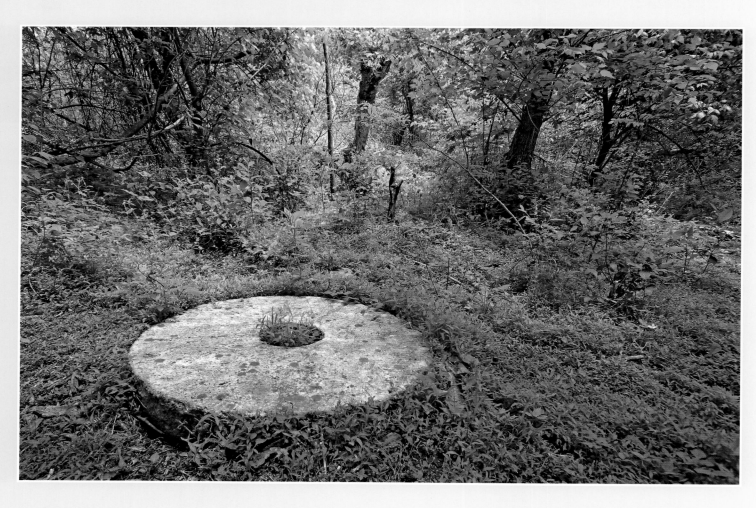

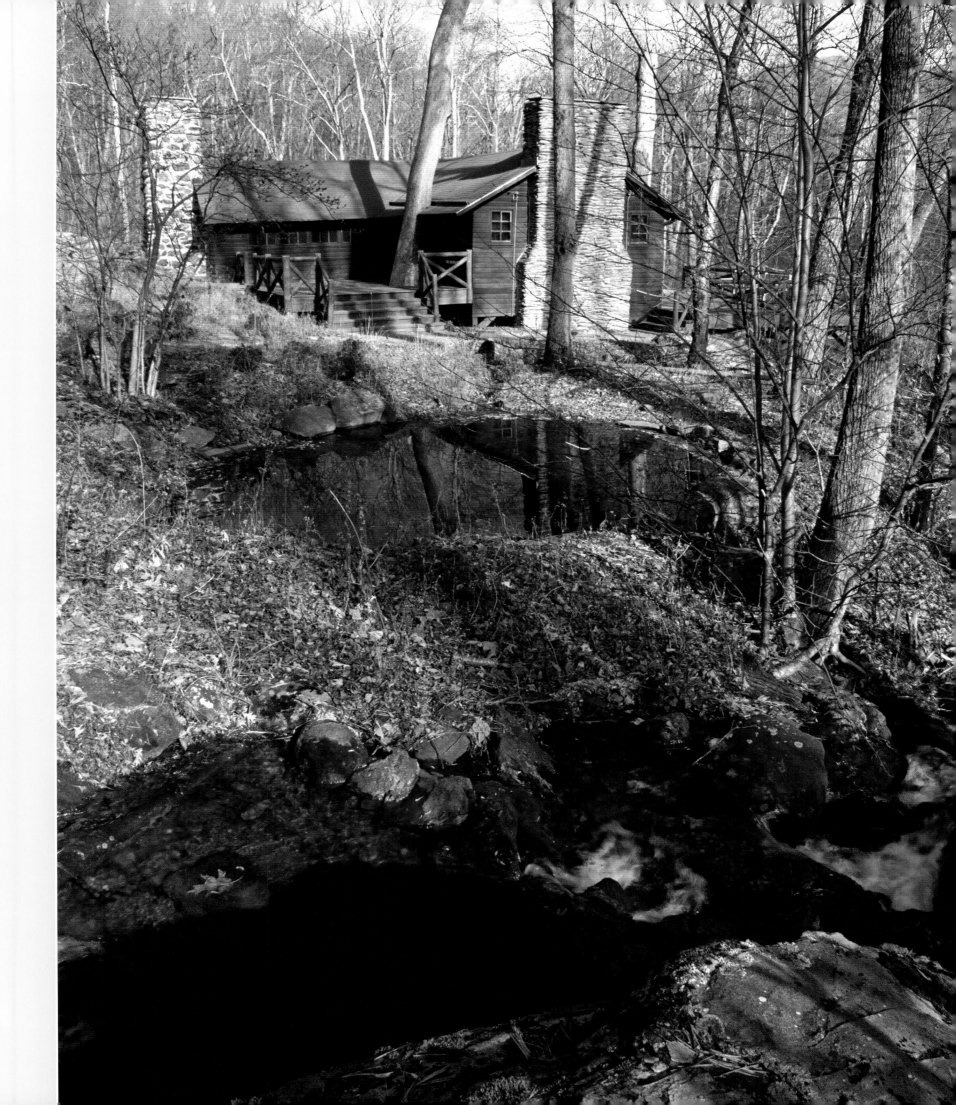

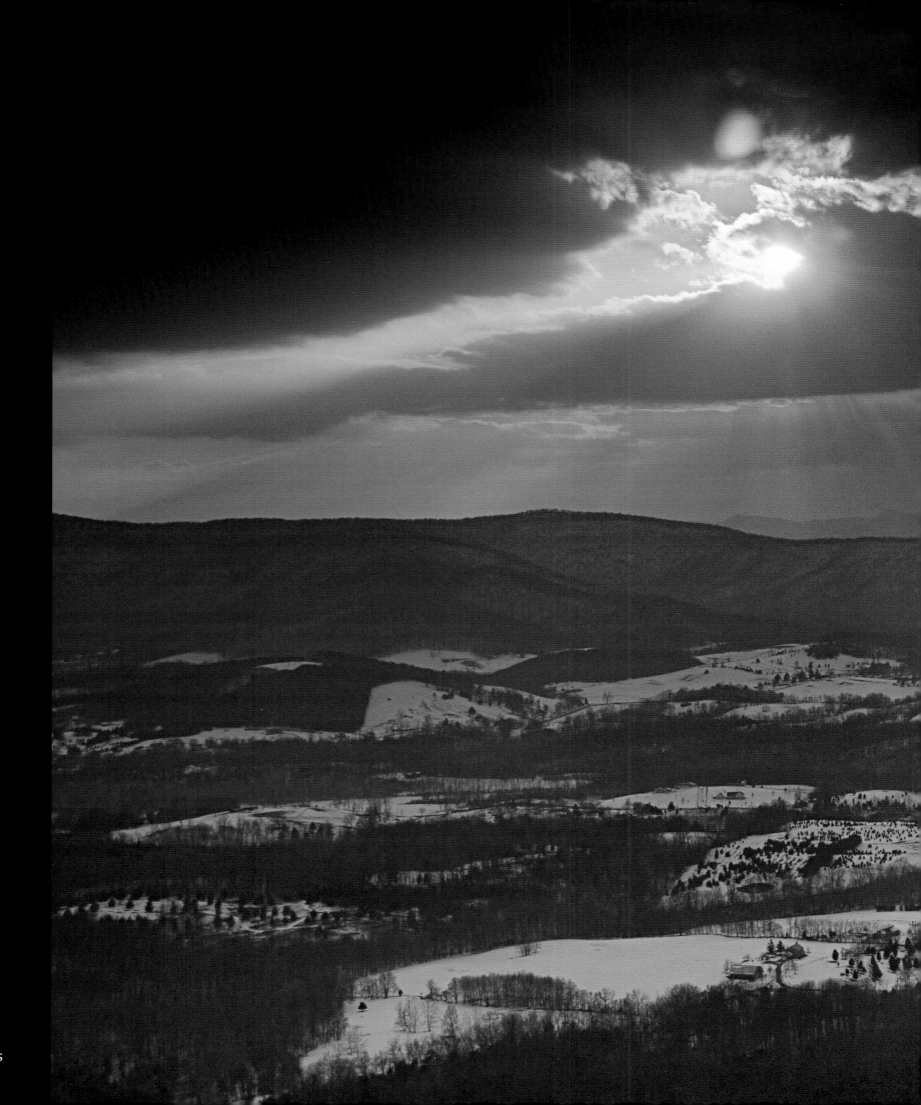

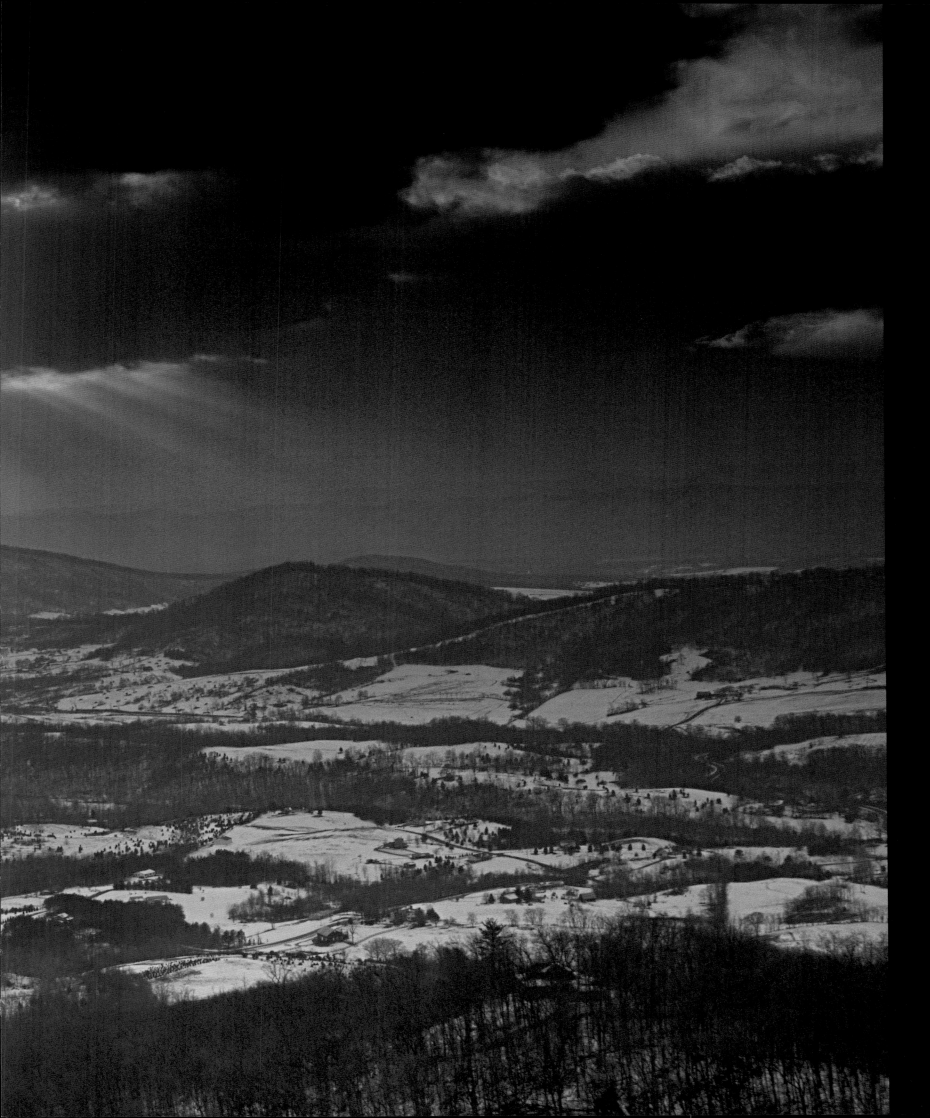

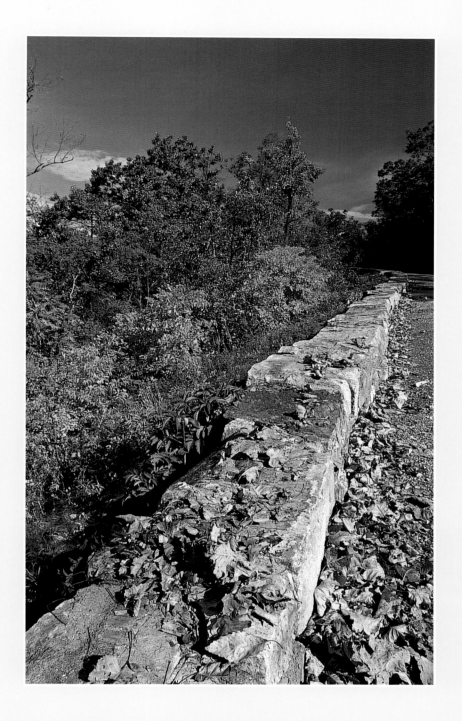

ABOVE: A hand-built stone wall at Rocky Mount Overlook.
The CCC built the overlooks on Skyline Drive in the 1930s.

LEFT: Turk Mountain Trail beckons you to stroll to Jarmin Gap,
near Sawmill Run Overlook.

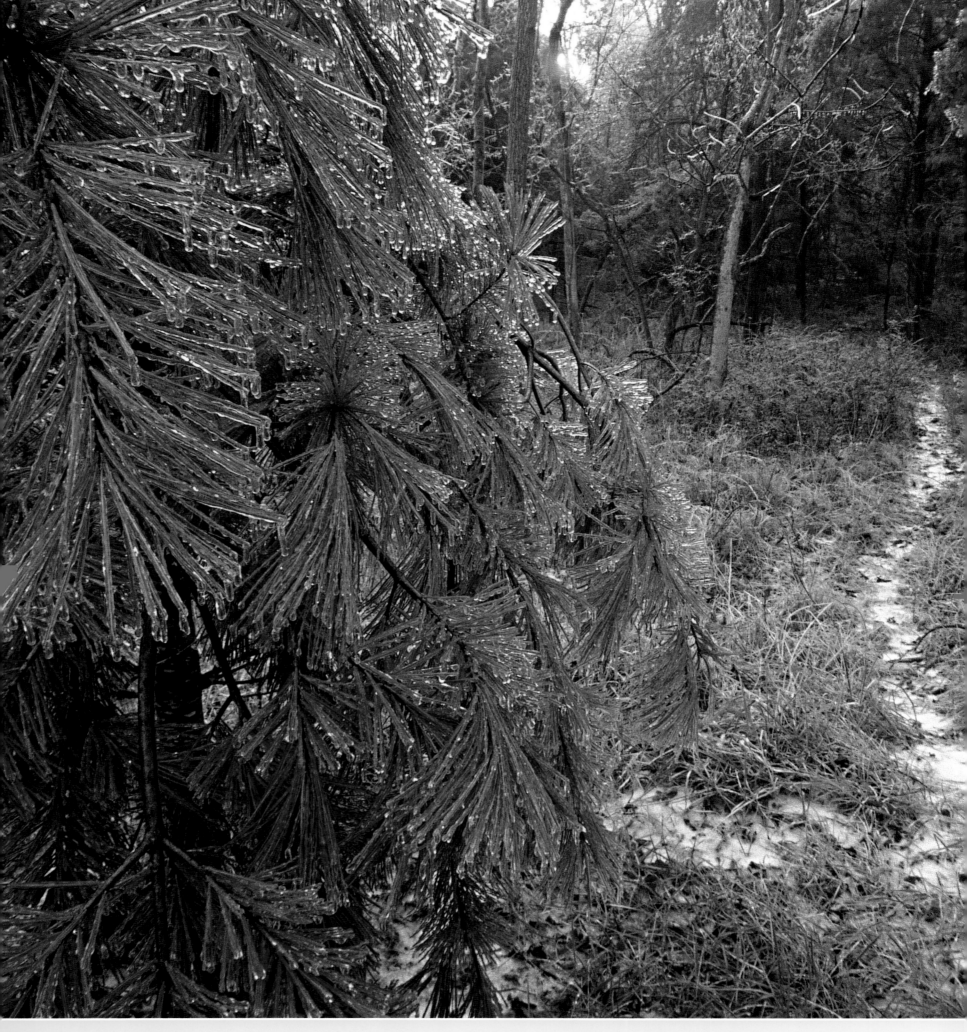

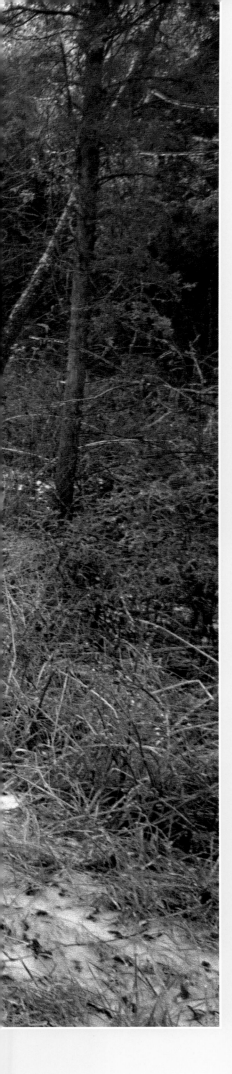

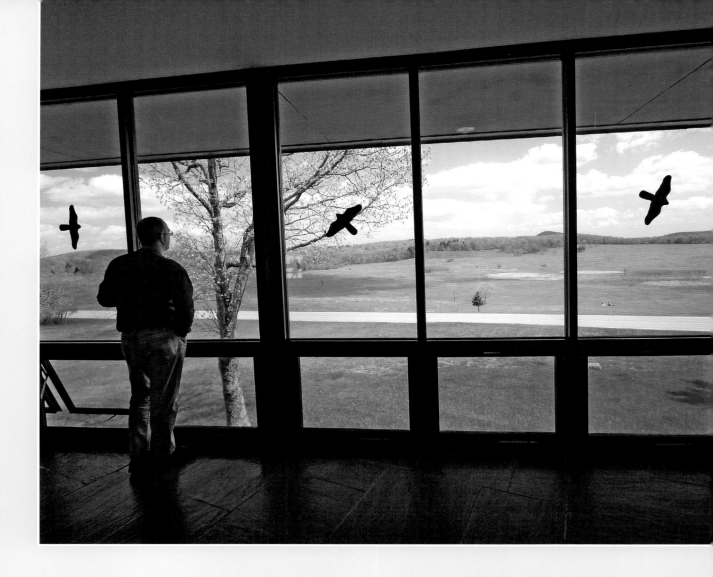

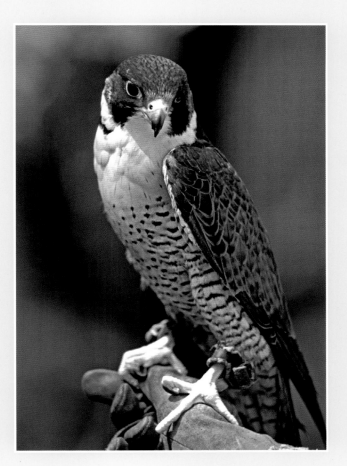

ABOVE: A lone tourist gazes at Big Meadows from the Harry F. Byrd, Sr., Visitor Center. Located at Milepost 51 on Skyline Drive, the center is named for a former Virginia governor.

LEFT: Peregrine falcons were successfully reintroduced to Shenandoah National Park and now breed and raise young here. At Hawksbill and Stony Man mountains, rangers set up spotting scopes so visitors can view peregrine babies in the nests.

FAR LEFT: This game trail intersects the Dickey Ridge Trail that winds through ice-coated white pines at the park's north end.

FOLLOWING PAGES: Rafts of clouds float across Big Meadows, the most-visited area in the park.

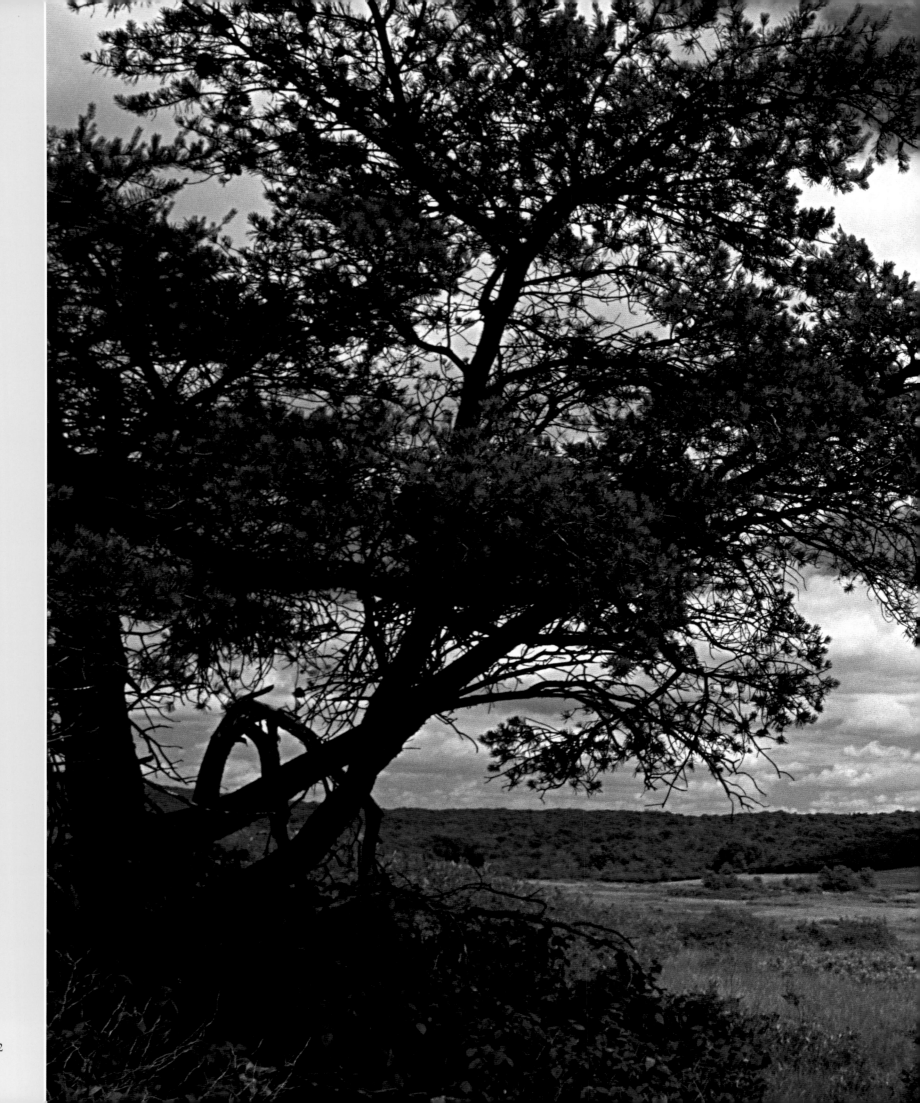

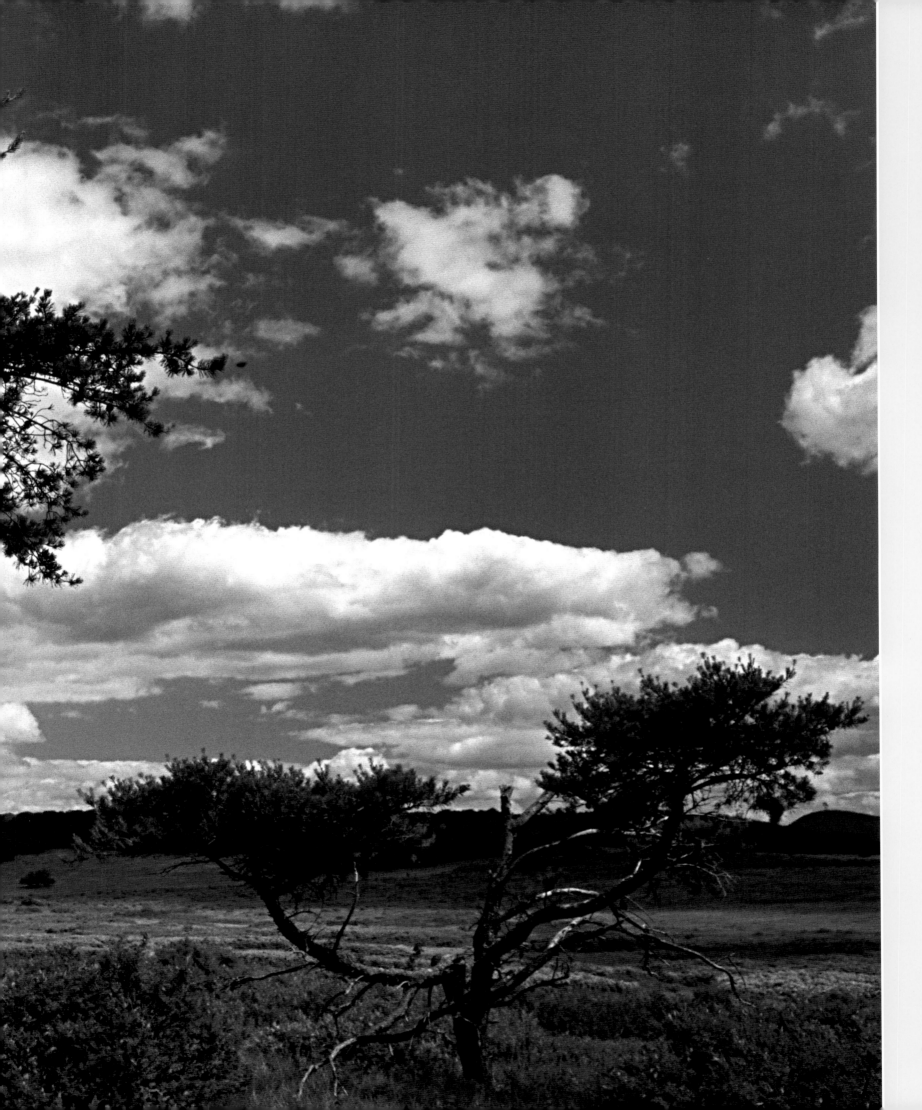

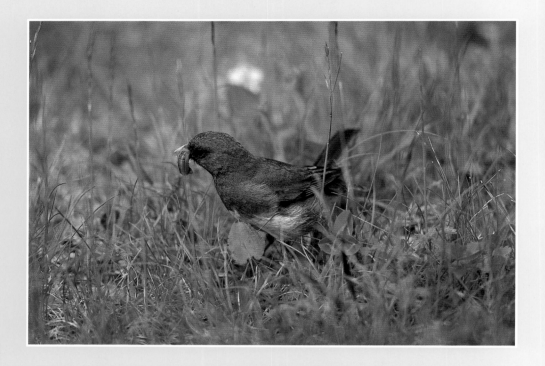

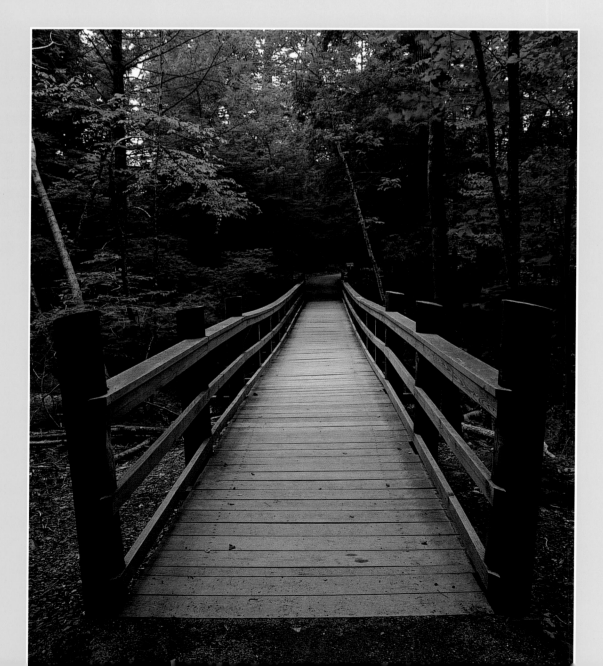

ABOVE: This Appalachian slate-colored junco—a rare subspecies found only in the Appalachian Mountains—hurries away with a tasty treat: a juicy caterpillar.

LEFT: This bridge allows hikers to keep their boots dry when the Limberlost Trail crosses the Robinson River.

FACING PAGE: Hogcamp Branch cascades down an embankment to create Dark Hollow Falls before it reaches the Rose River. There are dozens of waterfalls in the park and this one is easy to view. It's less than a mile-and-a-half round-trip hike to this beautiful waterfall.

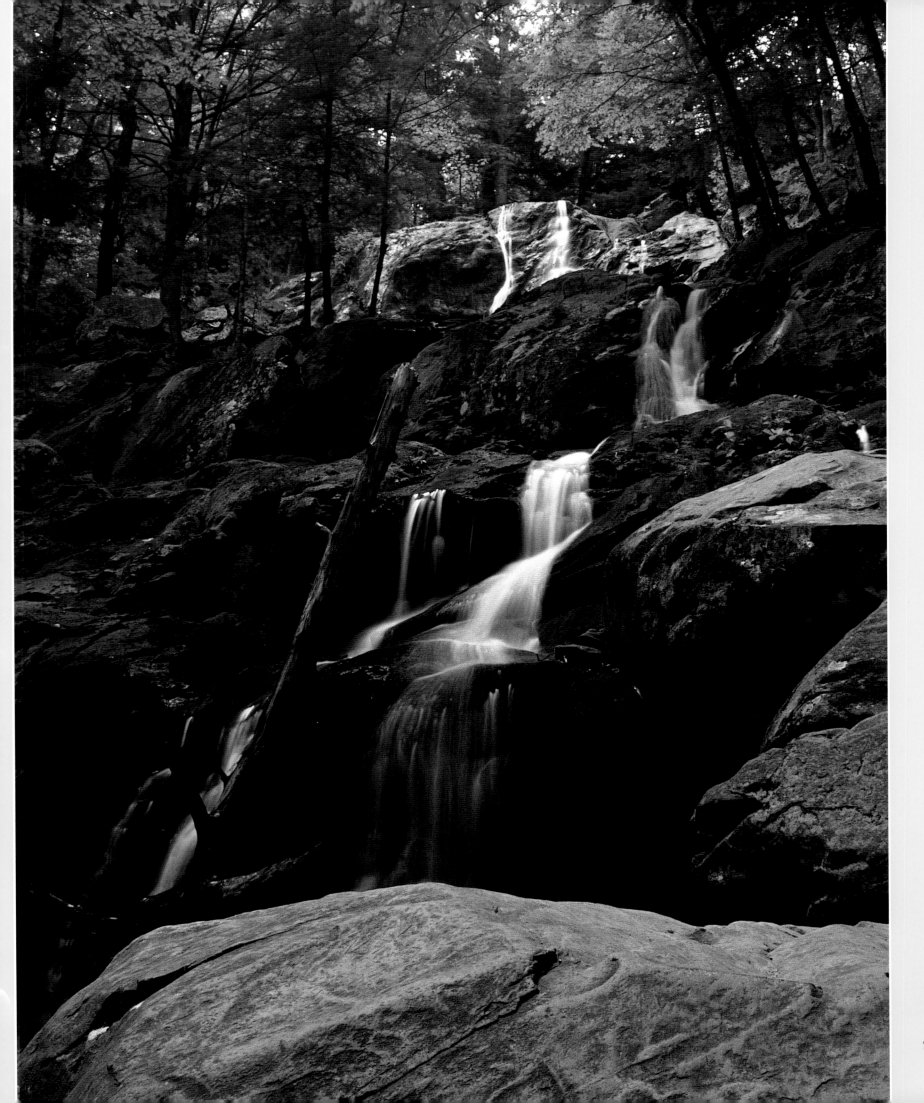

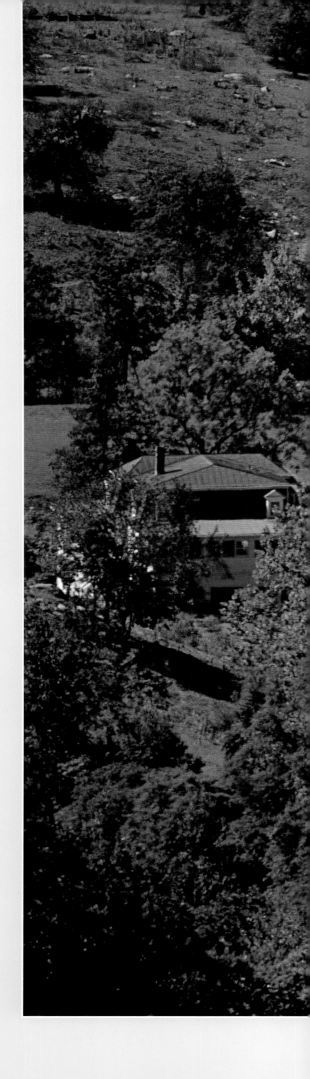

ABOVE: The Appalachian Trail, on the Calf Mountain Summit Trail section through Beagle Gap, winds through an apple orchard.

RIGHT: The first settlers began farming in the Shenandoah Valley in the early 1700s. This working farm is seen from Gooney Manor Overlook.

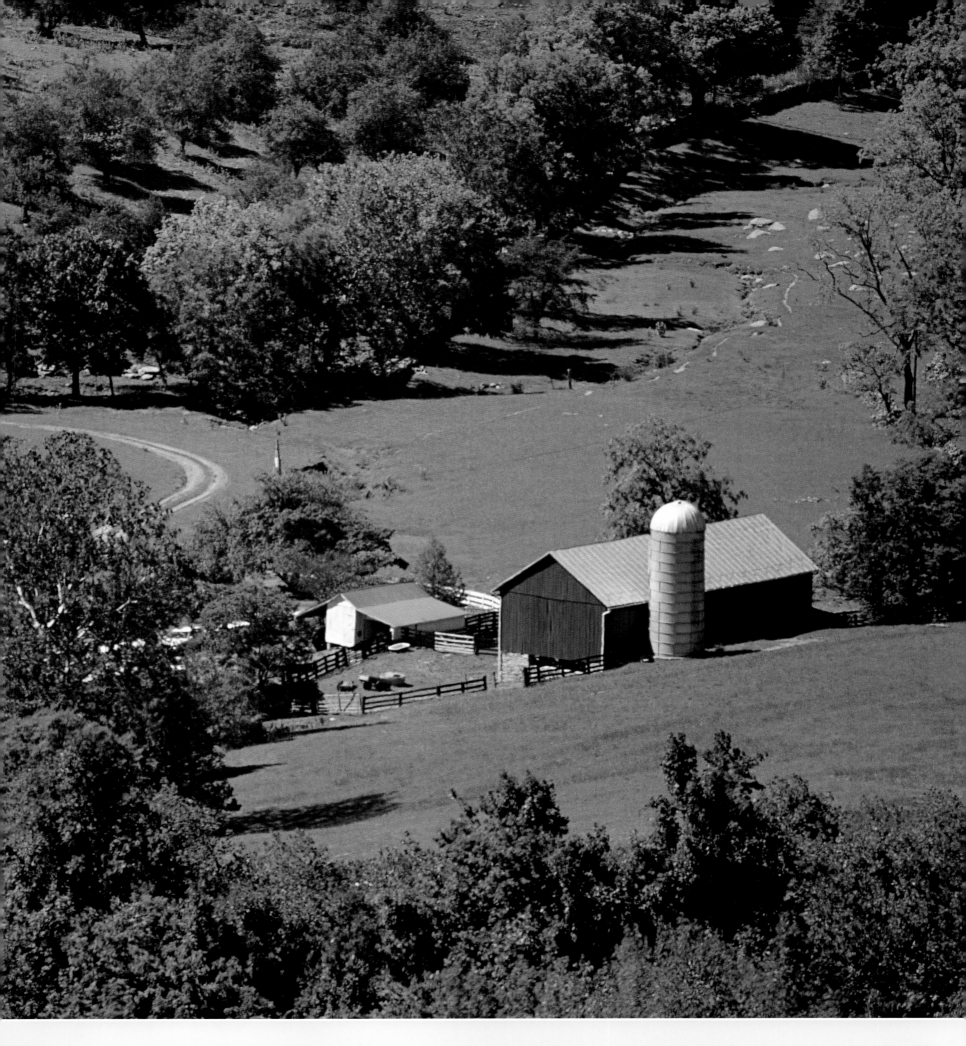

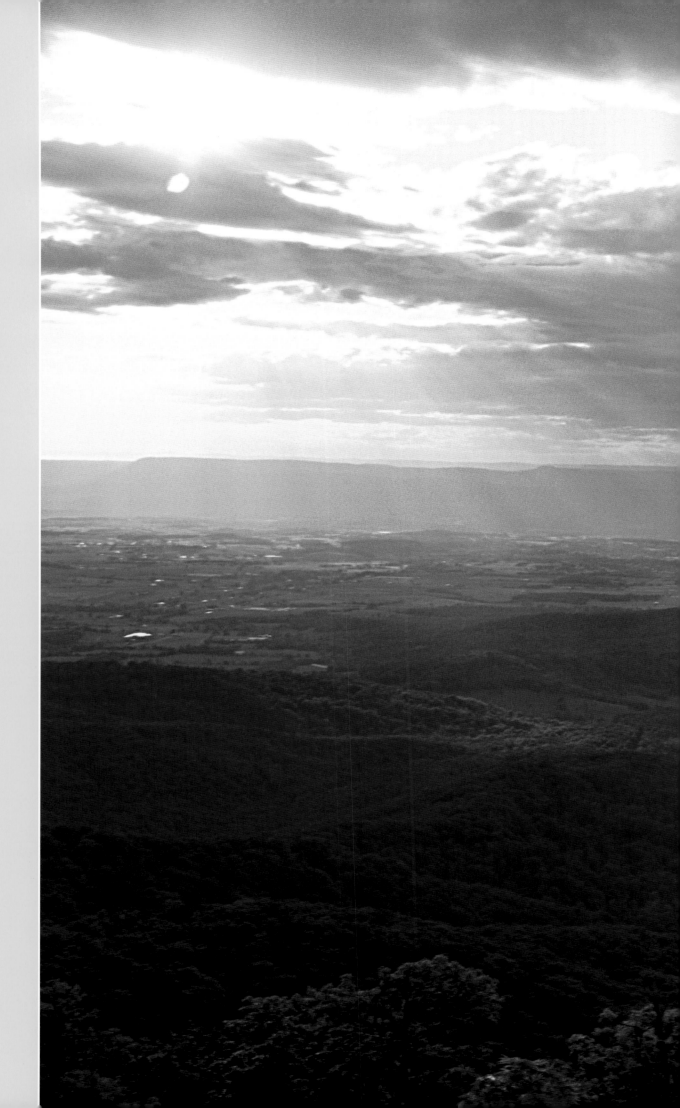

Stony Man Overlook offers an unparalleled view of Lake Arrowhead, Massanutten Mountain, and the Shenandoah Valley. The nearly 50-mile-long Massanutten Mountain divides the Shenandoah Valley in two.

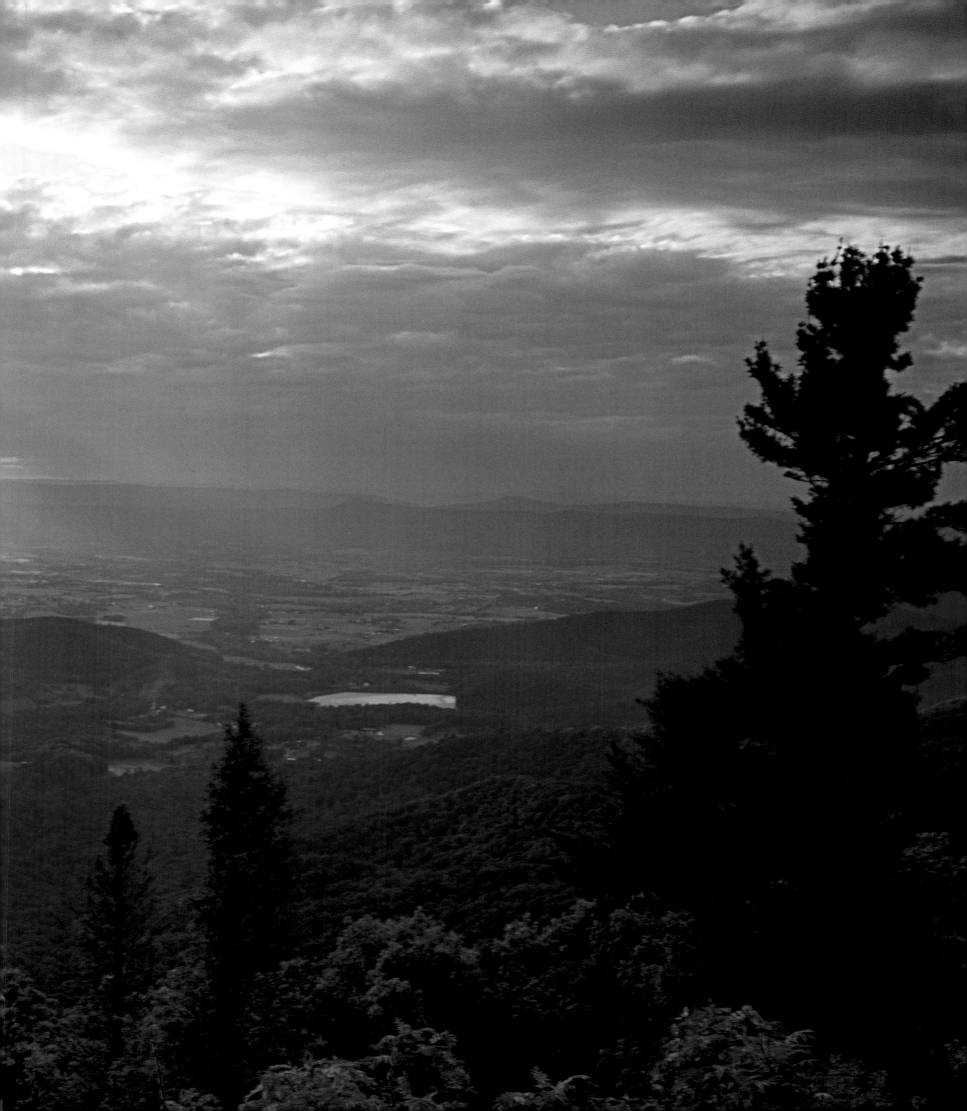

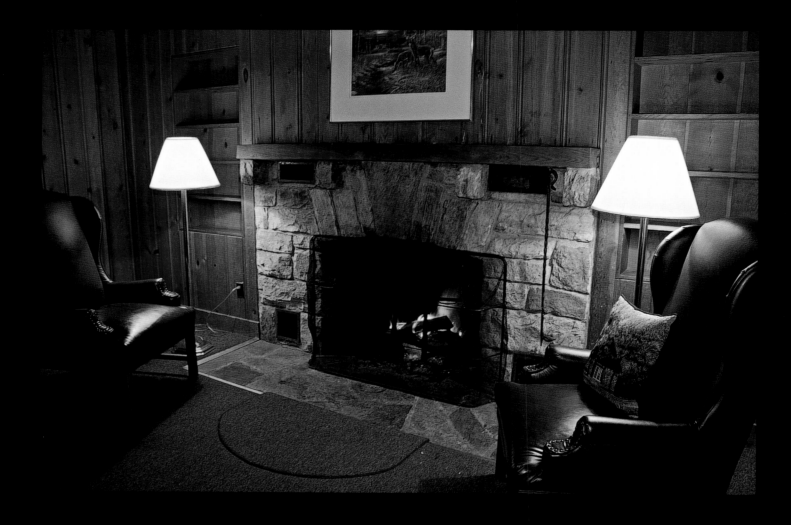

ABOVE: Many of the rooms and cabins in the rustic Big Meadows Lodge have fireplaces where guests can warm up and relax.

FACING PAGE: Sunset reddens the sky, as seen from Swift Run Overlook.

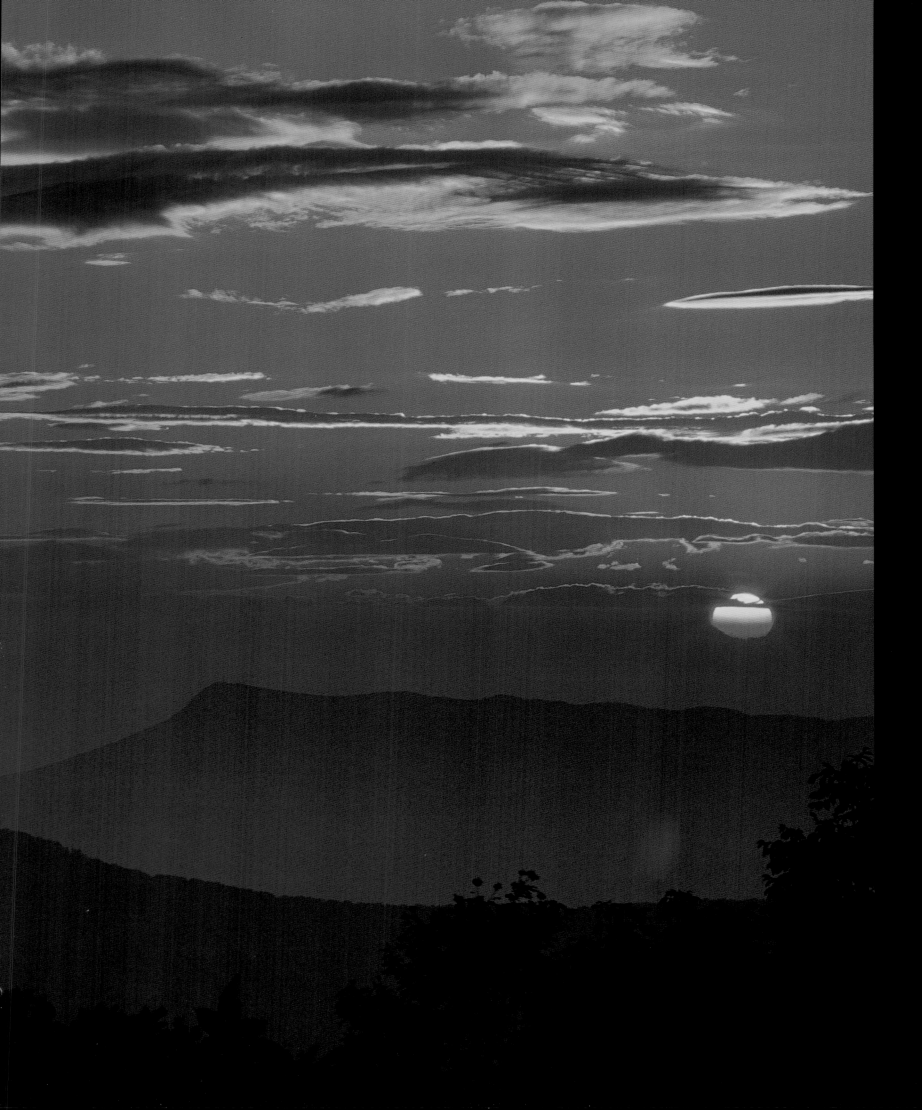

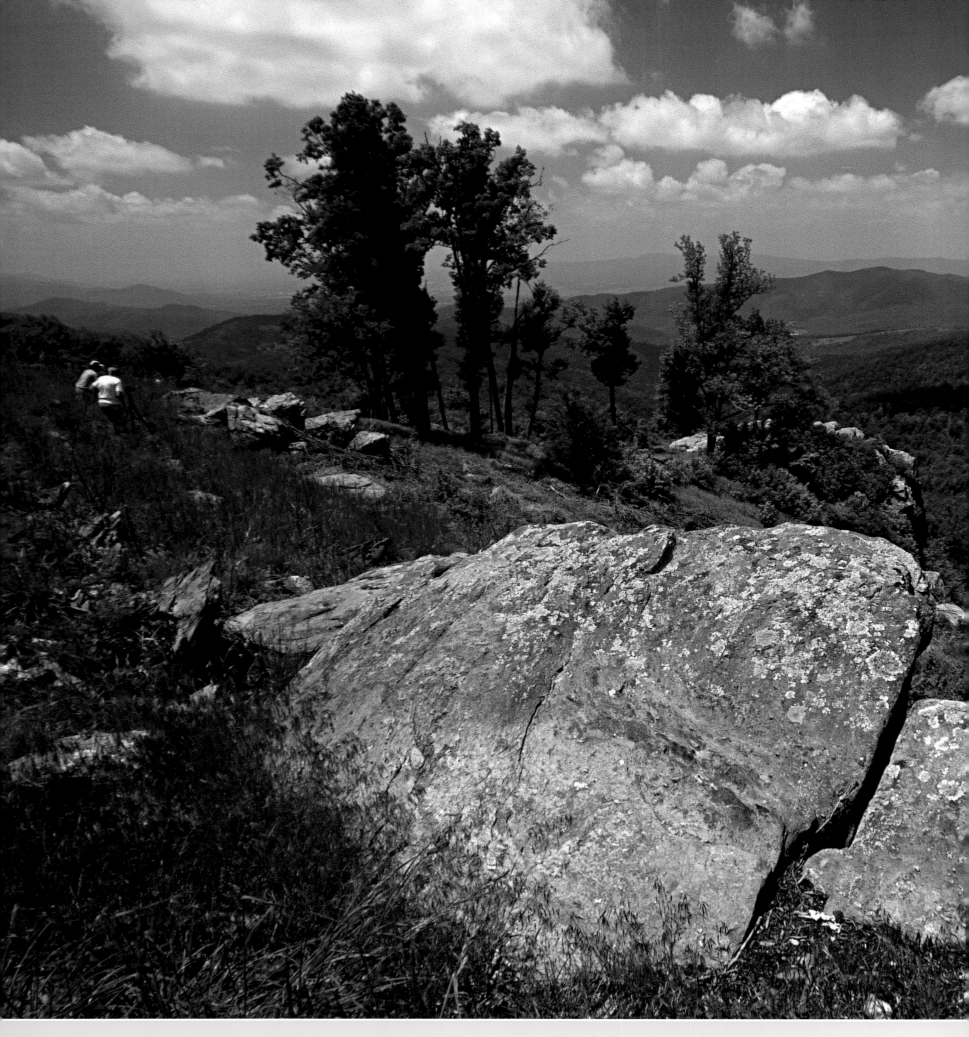

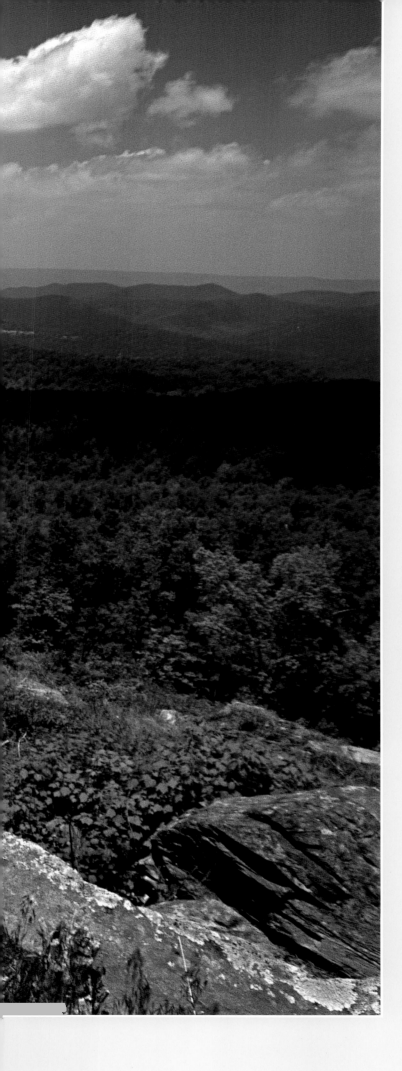

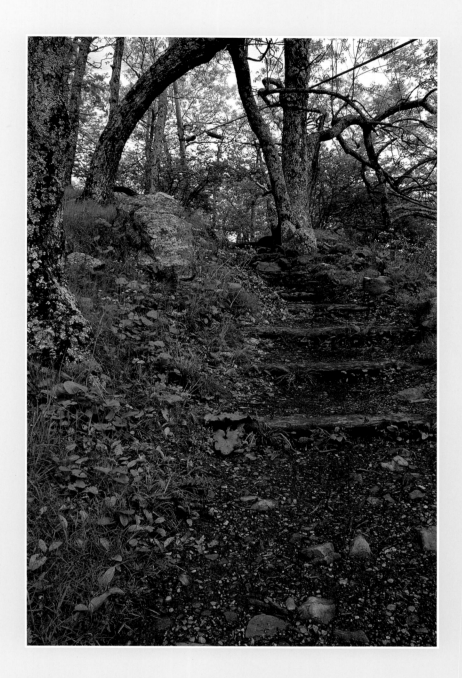

ABOVE: Blackrock Summit Trail gets you up high quickly. An easy hike from Big Meadows Lodge, it features a great sunset-watching spot with a view of the Shenandoah Valley.

LEFT: Basalt rock of the Catoctin Formation juts out at The Point Overlook. This basalt basement rock that underlies the Blue Ridge Mountains slowly solidified from molten magma.

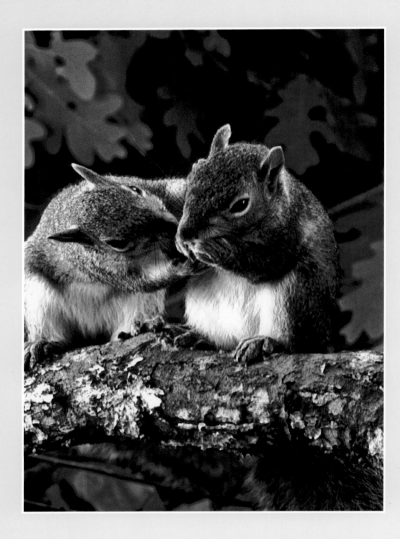

ABOVE: Eastern gray squirrels snack in a white oak tree.

RIGHT: Crustose lichens, which appear tight and flat, and foliose lichens, which look like leaves stuck to the rock, both find good anchorage on boulders in White Oak Canyon. A lichen is an organism that results from the symbiosis between an algae and a fungus and makes it possible for other plants to gain a foothold.

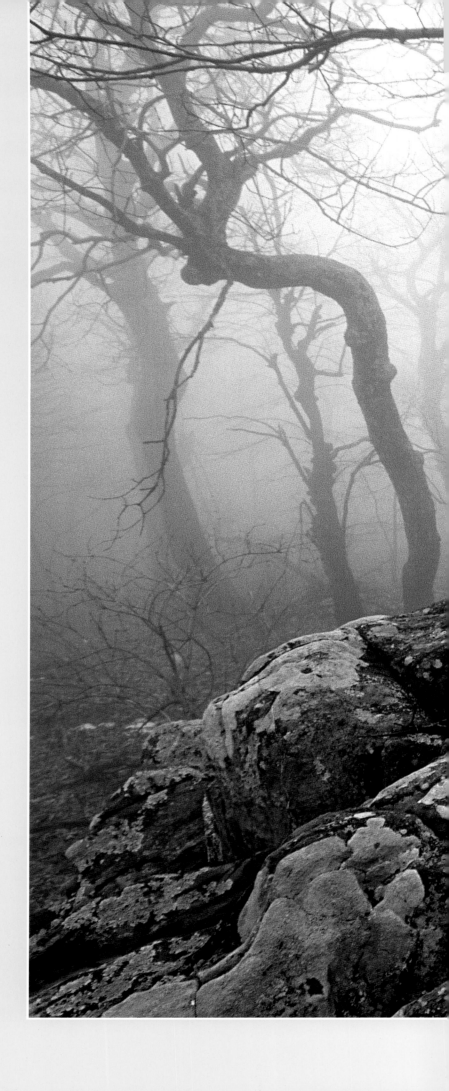

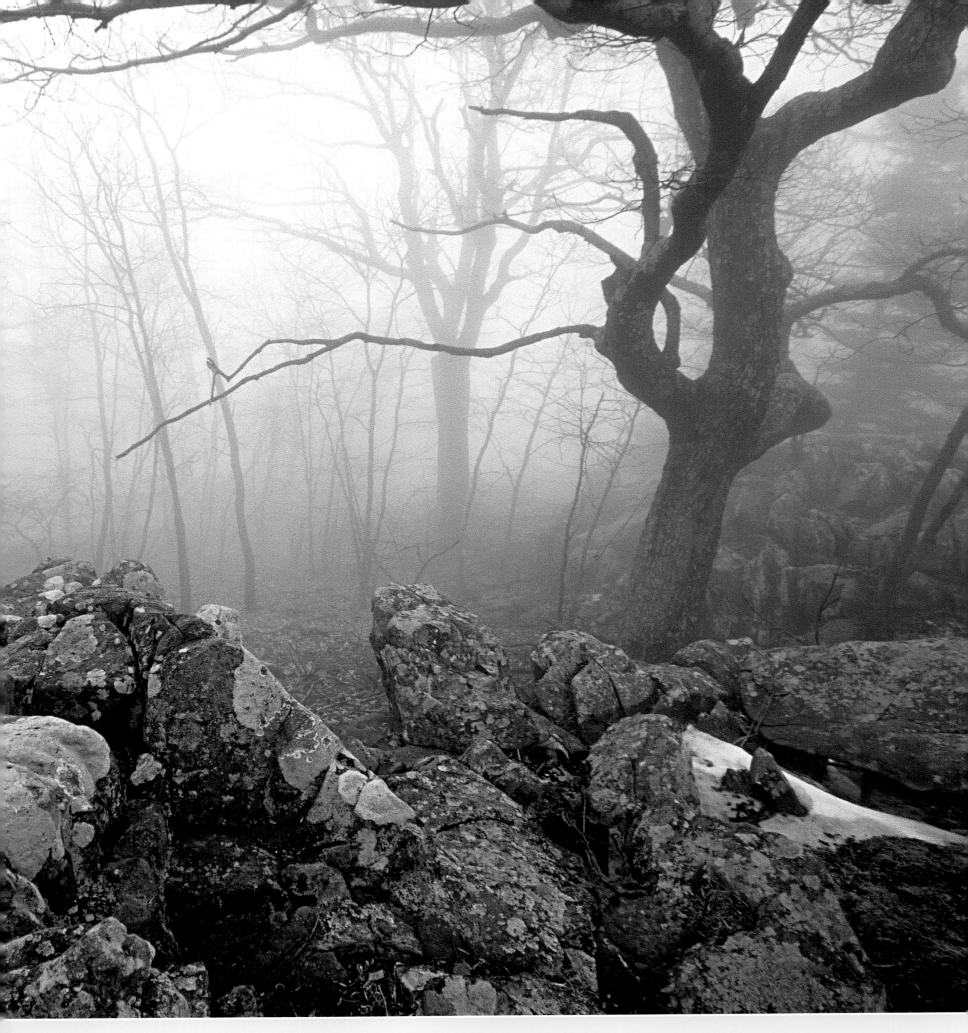

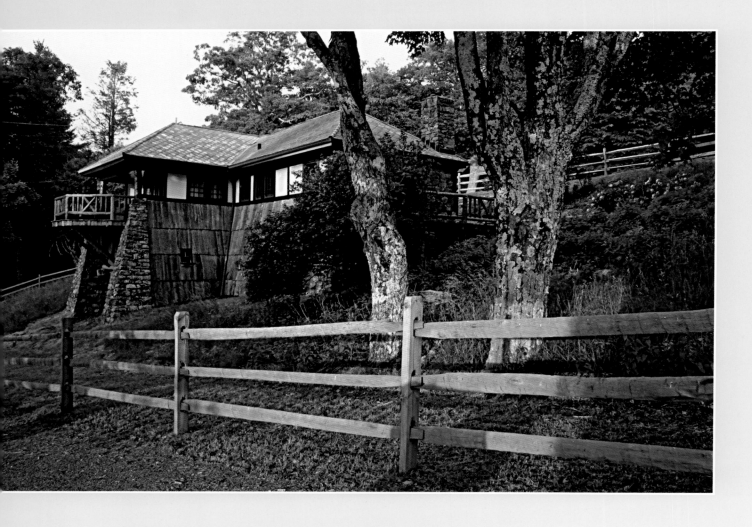

ABOVE: Massanutten Lodge has been restored to its 1916 appearance. The word "Massanutten" means either "the basket that native tribes wove" or "sweet potatoes."

RIGHT: Red-bellied woodpeckers are common at low elevations, feeding on insects and living in holes in dead trees. You can identify the male by his full red cap.

FACING PAGE: Can you see the man in the mountain? Stony Man resembles the profile of a man with a chiseled brow, hooked nose, mustache, and full thick beard, lying down. The 4,010-foot Stony Man, the second highest peak in the park, is composed of greenstone rock that was formed 800 million years ago when lava covered the land.

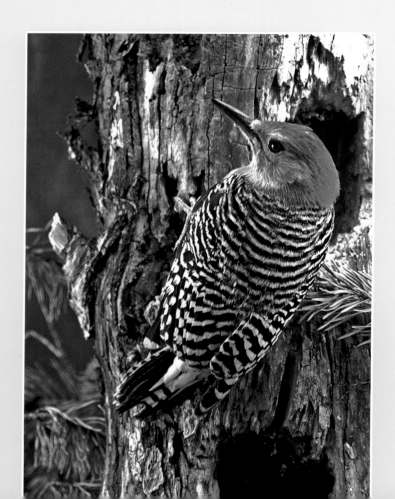

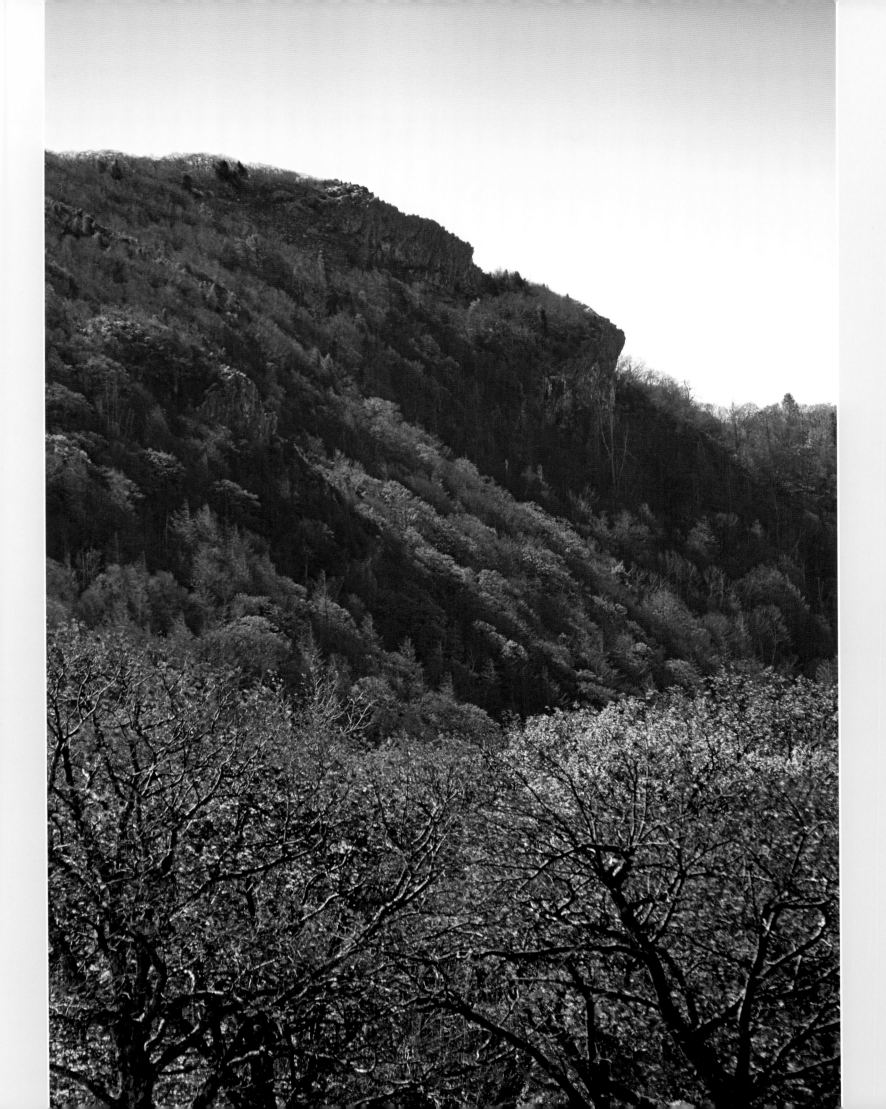

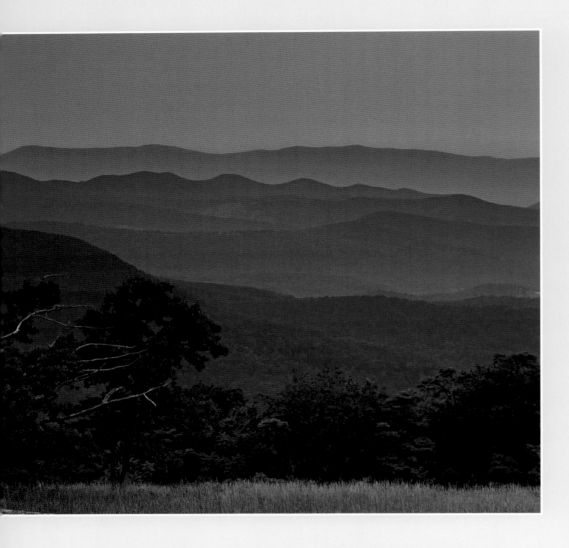

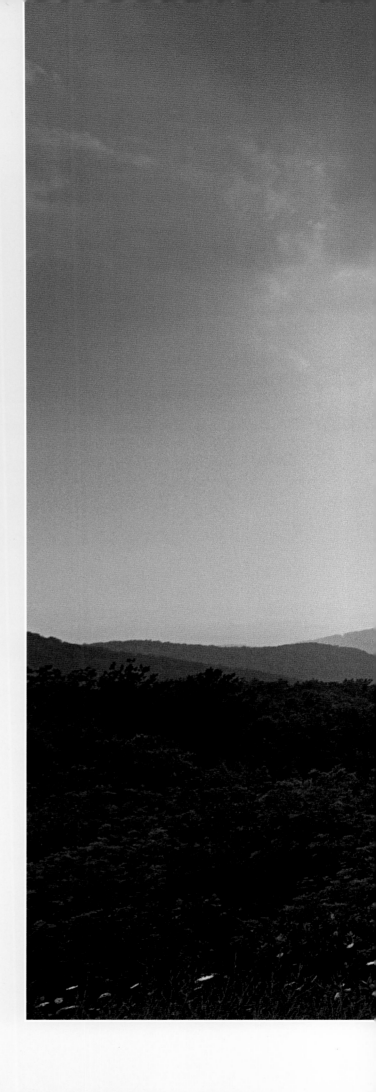

ABOVE: The famous blue-colored ridgelines, as seen from Spitler Knoll Overlook. Traditionally, the characteristic blue haze was from trees releasing moisture into the air. Today up to eighty percent of the haze is from industrial pollutants.

RIGHT: Rip Rap Overlook affords views of spectacular skies and spectacular mountains.

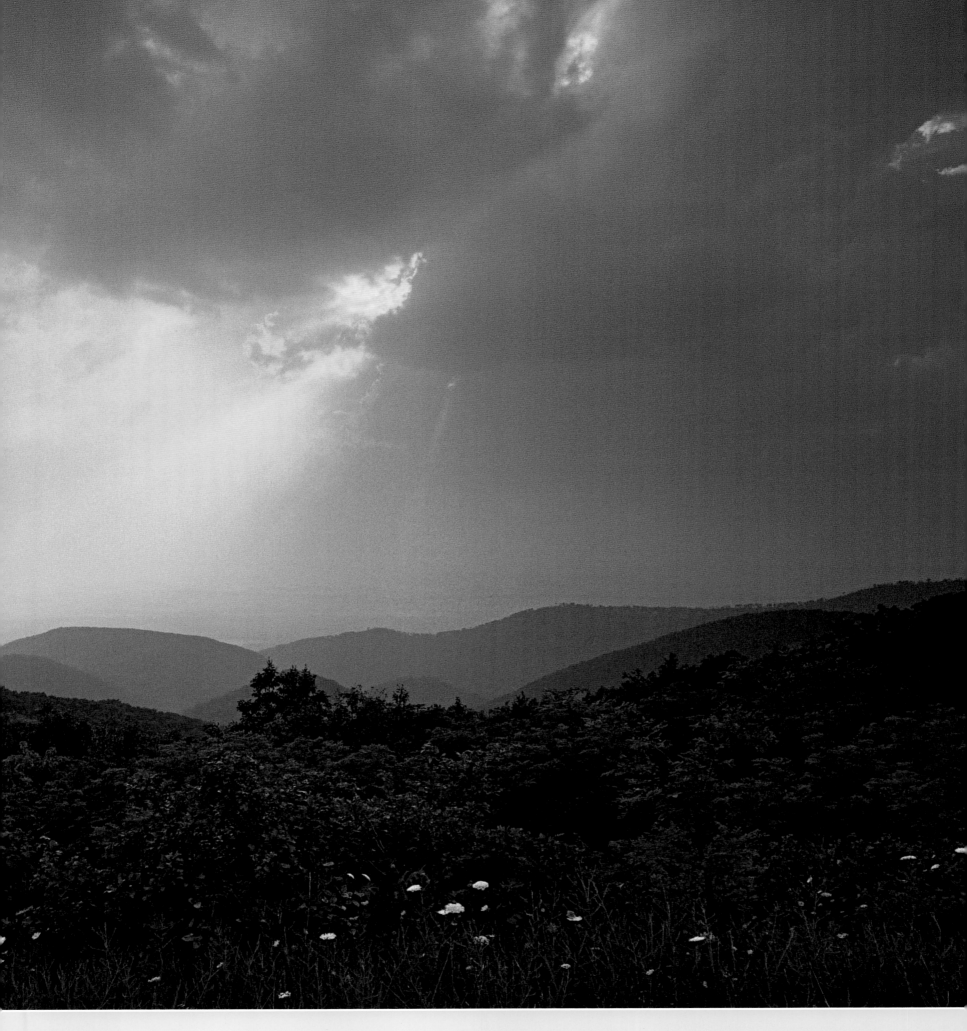

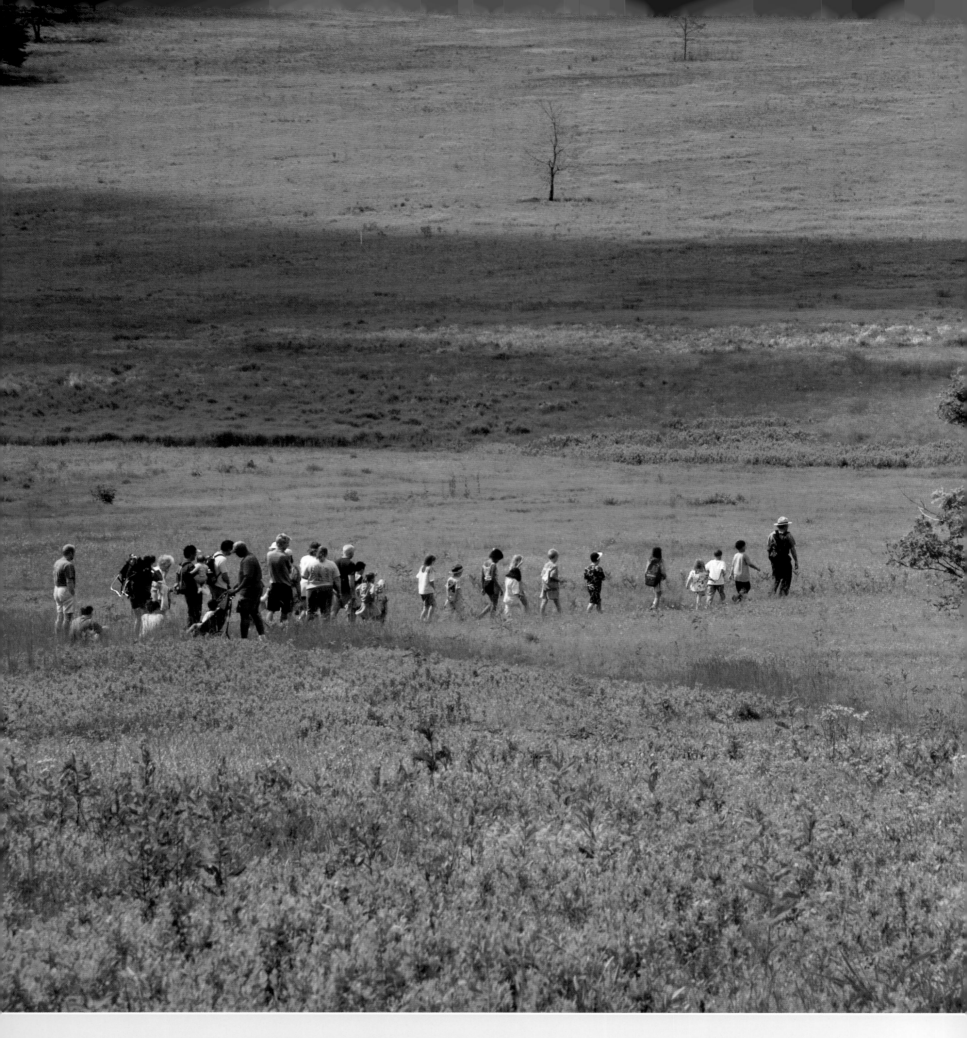

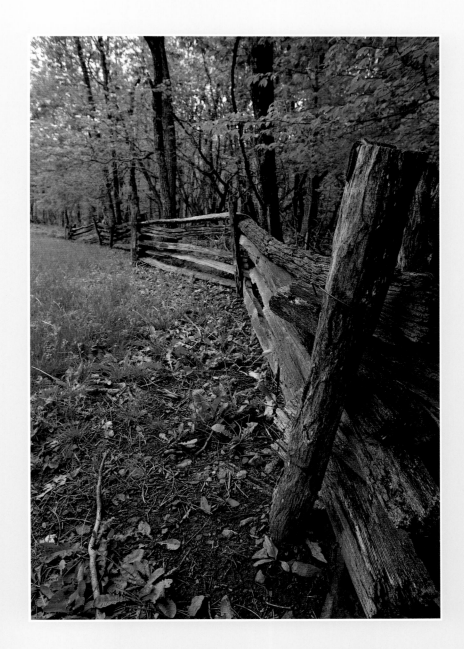

ABOVE: A split-rail fence at Pass Mountain Overlook in the park's central district.

FACING PAGE: A ranger leads a group of children on a hike across Big Meadows.

RIGHT: An eastern chipmunk perches on a deadfall. Look closely in the long crack of the trunk to see British soldier lichen, so-named because it is capped in red.

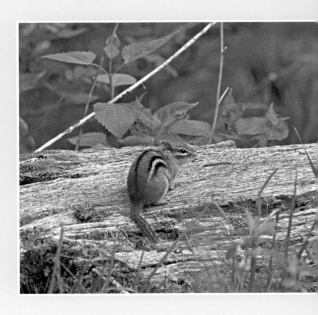

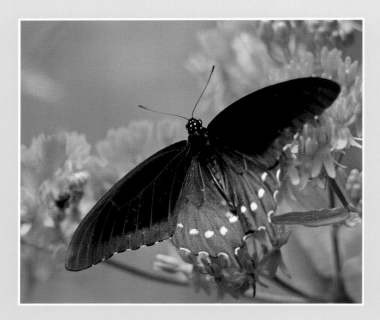

ABOVE: A Pipevine swallowtail searches for nectar on a milkweed blossom. The adults have an interesting survival strategy: The females lay eggs only on plants from the poisonous Pipevine family, such as Dutchman's pipe and Virginia snakeroot. The caterpillars eat the plants without being harmed, and the chemicals make them poisonous to most predators.

RIGHT: The view from Brown Mountain Overlook is expansive. The white-colored rocks on the near ridge are composed of Erwin quartzite; the Allegheny Mountains dominate the far horizon.

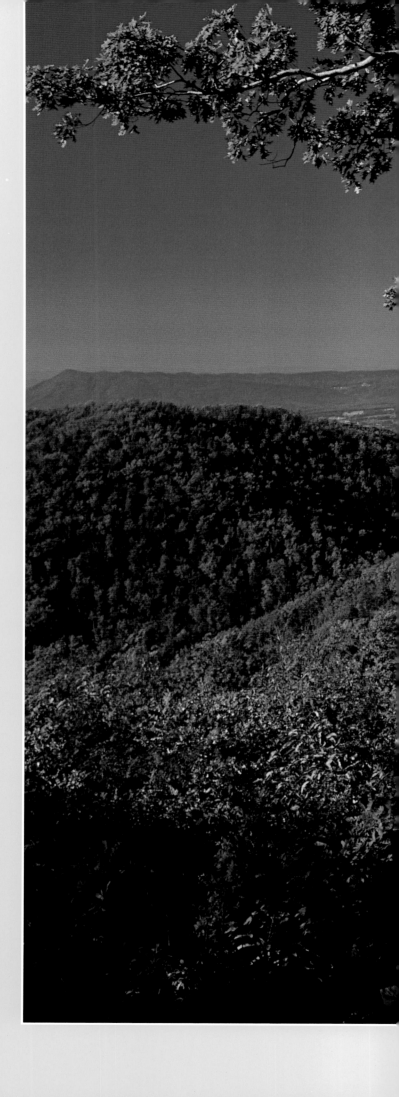

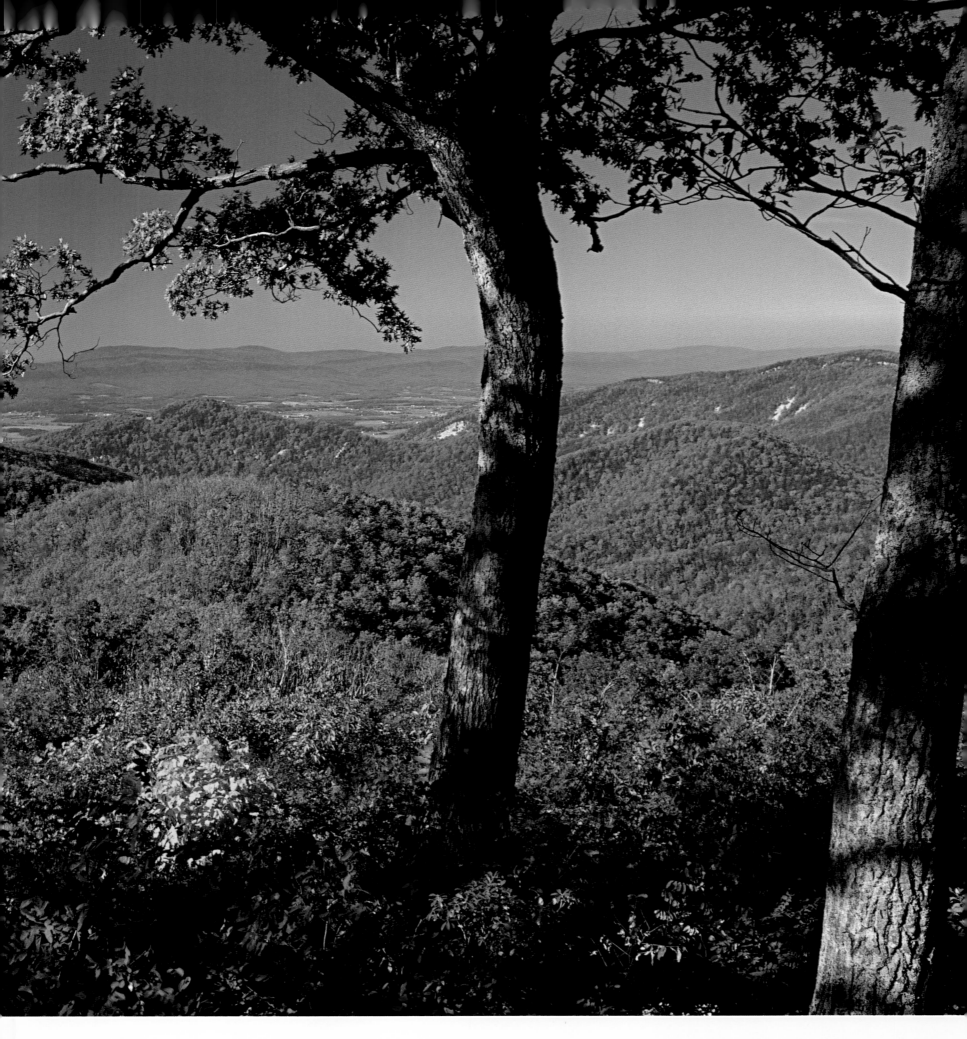

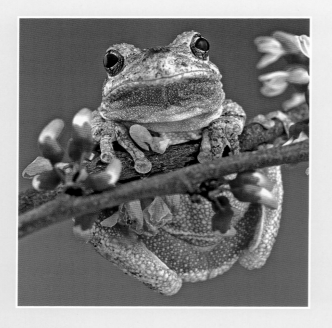

ABOVE: A gray tree frog clings to a redbud. Tree frogs climb easily because they have suction discs on their feet.

RIGHT: Springtime travelers get an immediate view of blooming redbud, near Milepost 1 on Skyline Drive. Eastern redbud is sometimes called Judas-tree. According to legends, Judas Iscariot hanged himself from a branch of the European species of redbud.

BELOW: Purple asters bloom along Skyline Drive. The entire park shelters 862 species of wildflowers; nearly one-fifth of them are in the aster family.

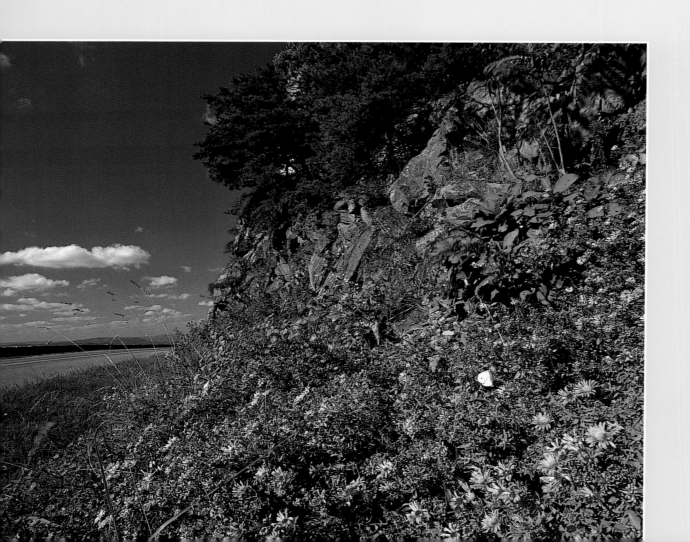

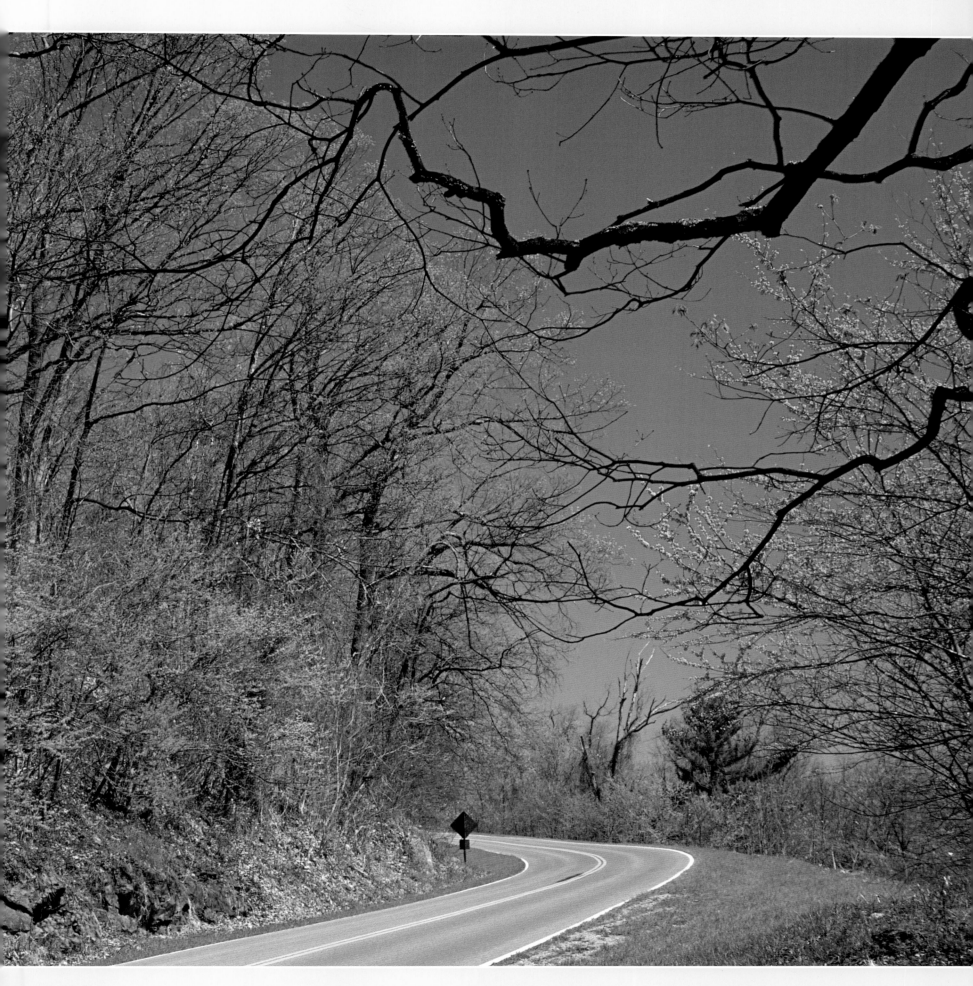

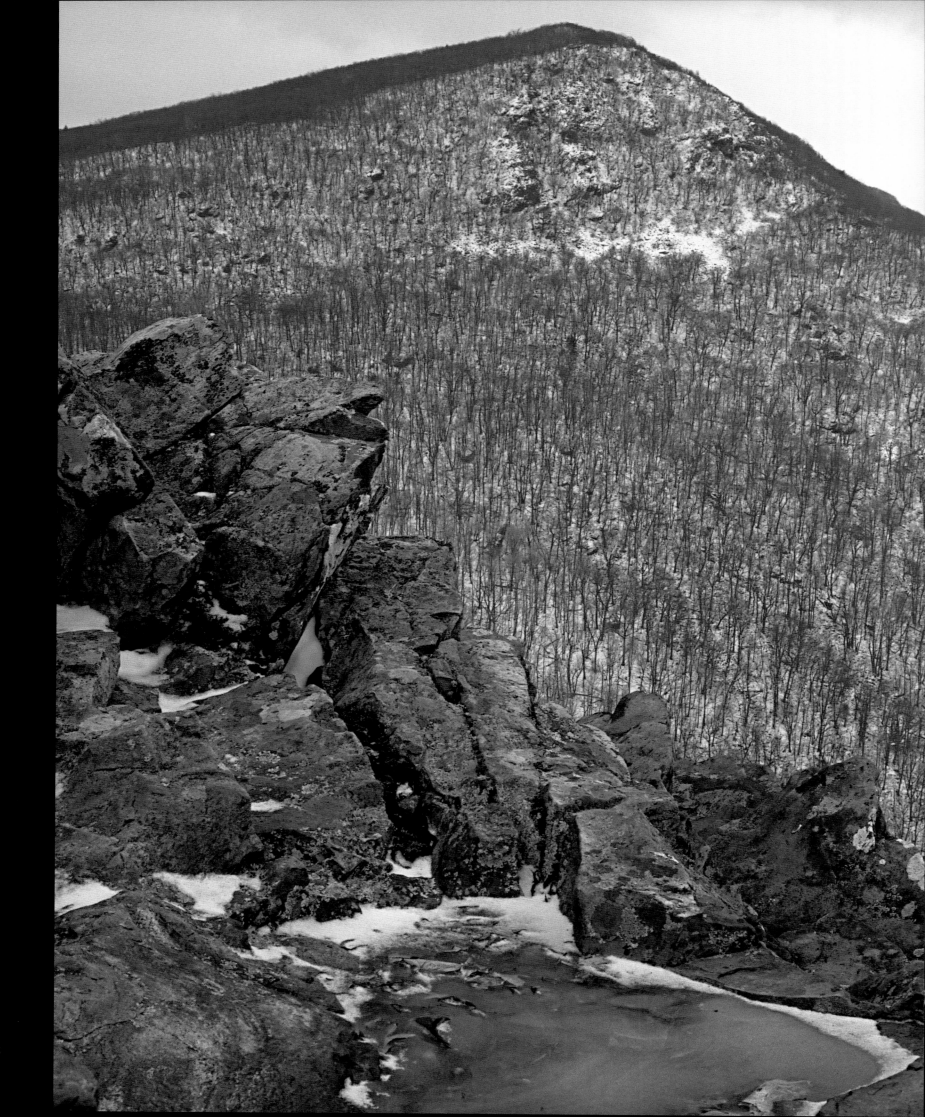

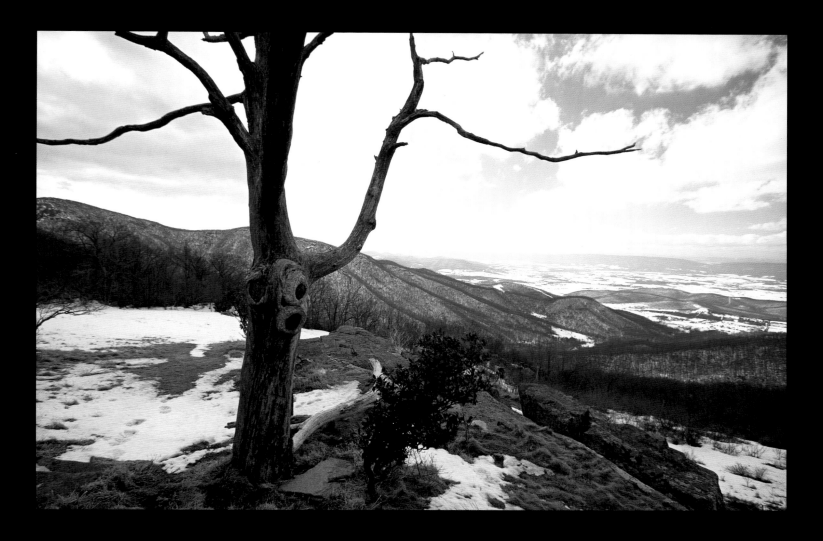

ABOVE: Conditions were too extreme for this tree to survive at Thorofare Mountain Overlook.

FACING PAGE: An icy puddle abuts Crescent Rock at the foot of Hawksbill Mountain.

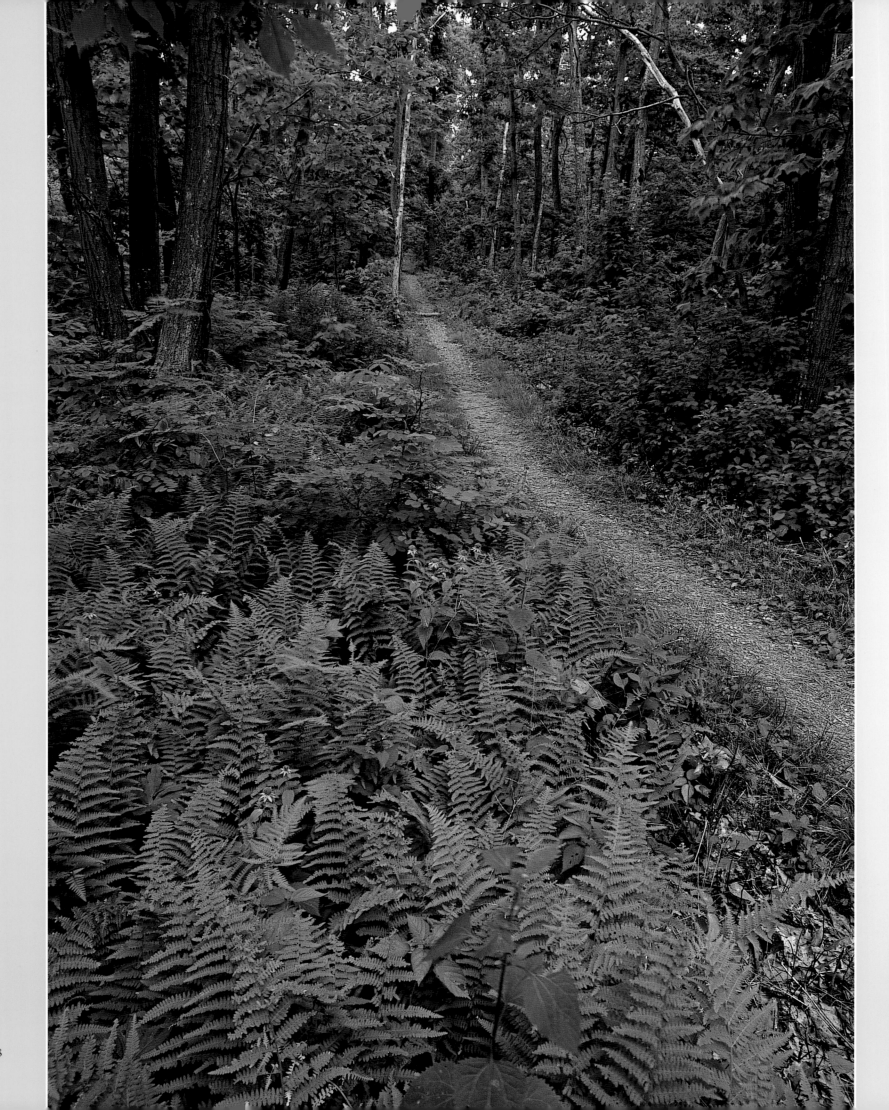

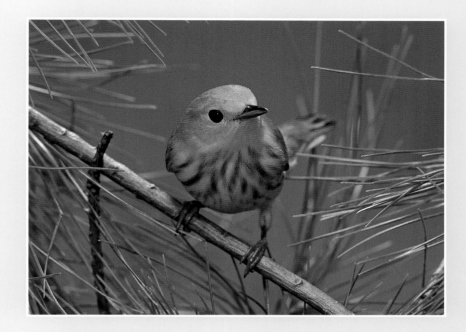

RIGHT: This bright yellow warbler is one of many warblers in the park, including the cerulean warbler, the chestnut-sided warbler, and the black-throated green warbler.

FACING PAGE: Hay-scented ferns line the Appalachian Trail on its way to Mount Marshall Summit from Milepost 16 on Skyline Drive.

BELOW: Two-feet-tall, thin-leafed sunflowers are a bright pool of yellow along Skyline Drive.

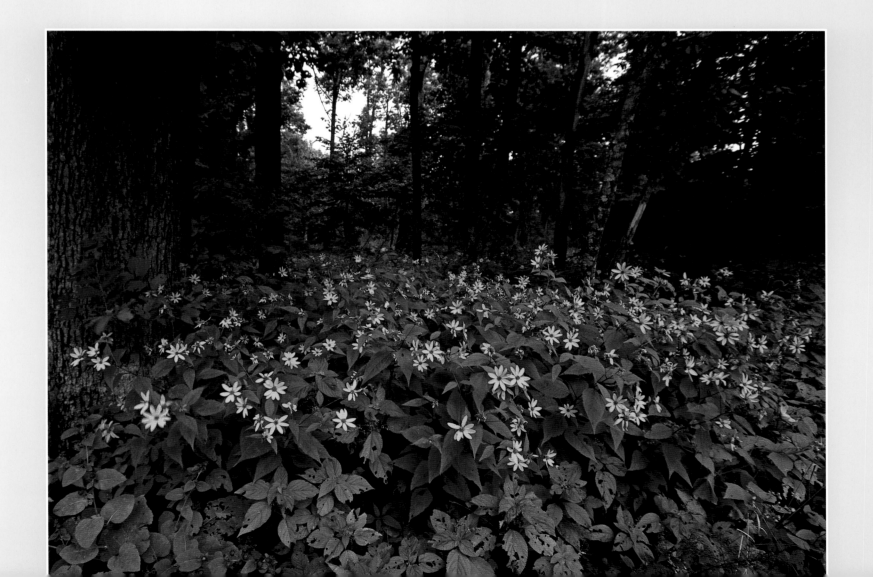

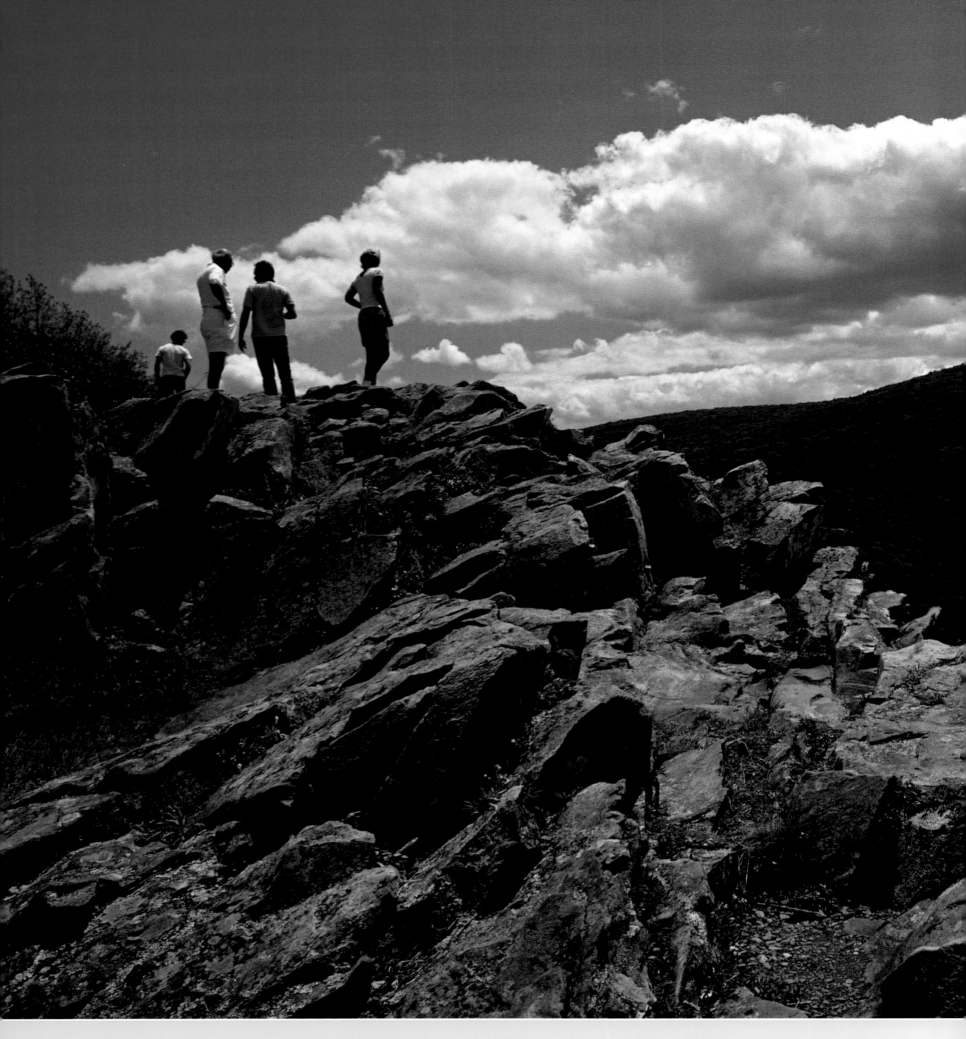

ABOVE: Three-toothed cinquefoils—a rare sight in the park because they are more typically found in Canada—grow around a wedge of rock.

LEFT: Hikers stand atop Crescent Rock to look at 4,051-foot Hawksbill Mountain, the highest mountain in the park.

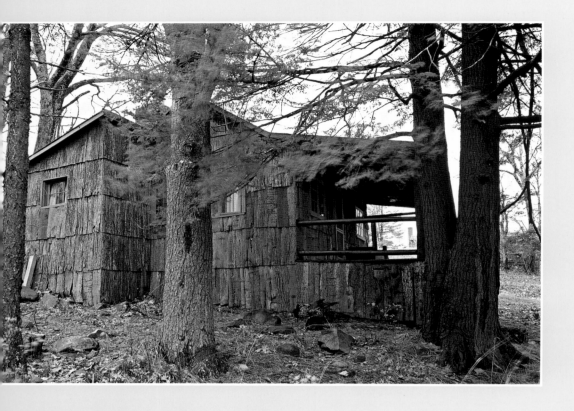

LEFT: Byrds Nest Cabin, built in 1906, is the oldest cabin still standing in the park.

FACING PAGE: The Appalachian Trail, littered with red- and yellow-hued oak and hickory leaves, at Compton Gap.

BELOW: A tent is pitched in a secluded site in Mathews Arm Campground, one of five campgrounds in Shenandoah National Park. At one time, gypsy moths denuded the campground's trees of their foliage, but the forest has rebounded and is now a lovely, shady place.

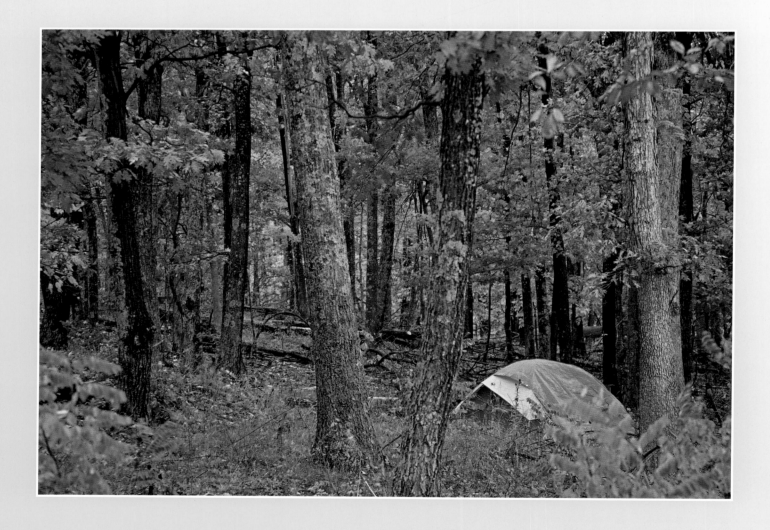

RIGHT: Springtime blooms are a bonus on any scenic drive. The flowering dogwood's beautiful white blossom is the state flower of Virginia.

BELOW: The white-flowered bloodroot is named for the red, milky sap in the stem, which makes a good dye.

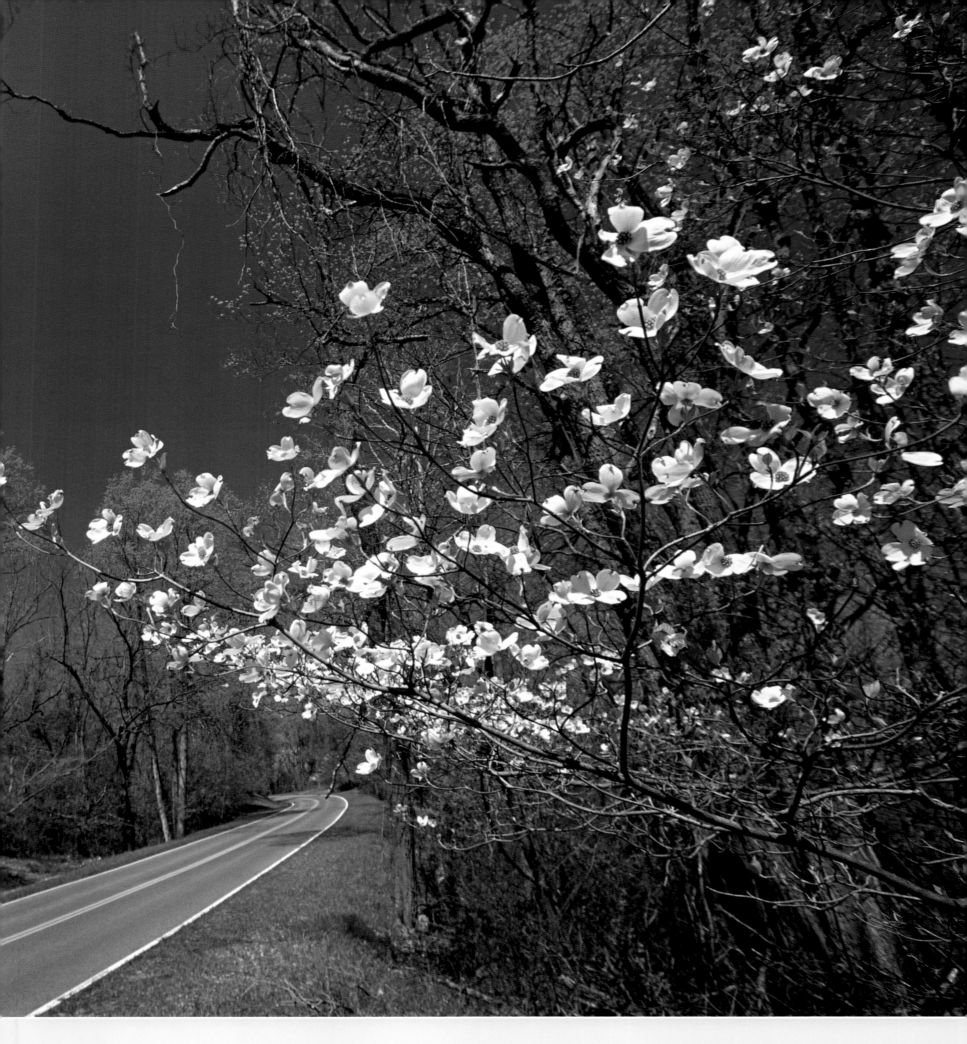

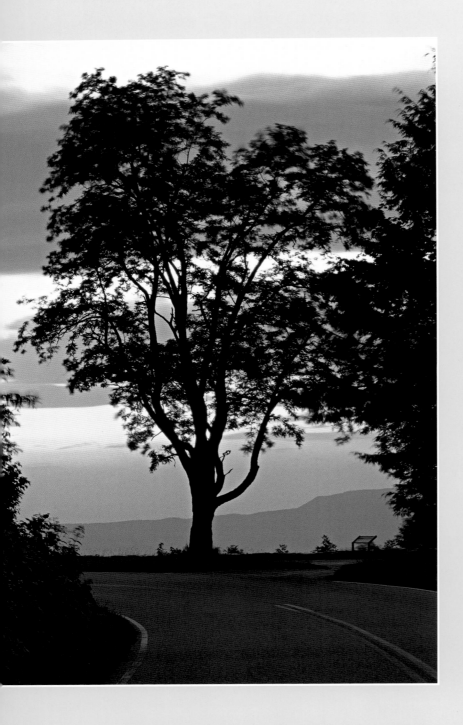

ABOVE: This tree is silhouetted by the sunset at Sandy Bottom Overlook. The overlook provides a picture-perfect vista of Massanutten Mountain, which is anchored at either end by the towns of Strasburg and Harrisonburg.

RIGHT: From the Hogback Overlook, winter sunshine brightens the Blue Ridge Mountains as they rise above Browntown Valley.

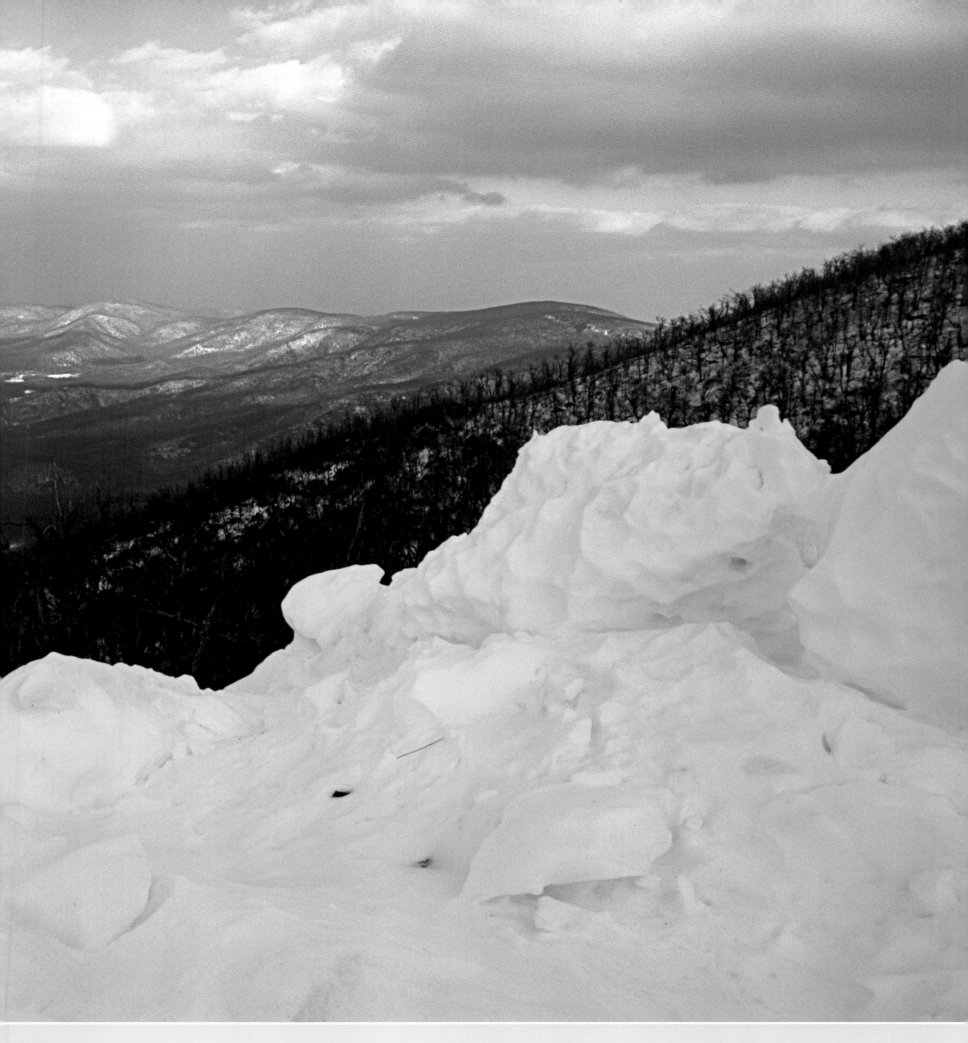

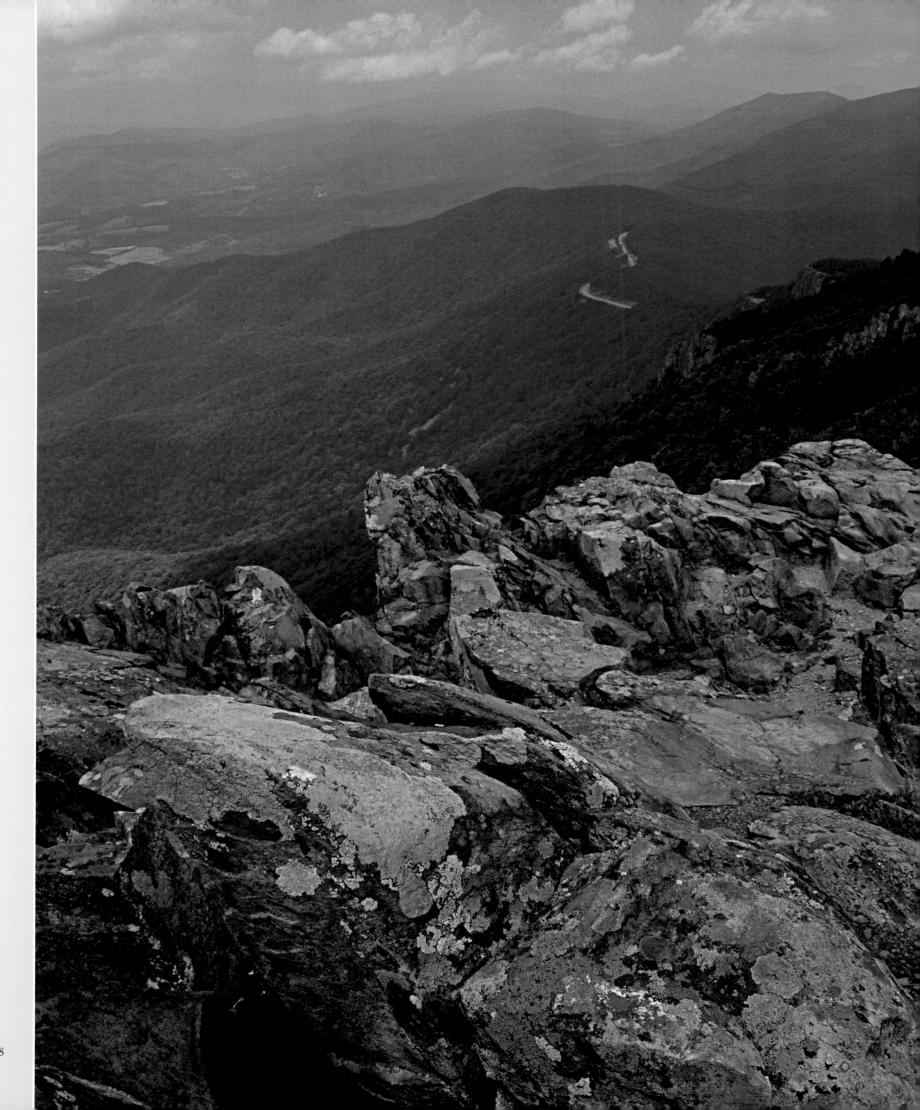

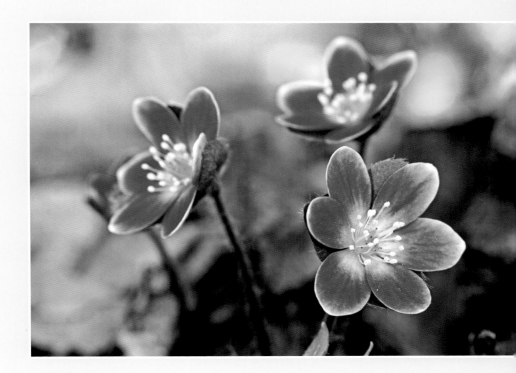

RIGHT: Round-lobed hepatica is sometimes called liver-wort because its leaves resemble the three lobes of a liver. Hepatica is one of the first plants to bloom each spring.

FACING PAGE: Skyline Drive meanders along the top of the Blue Ridge Mountains, providing nonstop views.

BELOW: Franklin Cliffs Overlook provides a sweeping view of Shenandoah National Park.

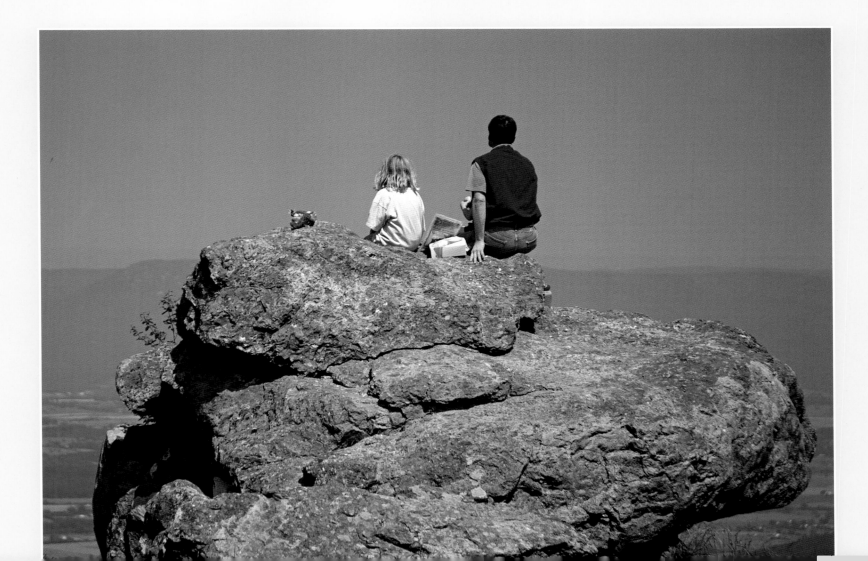

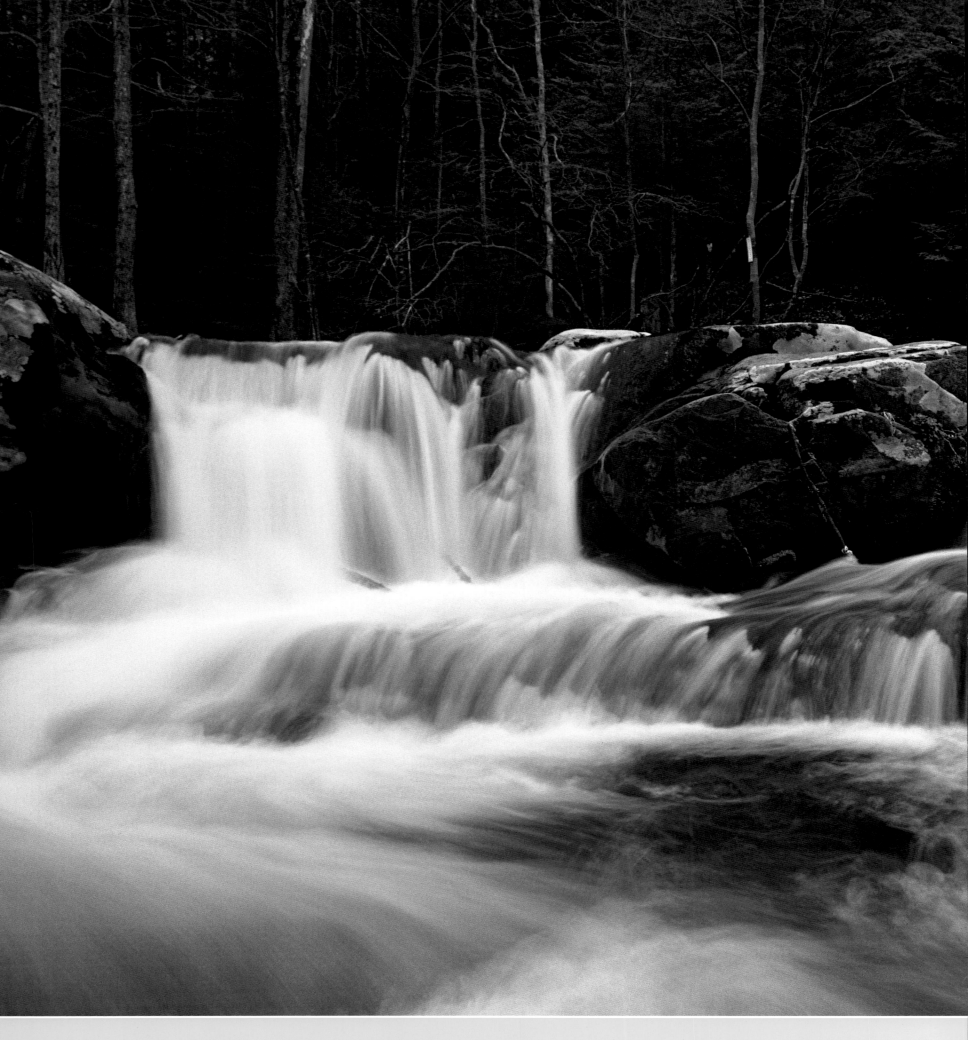

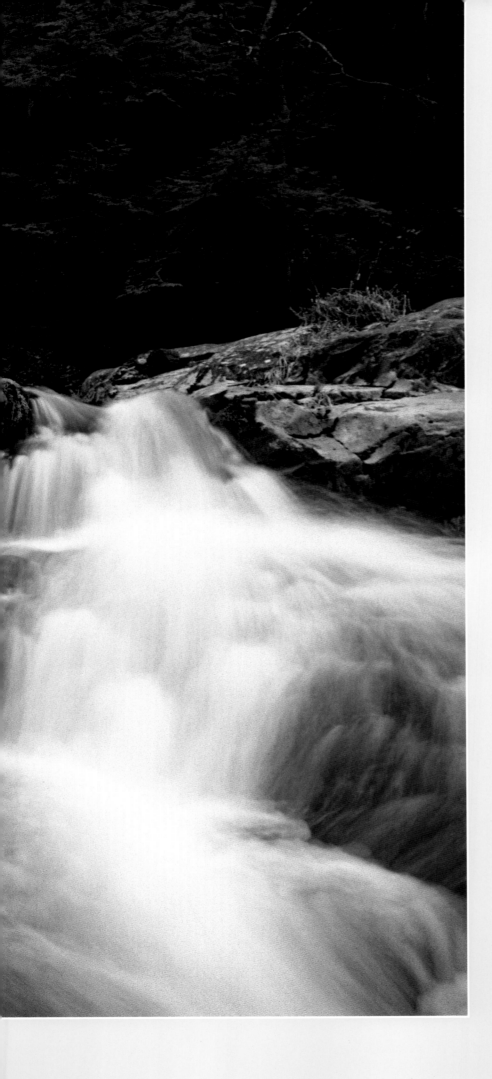

LEFT: The Rapidan River carries water from Doubletop Mountain to its confluence with the Rappahannock River, en route to Chesapeake Bay. Many of Shenandoah National Park's streams are suffering from the effects of acid rain, as are many aquatic systems along the spine of the Blue Ridge Mountains.

BELOW: Brook trout, the only native trout in the park, depend on clear, clean, cool, fast-flowing streams. The park has 34 species of fish.

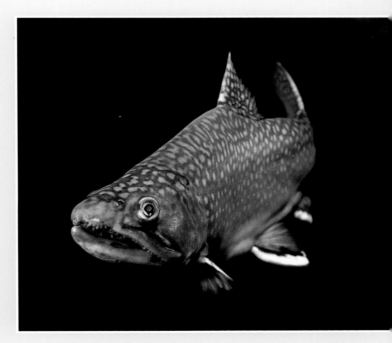

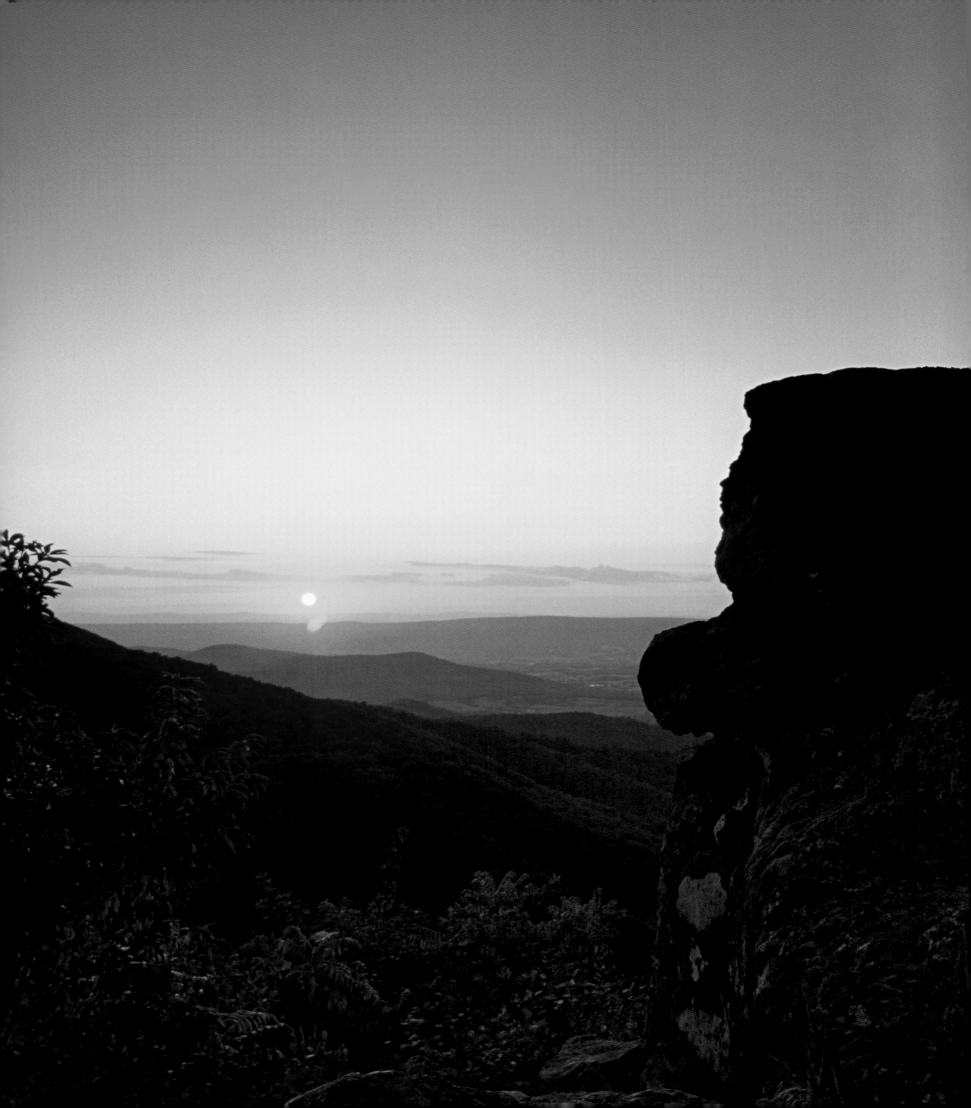

Shenandoah National
Park's beautiful natural
features provide ample
opportunities for people
to pause and reflect.

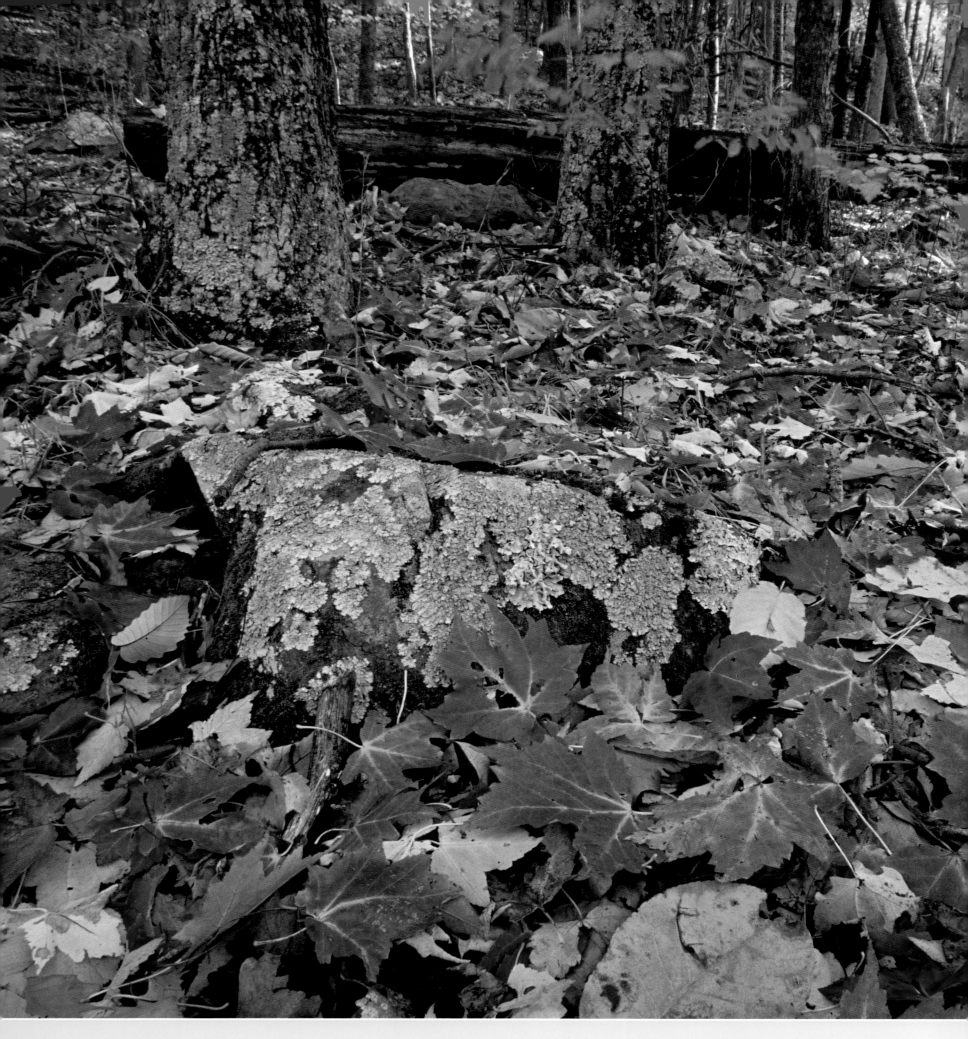

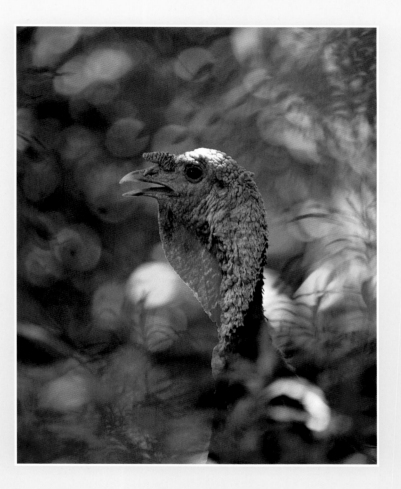

ABOVE: This wild turkey pauses, alert, its waddle backlit by a late-day sun.

LEFT: Elkwallow, littered with autumn's best and brightest. This is an old name. Overhunting and changes in habitat wiped out elk in the region by 1855.

115

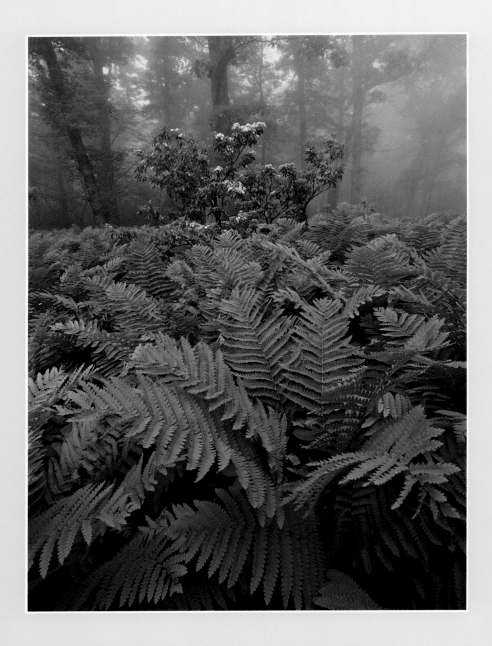

ABOVE: A rose azalea blooms pink behind a cluster of interrupted ferns near Pinnacles Overlook.

RIGHT: Skyline Drive beckons through a misty tunnel of greenery in the Lewis Mountain area. The park contains as many as 100 species of trees.

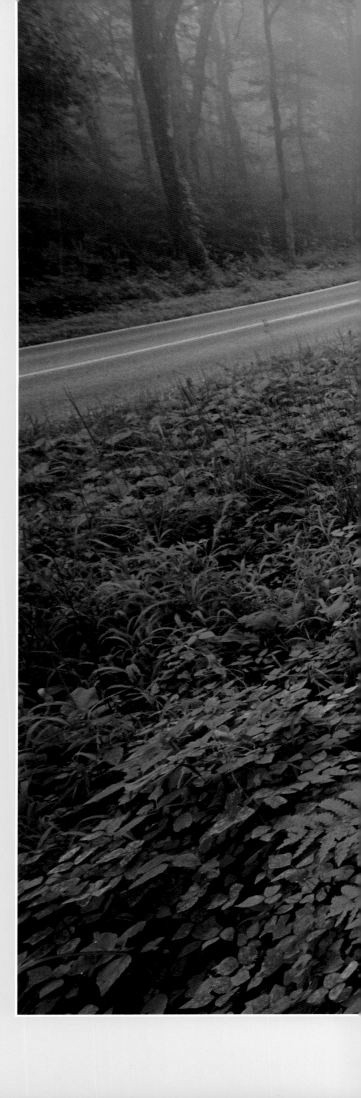

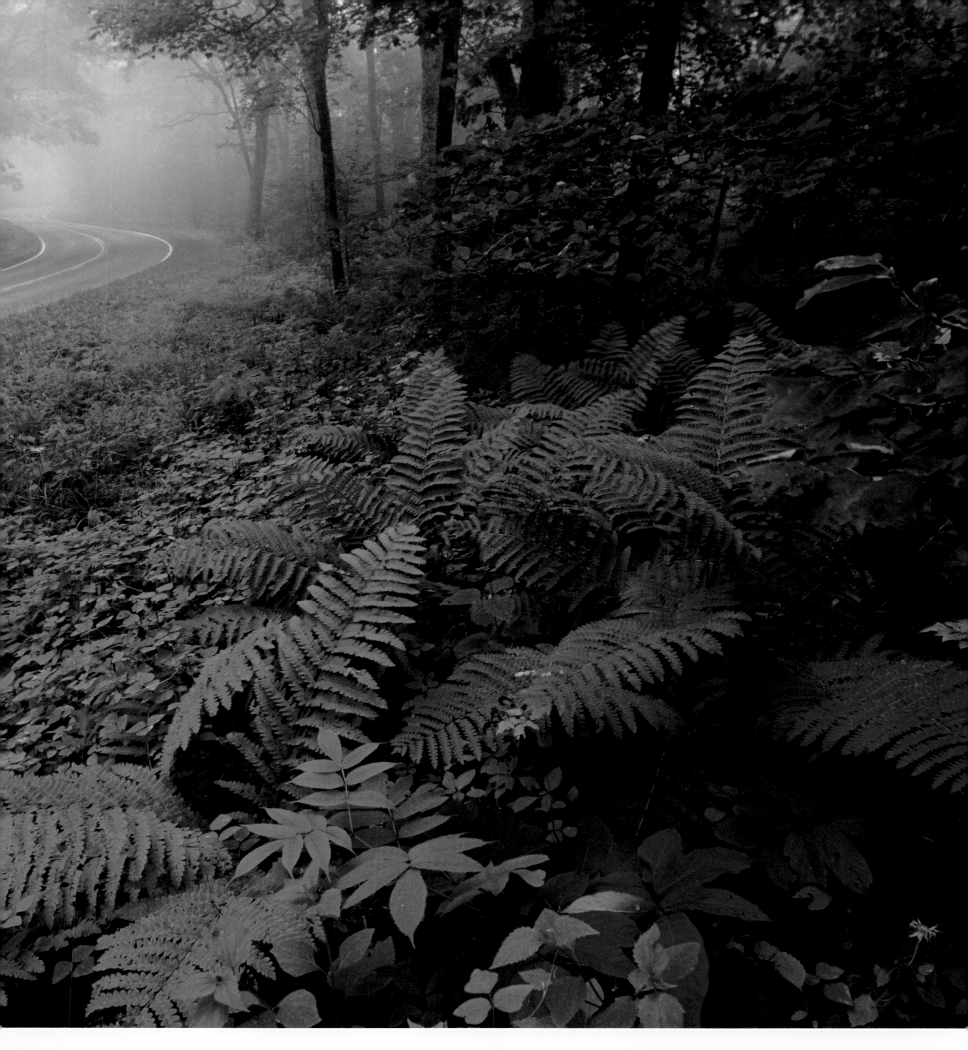

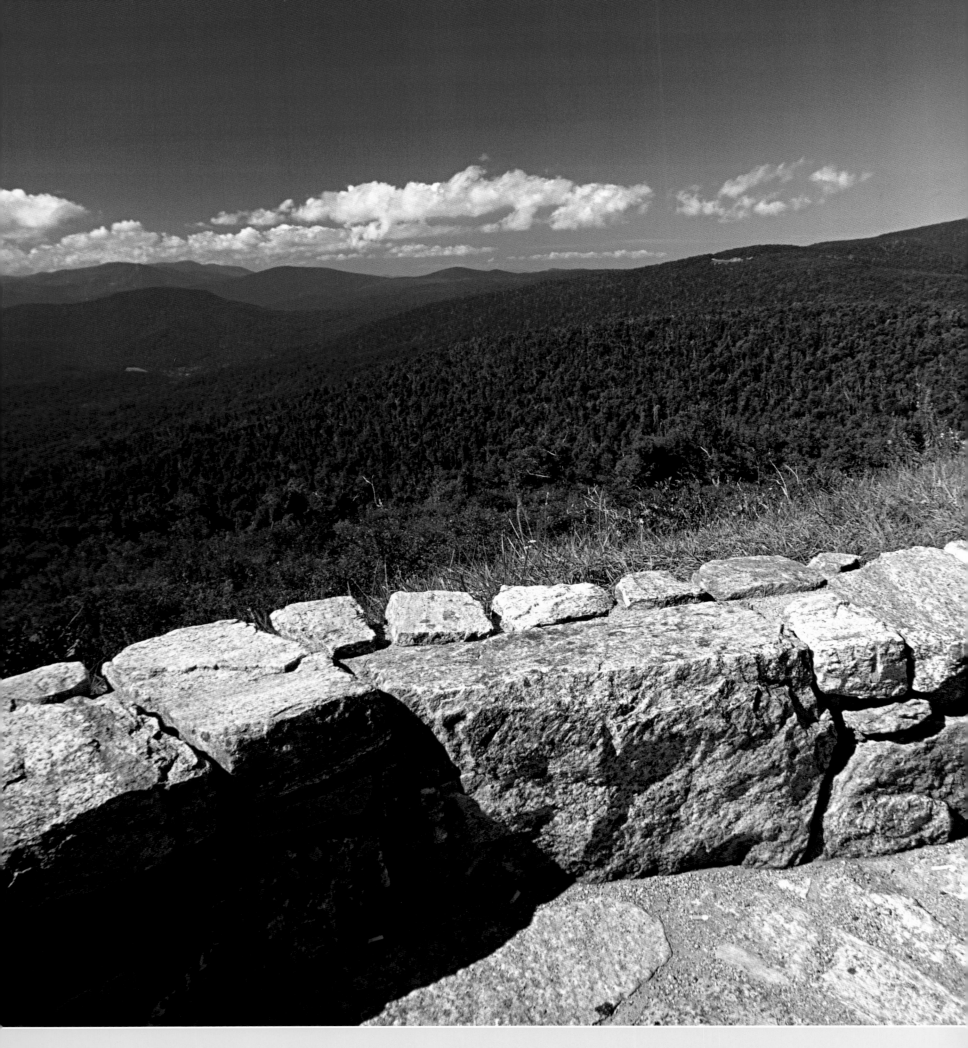

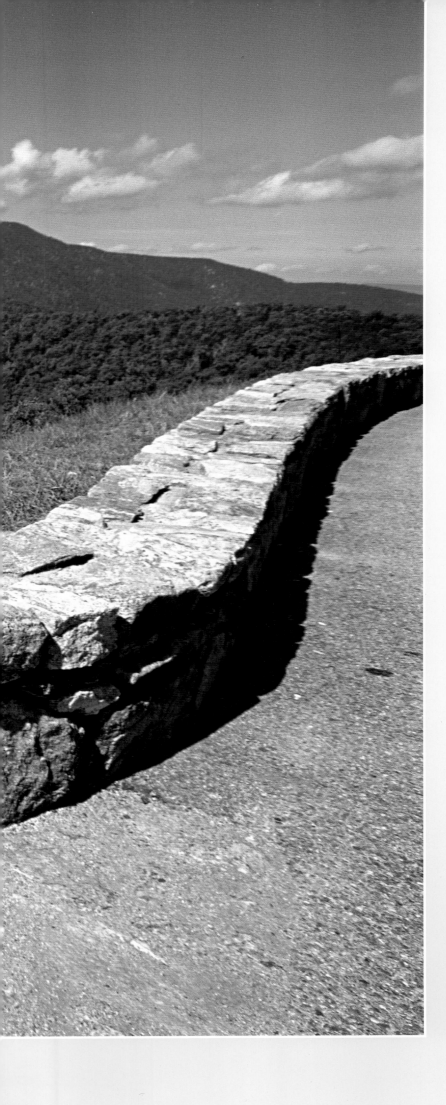

LEFT: The solid stone wall built by the CCC in the 1930s outlines the perimeter of Range View Overlook, which provides a sweeping view of the Blue Ridge Mountains.

BELOW: A forked-tongued northern copperhead, one of two poisonous snakes indigenous to the park. The other is the timber rattlesnake. The park has twenty species of snakes, eleven species of frogs and toads, six species of turtles, and four species of lizards.

FOLLOWING PAGE: Sweet solitude: fly-fishing for trout in the Rapidan River.

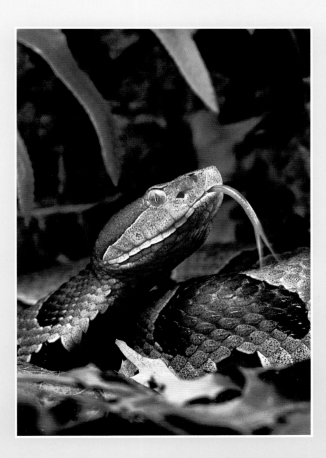

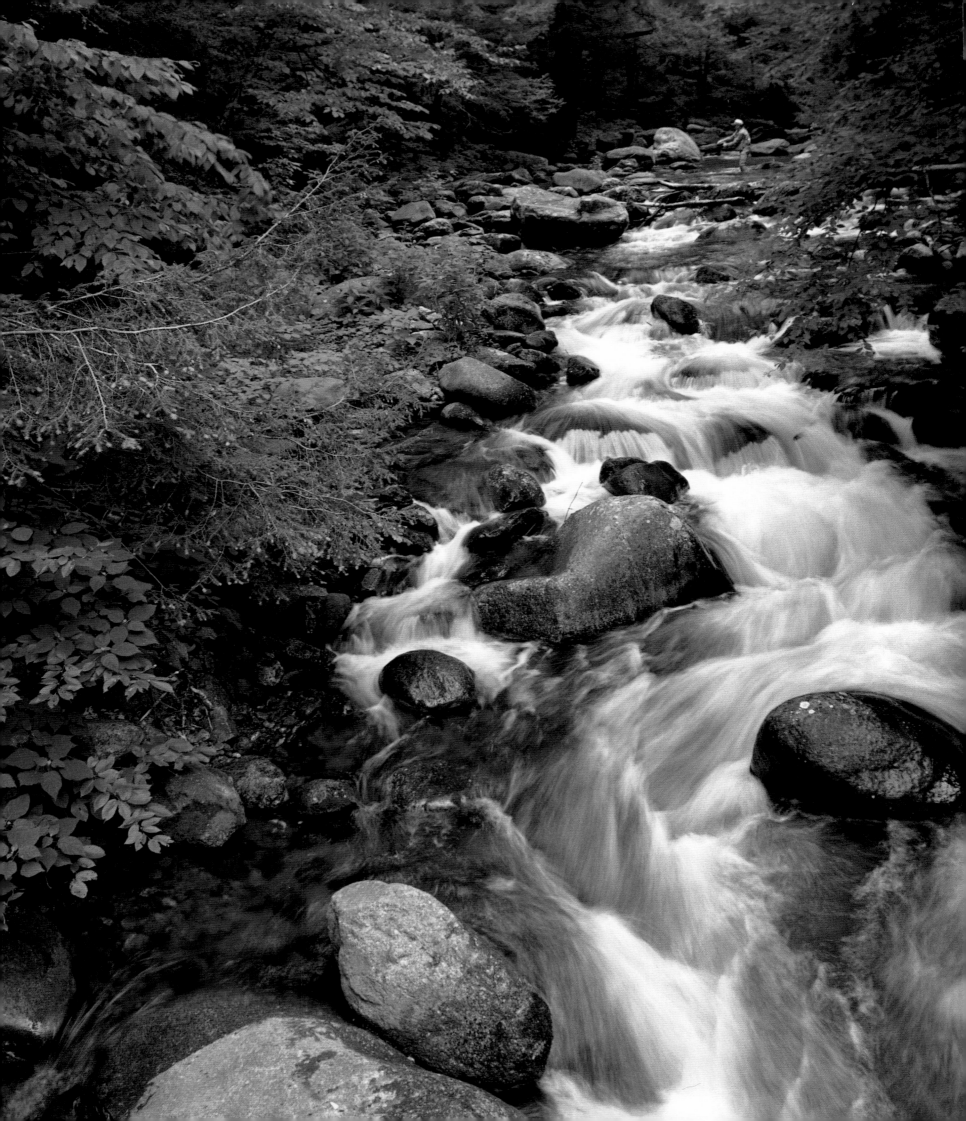